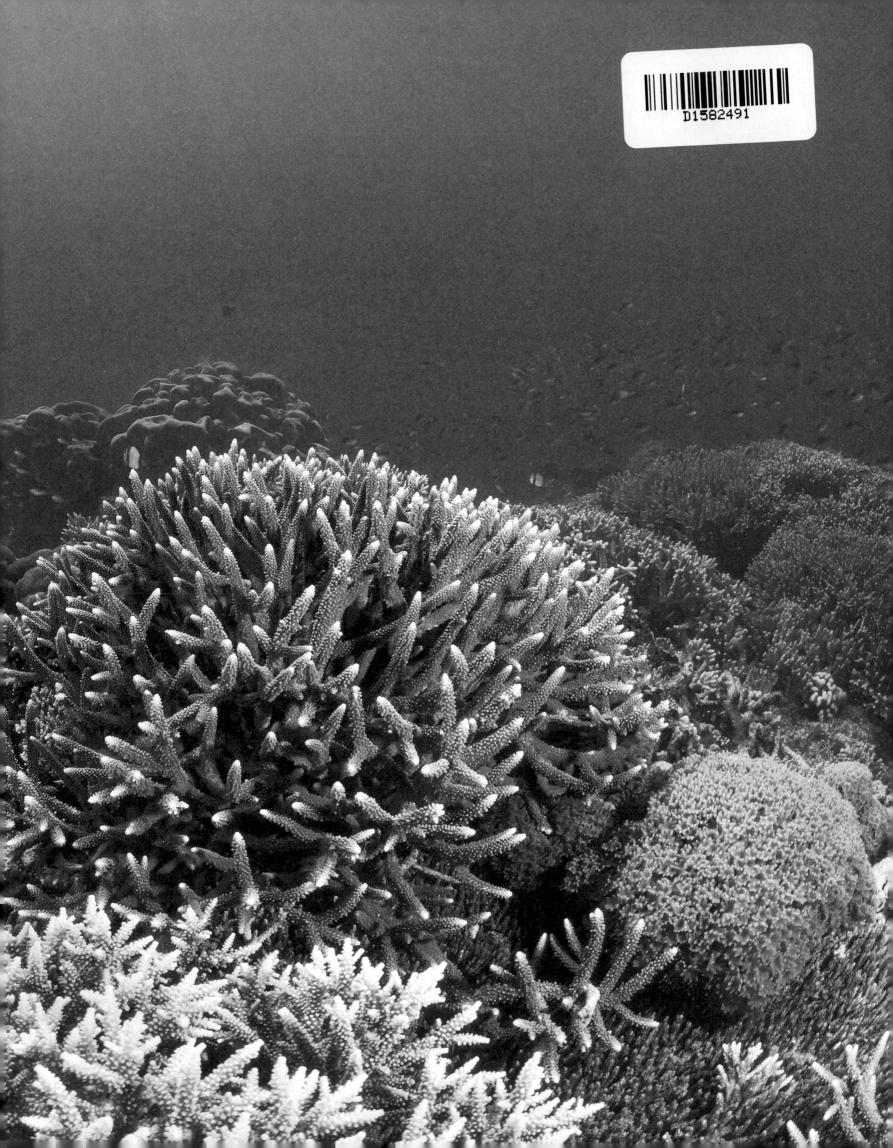

REEFS
REVEALED

ALEX MUSTARD

REEFS
REVEALED

CONSTABLE • LONDON

Constable & Robinson
3 The Lanchesters
162 Fulham Palace Road
London W6 9ER
www.constablerobinson.com

First published in the UK in 2007 by Constable,
an imprint of Constable & Robinson Ltd

ISBN: 978-1-84529-634-6

10 9 8 7 6 5 4 3 2 1

Title page

A tiny (12 mm) pygmy seahorse *Hippocampus denise*
clings to a gorgonian *Subergorgia mollis*.
Misool Island, Raja Ampat, Indonesia. Ceram Sea.
Nikon D2X + 105mm. 1/250th @ F36

CONTENTS

Introduction 11

THE IMAGES 18
Coral spawning 40
The commensal goby 52
Mangrove world 86
The mimic octopus 96
Cleaning stations 112
The walking shark 124
Anemonefish 136
Mating hamlets 174

Note on the Photography 188
Selected Bibliography 191
Acknowledgements 192

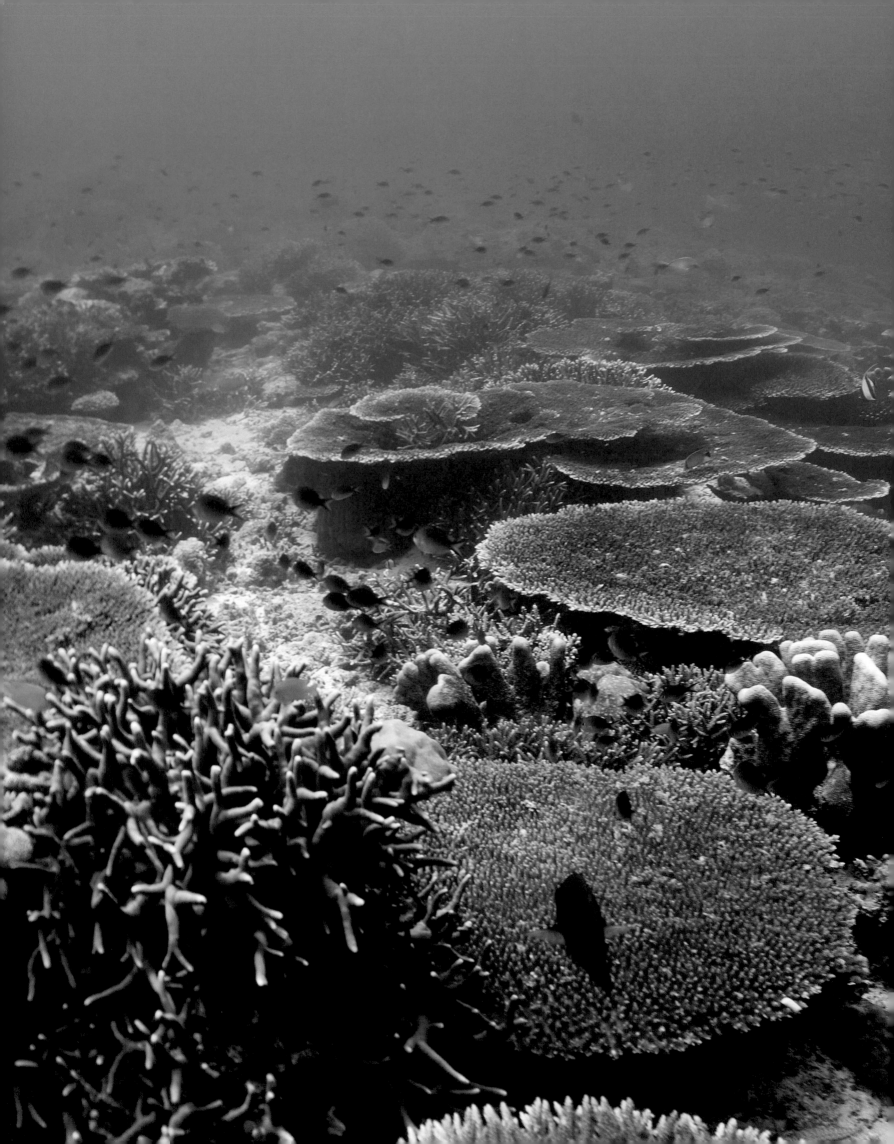

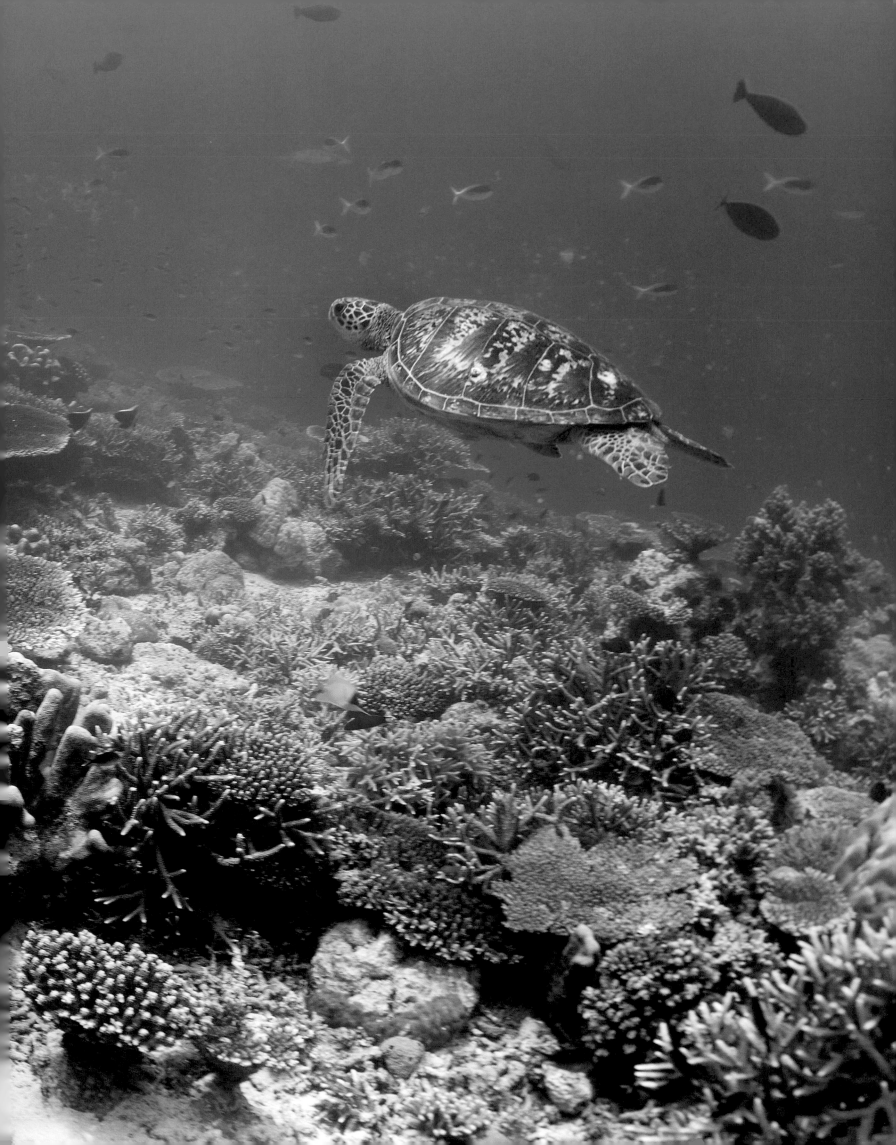

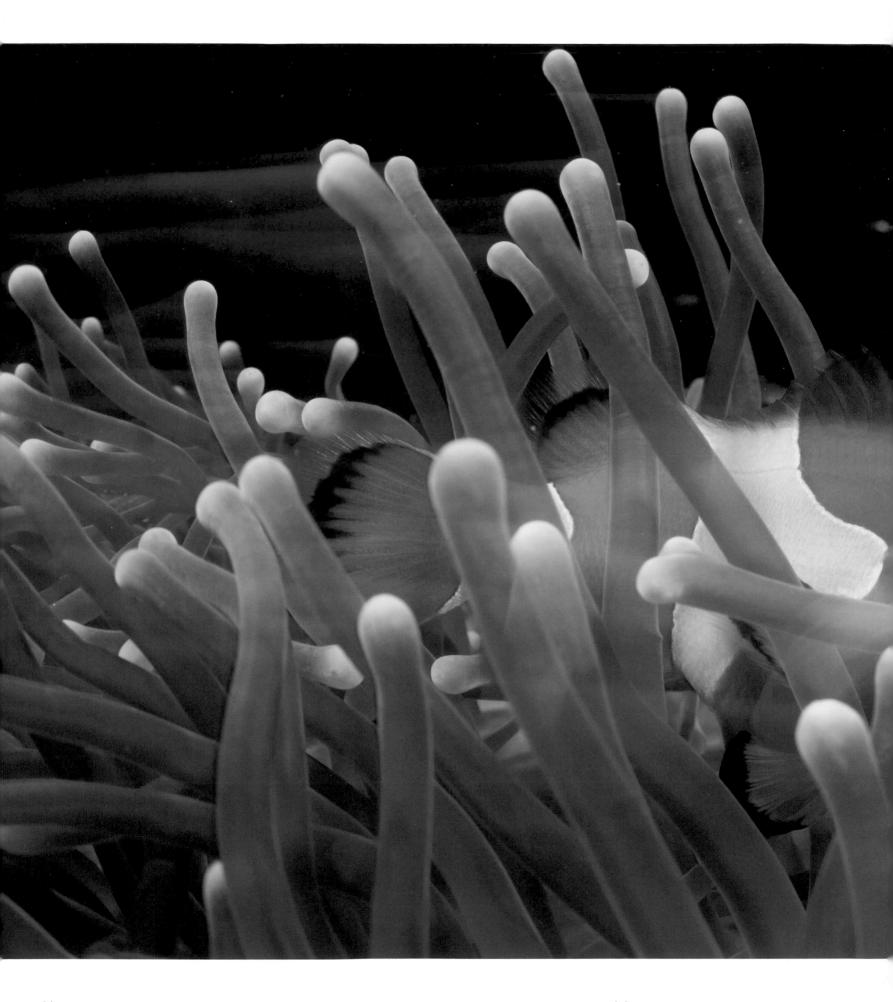

<< A green turtle *Chelonia mydas* swims over a shallow
coral garden.

Sipadan Island, Sabah, Malaysia. Molucca Sea.
Nikon D2X + 16 mm. 1/50th @ F5

∧ A clownfish *Amphiprion ocellaris* swims through the
stinging tentacles of an anemone *Heteractis magnifica*.

South Bird's Head peninsula, West Papua, Indonesia.
Nikon D2X + 10.5 mm + 1.5x TC. 1/6th @ F8

>> Homeless secretary blenny *Acanthemblemaria maria*
looks for a wormhole.

West Bay, Grand Cayman, Cayman Islands.
Nikon D2X + 105 mm. 1/180th @ F25

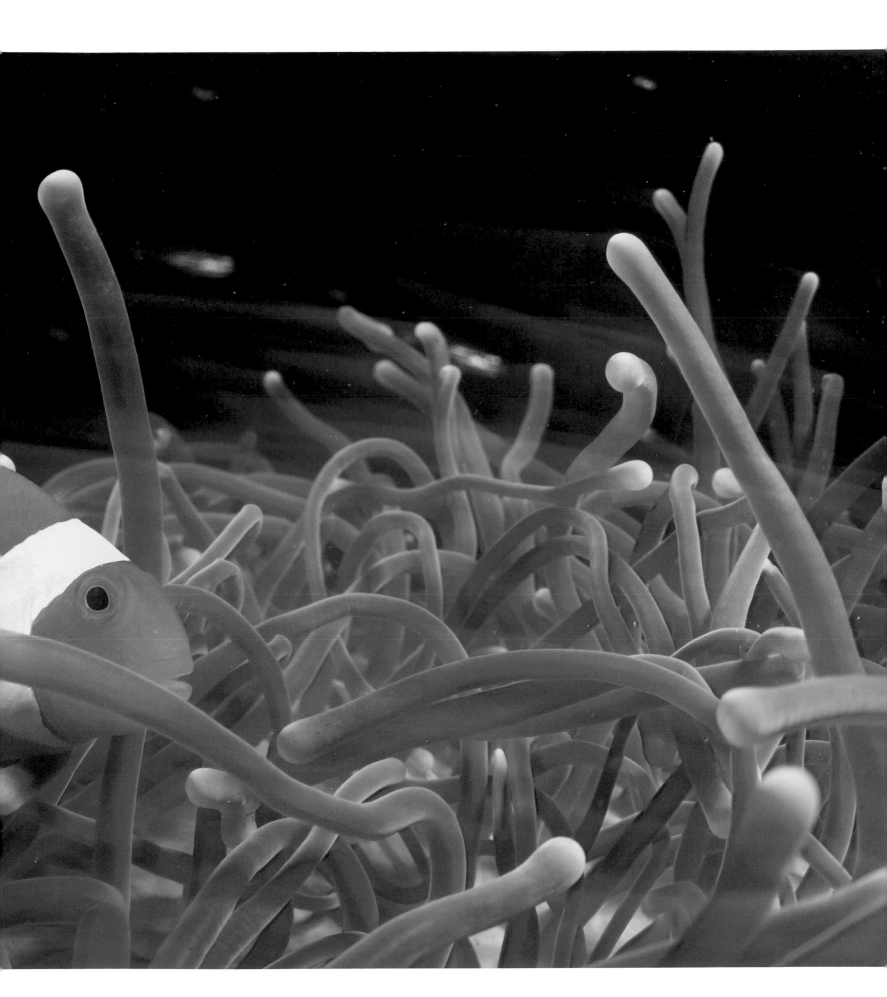

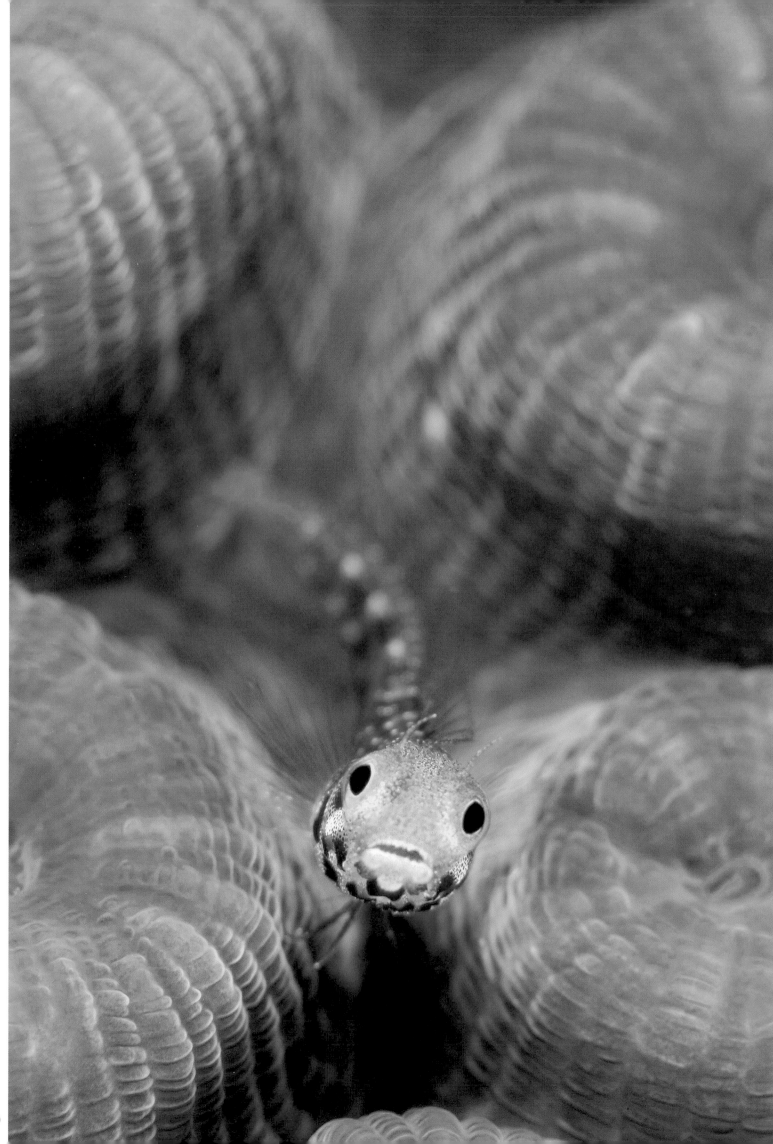

Imagine, for a moment, that you are not on Earth but, instead, taking a stroll on the Moon. Personally, I find that getting off the planet helps me put things in perspective. Looking back at our world you cannot help but be struck by its beauty – a blue, white and green glowing sphere alone against the vast black emptiness of space.

The disc of the Earth appears four times larger than the Moon in our sky, and even with the naked eye we can easily identify features. But none of these features are man-made. In a low space orbit around Earth it is possible to see cities, major roads, fields, but even 10 per cent of the way to the Moon the Great Wall of China can no longer be seen. Just one structure built by a living community is visible from the Moon: an iridescent turquoise chain, stretching up the east coast of Australia for more than 2,000 kilometres, in an ocean of royal blue – The Great Barrier Reef.

Coral reefs are arguably the most fascinating and breathtakingly beautiful ecosystems on Earth. Life here is amazingly abundant, colourful, complex, highly productive and more diverse than anywhere else in the oceans. Reefs are also important to humanity. They provide a source of income, food and coastal protection for more than 500 million people in over 100 countries. Reefs contribute significantly to regional economies, for example, the Great Barrier Reef attracts 1.8 million tourists per year, generating more than US$3.3 billion, and Florida's coastal ecosystems produce an estimated US$2.7 billion per year. Economists calculate that, globally, reefs provide a net annual benefit of US$30 billion, although figures ten times higher are also quoted.

Such figures may be the most persuasive arguments for our policymakers, but they don't quite sum it up for those of us who have sampled coral ecosystems first hand. Dollar signs can never adequately describe the cultural, aesthetic and ecological value of reefs. Reefs lay down thick deposits of calcium carbonate, storing away carbon and regulating atmospheric carbon dioxide. For every gram of carbon dioxide that is incorporated into their living tissue another gram is locked into their skeleton. Coral reefs are responsible for about half of all calcium carbonate (limestone) production each year.

Reefs are also unrivalled banks of marine biodiversity. To date we have documented about 1.86 million plant and animal species on our planet. Given our natural terrestrial bias, only about 15 per cent of these are from the oceans. Science has described just under 100,000 species of coral reef plants and animals, about 33 per cent of the total count for the oceans. And most authorities agree that we have described only 1 in 20 marine species. Admittedly, most of the remaining biodiversity is on the microscopic

scale, but not always! Several of the photographs in this book show new, as yet undescribed species, on page 124 you can see a species of shark that was discovered by scientists in 2006 and is currently unnamed. The lowest accepted estimate for the total number of species living on coral reefs is 618,000. The upper estimate is just under 10 million.

Species richness is a useful measure of variety, but it fails to tell the whole story of the extraordinary biodiversity concentrated within coral reefs. Phyletic diversity is much more revealing. All living animals are classified in 34 phyla (or taxonomic groups). Each phylum represents a fundamentally different morphological engineering solution to the problems of multi-cellular life. The more of these phyla present in an ecosystem, the more different types of animals it supports and the greater its genetic diversity. Tropical rainforests represent arguably the most biodiverse ecosystem on land and cover an area 20 times greater than coral reefs. Rainforests are home to nine phyla. If we cheat and also include the freshwater rivers and lakes associated with rainforests, we can push this number to 17 phyla. Coral reefs support 32 of the 34 phyla.

Increasingly, this dazzling kaleidoscope of creatures is proving a productive source of pharmaceutically active compounds. Treatments for HIV, cancer, leukaemia and malaria, as well as analgesic and anti-inflammatory agents have been derived from well-known reef sponges, molluscs, corals and algae. Coral, implanted within bone cells, can even be used to help to heal severe bone fractures. How much more is to come as we really get to know reefs?

Returning to our Moon for a moment, even a quick glance back at the Earth reveals that the Ocean dominates our planet. Oceans cover 71 per cent of the Earth's surface (about 360 million km^2) with an average depth of 3.8 kilometres. The ocean provides 99.5 per cent of the volume occupied by life on Earth. Given the proportion of species they support, it is perhaps surprising to learn that coral ecosystems occupy a very small area of the oceans – about 600,000 km^2, an area roughly the size of France or one-sixth of 1 per cent of the oceans' area. Their volumetric contribution is even less when you consider that reefs typically thrive in water shallower than 30 metres, less than 1 per cent of the average depth of the ocean. The distribution of coral reefs is limited by the narrow physiological tolerance of the reef-building species. Dependent on bright sunlight, nearly all reefs are in shallow water, distributed in the tropics and subtropics from Tokyo Bay in the north (34°N) to Lord Howe Island in the south (31.5°S). Their

distribution is further limited by patterns of temperature, salinity, nutrient concentrations, turbidity, calcium carbonate super-saturation, substrate type and exposure to waves.

Dip your head into the water around any coral reef and you will immediately notice its clarity. On some days the water is so transparent that it can give you a feeling not unlike flying and, for some, even a sense of vertigo. One reason that the water is clear is because in comparison with temperate seas it has very little planktonic plant life growing in it. Plants need both light and fertilizing nutrients to grow. In the tropics there is a lot of light, but generally there are not enough nutrients dissolved in the surface waters. Tropical waters support little life and are often referred to as the deserts of the ocean. Yet these same deserts contain the massive structures and rich communities of coral reefs, flourishing with 100 times more growth of life than the surrounding water.

Reefs thrive in these ocean deserts because the tissue of each reef-building coral is packed with zooxanthellae – single-celled algae – supercharging the lives of this symbiotic partnership with solar energy. Typically there are between one million and five million zooxanthellae within a square centimetre of coral tissue. The algae flourish because nutrients are plentiful inside the coral in comparison with the desert waters outside. These nutrients come mainly from the coral's waste products and are tightly recycled. The zooxanthellae take water and carbon dioxide, and photosynthesize oxygen and sugars, much of which (up to 95 per cent of sugars) is taken by the corals as food. Reef-building corals get nearly all their nutrition from zooxanthellae, which is why they are restricted to brightly lit shallow depths and grow into light-catching shapes similar to plants. It is with good reason that we often refer to shallow reefs as 'coral gardens'. Deprive a coral of light and it will starve to death within a few weeks.

Photosymbiosis is a good strategy, providing animals with an extra nutritional capability, and it has evolved independently many times. On modern reefs species of sponges, molluscs, flatworms, segmented worms and sea squirts also contain internal symbiotic algae. These relationships are thought to evolve when hosts feed on a potential symbiont and over the millennia evolve a strategy to make the relationship permanent. The lettuce-leaf slug *Elysia crispata*, found in the Caribbean, feeds on algae. Many of the plant cells it eats are digested, but some are passed intact to branches of their gut that extend into the bushy appendages on their backs. Here the algae continue photosynthesizing, providing additional nutrition. Perhaps evolution will make this a more permanent relationship.

Photosymbiosis provides reef-builders with a food source, allows them to thrive in low-nutrient environments and, importantly, enhances the rate at which they can build their calcium carbonate skeletons. As zooxanthellae photosynthesize they use up carbon dioxide in the coral tissues, improving the conditions for calcification and speeding up the processes of reef building. Despite a reputation to the contrary, corals can grow quickly. The branches of *Acropora* species can grow by as much as 15–20 centimetres in a year, although more massive species, such as *Montastrea*, grow more slowly, with healthy colonies adding a maximum of 0.5 centimetres in a year. Waves and currents wear away the reef and many members of the reef community actively erode the reef structure by mechanical or chemical means. For example, parrotfish chomp and scrape, and some bivalves, worms and sponges dissolve. Zooxanthellae are crucial to the existence of reefs because they enable reef builders to calcify faster than the cumulative rate of erosion.

Reef-building corals receive almost all of their nutritional requirements from their zooxanthellae, but they continue to feed in other ways to ensure a balanced diet. Corals are colonies of many genetically identical polyps, simple animals with a ring of stinging tentacles around a mouth. These tentacles enable the coral to feed as a predator, snaring plankton from the water. Some corals can also trap particles and plankton in mucus nets that they secrete and even get additional nutrition by absorbing dissolved organic compounds from the water. This varied feeding provides corals with essential compounds that they cannot obtain from their zooxanthellae. Uniquely, this allows corals to occupy several levels of the reef's complex food web simultaneously: photosynthesizing, absorbing dissolved matter, filter feeding with their mucous nets and actively catching prey with their polyps.

Reefs stand as monuments to the perfection of the multiple adaptations of corals to their nutrient-poor environment. Corals are not the only reef builders: calcareous algae, single-celled foraminifera (shelled protozoa with perforations through which false legs protrude), and other invertebrates also contribute significantly. The resulting habitat provides the structural basis for this complex, productive and diverse ecosystem.

Paradoxically, coral reefs are both geologically ancient and surprisingly young. Both reef-forming corals and fish first evolved more than 450 million years ago, although modern corals have been the dominant reef builders for only about the last 65 million years, since a mass extinction of life on Earth that wiped out the dinosaurs as well as 50 per cent of marine genera.

Modern reef fish evolved simultaneously, undergoing a period of rapid diversification between 65 and 50 million years ago. By about 50 million years ago the community had evolved into all the groups we currently see. Of course, the species were different, but surgeonfish were already surgeonfish and butterflyfish were already butterflyfish. As a result, the biology of both reef fish and corals is intimately intertwined.

Our current coral communities are a far from unique phenomenon in geological history and marine species, starting with bacteria, have built reefs for at least 3,500 million years. Shallow water reef communities have evolved and become extinct numerous times, driven by calcium carbonate reef-building species as diverse as single-celled bacteria and algae to multi-cellular invertebrates, such as sponges, worms, crinoids, bryozoans, bivalves and ancient corals. Furthermore, although the cast of characters in modern reefs has been broadly similar for the last 50 million years, their performance has been frequently interrupted.

Perhaps the largest change occurred with the rise to dominance of a genus of branching corals called *Acropora*. This genus graduated from the chorus line to become the star of the show, accounting for up to 80 per cent of the coral cover on modern reefs. This *Acropora* revolution occurred just 2 million years ago, very recent in geological terms, and a time when early members of our genus, *Homo*, were already walking the Earth. This community shift was initiated when a number of coral species died off and the fast-growing *Acropora* diversified to exploit the vacant niches.

Modern reef development in the last 150,000 years (since our species *Homo sapiens* has been around) has been dominated by glaciation cycles and the associated large fluctuations in sea level. The last major ice age reached its climax 18,000 years ago, sucking up vast quantities of water into glacial ice sheets covering large areas of North America and northern Europe. Sea level was about 120–135 metres lower than now. The retreating sea left existing reefs high and dry, which would have looked like steep rocky hills covered with tropical plants and trees on the coastal plains. Wind, rain, roots and rivers eroded these exposed reefs, cutting gaps in barriers and eroding cave systems in the porous limestone. Meanwhile, new reefs developed in the sweet-spot of sunlit water shallower than 30 metres.

Around 15,000 years ago the ice began to melt and sea levels rose rapidly, stabilizing at current levels about 7,000 years ago. At its peak, the ice melt was rapid and sea level rose by more than 10 metres per century. The reefs formed during the glaciation could not grow fast enough to keep up. Their zooxanthellae could not get the light they needed and the reefs

were effectively drowned. However, when the exposed, weathered reefs were once again submerged, they provided ideal platforms for new coral growth. Most of our current reefs are thin veneers, rarely more than 20 metres thick, growing on these much older reef foundations. The community took a couple of thousand years to recover properly from these disturbances, meaning our living reefs are usually less than 5,000 years old. To put this in context, while modern coral reefs were forming, the Egyptians were building pyramids at Giza and, not far from where I live, Britons were worshipping at Stonehenge.

In the short term such catastrophic changes cause devastation to reefs, but on a scale of thousands of years, reefs persist, recover and even flourish in the face of disturbance. For example, sea level fluctuations in the West Pacific interacting with the complex island geography of much of south-east Asia may destroy reefs in the short term, but also act to isolate populations, restrict gene-flow and provide a mechanism for speciation. On short timescales reefs are biologically fragile and significantly degraded by disturbance. However, over longer periods reefs are geologically robust, persisting in a state of disequilibrium that promotes biodiversity.

The word 'reef' is derived from the Middle English *riff* and the Old Norse *riff*, seafaring terms for hazardous, submerged ridges that rise close to the surface. Biologically, we use the word 'reef' interchangeably with the term 'coral reef' to describe the variety of structures built by the community. Structurally, most reefs can be classified into four main types: patch reefs, fringing reefs, barrier reefs and atolls.

Patch reefs are small discrete coral growths rising from the floor of shallow lagoons or bays and are surrounded by sand or seagrass beds.

Fringing reefs are the most common type. They occur close to shore, forming a fringe of coral running parallel with the coast, often separated by a narrow, shallow lagoon. The coastal fringing reefs in parts of south-east Asia support the most diverse reef communities in the world.

Barrier reefs grow much further from shore, enclosing wide and deep lagoons. There are 30 large barrier reefs in the world, including those in Fiji, Madagascar, Belize and, of course, the Great Barrier Reef in eastern Australia.

Atolls are low and large ring-shaped reefs, formed on extinct oceanic ridges and volcanic islands. There are about 300 atolls worldwide, usually

isolated in the open ocean and often forming chains. Appropriately, the word 'atoll' is derived from the Maldivian word *atolu*; the Republic of the Maldives is a country based entirely on a chain of 26 atolls in the Indian Ocean. Many large reefs also develop multiple flat islands – the 1,000 islands of the Maldives reach a maximum elevation of only 2.4 metres, making it the world's lowest-lying country.

Charles Darwin famously provided the explanation of how atolls develop, which he first presented in London some 170 years ago. Darwin's elegant explanation was that on an atoll the different types of reef were, in fact, all the same – just seen at different stages of development. Fringing, barrier and atoll reefs are a successional series, which is able to develop as the underlying bedrock submerges. Darwin hypothesized that fringing reefs develop first around volcanic islands. The reefs grow outwards and upwards because oceanic waters provide better growing conditions than lagoons. Fringing reefs develop into barrier reefs, and barriers into atolls as the island sinks and the reef grows ever thicker to stay in the sunlit shallows.

Decisive evidence for Darwin's theory had to wait 115 years, and came from a most unlikely source – the US Military. In the late 1940s and early 1950s, the US Navy was in the Marshall Islands, in the Pacific, to test the world's first hydrogen bomb, codenamed Ivy Mike. They drilled deep holes into Enewetak atoll to ensure its geological stability for the test. These boreholes were the first to pass right through an atoll's coral-limestone rock into the oceanic volcanic basalt below. The drilling revealed that even more than one kilometre from the surface the limestone rock was still composed of shallow water reef species. Darwin was right: shallow fringing reefs had formed directly on the lava rock of the island, growing ever upwards as the island became completely submerged. Limestone reef deposits 1,300 metres thick, laid down intermittently over the last 60 million years, cap the volcanic rock at Enewetak.

Globally, 15 per cent of reefs are in the tropical Atlantic Ocean, 53 per cent in south-east Asia (including the Indian Ocean), 19 per cent are in the Pacific Ocean and 9 per cent grow coastally in the Red Sea, the Arabian Gulf and off East Africa. At the broadest scale reef life can be divided into two separate regions: Atlantic and Indo-Pacific reefs, kept apart by the American and African landmasses. Plenty of reef-associated ocean species (like large sharks, rays, barracuda and so on) are present in both, as are a few bona fide reef species, such as the porcupinefish *Diodon hystrix*, the scrawled filefish *Aluterus scriptus* and Christmas-tree

worms *Spirobranchus giganteus*. But in general, the reef fauna of these two regions comprise different species, although they are clearly descended from common ancestors with closely related species filling similar ecological roles.

Within each region species distributions vary and both have their diversity hotspots. In the Atlantic, biodiversity peaks around the Caribbean islands, diminishing rapidly to the north, south and east. In the Indo-Pacific biodiversity reaches its peak in the 'coral triangle' of south-east Asia. This imaginary triangle stretches from Sumatra in the west, to the Philippines in the north-east and the eastern end of New Guinea in the south-east. Scientists (and even tourism bodies) continue to argue over the exact bounds, but the take-home message is that reef diversity diminishes with distance from the south-east Asian archipelago. Diversity falls off more rapidly eastwards across the Pacific and more gradually to the west across the Indian Ocean. Endemic species are most common in isolated reef systems, such as those in Hawaii and the Red Sea. In Hawaii more than 30 per cent of fish species are found only there.

The Indo-Pacific reef fauna has many more species than that of the Atlantic. There are more than 4,000 Indo-Pacific fish species, compared with fewer than 900 in the tropical Atlantic. Crustaceans, molluscs and corals show similar patterns. The richest Indo-Pacific reefs can support up to 600 species of reef-building coral; the whole of the Atlantic has fewer than 100. Other groups show smaller differences: sponges are much more evenly distributed, with Caribbean reefs supporting about 65 per cent of the number species in the Indo-Pacific. Interestingly, when some Indo-Pacific species are accidentally introduced they seem to thrive amongst the impoverished fauna of other reefs. The Indo-Pacific orange cup coral *Tubastrea coccinea* was probably introduced to the Caribbean by shipping more than 50 years ago. It is now widespread in the region. More recently, since about the mid-1990s, Indo-Pacific lionfish *Pterois volitans* have become established around Florida and northwards into the Carolinas as well as in the Bahamas. These lionfish were almost certainly released from aquaria and are successfully reproducing and spreading quite rapidly through the region.

The majority of reef species are widespread because of their lifecycles. Most adult reef fish tend to stay in the same place for most of their lives, while corals and other sessile invertebrates do not move at all. The important job of dispersal isn't done by the adults, but is left to the newborn. Sexual reproduction in most reef species results in pelagic larvae. These leave the reef and join the 'eat or be eaten' plankton community, which disperses them far and wide, usually to be eaten by the host of other creatures that feed on plankton. The larval stage usually lasts between a

few days and a couple of months, depending on the species. It ends when the young settle on the reef, rapidly metamorphosing into their adult forms. Larval fish may find their way back to the reef by sensing the smells and sounds of the reef community.

Reef creatures put a lot of energy into reproduction to overcome the long odds against survival of the pelagic larval stage. Many reef fish spawn throughout the year, some daily. And a few species put energy into caring for their eggs, giving them a head start when they join the plankton. As you might expect, in this hotbed of diversity a great variety of reproductive techniques are explored. Corals and other non-moving invertebrates tend to spawn *en masse* once or twice a year, filling the water with eggs and sperm and ensuring high rates of fertilization. Fish sex is weirder still. There is external fertilization, internal fertilization, egg laying, broadcast spawning and even mouth and pouch brooding. Species form pairs, or spawn in groups, there are harems, sex changes, lies about sexual identity and even fish that switch sexual roles several times an evening. If fish used the Internet there would certainly be some unusual websites!

A few reef species skip the pelagic larval stage entirely. For example, the spiny puller damselfish *Acanthochromis polyacanthus* guards its eggs, and the young stay with their parents until they are about a centimetre long, after which they form crèches of their own. Although this fish is quite widespread in south-east Asia, its appearance varies greatly, which may indicate that its lack of regular dispersal may be driving speciation. When I have photographed this species in Sulawesi the adults have been a very dark brown, in other areas they may be silvery or chocolate-dipped with brown heads and bodies, and white tails.

Larger species, such as sharks and rays, dolphins and sea snakes, give birth to live young. Turtles haul themselves on to land to lay eggs in sandpit nests, although they do have a pelagic stage as the young tend to spend their formative years in the open ocean before returning to the reef. The pelagic larval stage clearly evolved long ago, as it is a ubiquitous part of so many species' lifecycles and, although short, this biological lottery is a crucial factor in determining adult population densities and community structure on coral reefs.

The abundance, activity and diversity of life can make a reef a confusing place to visit. Understanding who eats whom is a sensible way to see order in the apparent chaos. When it comes to the reef's food web a few generalizations are useful, but we must remember that many rules are broken in a realm where nature runs riot. Most reef creatures show a high degree of specialization for a particular mode of feeding: butterflyfish have delicate snouts for picking invertebrates from the reef and goatfish have barbels (feelers near the mouth) for digging in the sediment. At the same time, these species are quite capable of switching feeding methods to make use of more abundant food sources. Both are beneficial: specialization promotes efficient use of a food source and flexibility saves effort by using the most accessible food. Adding to the complexity, most reef species change their feeding methods as they grow. For example, almost the entire reef population feeds on plankton during the pelagic larval stage. Despite all the exceptions, I still think it is worth discussing the general rules of several modes of nutrition.

As much as 50 per cent of the photosynthetic activity on reefs does not involve the zooxanthellae living symbiotically within corals but, instead, the free living algae on the reef. This is surprising because reefs do not support lush forests of seaweeds. In fact there are lots of plants on reefs, but most are consumed by herbivorous fish as fast as they grow. Place a small cage on the reef to exclude herbivores, and thick seaweeds soon appear. The extent of algal growth is most clearly revealed by the high numbers of herbivorous fish: parrotfish, surgeonfish, damselfish, rabbitfish and others account for up to 50 per cent of all fish biomass on shallow reefs. By mowing down the algae, herbivores maintain the balance between corals and algae on the reef.

Algae is not the most nourishing or digestible food, and herbivorous reef fish have many physiological and behavioural adaptations to exploit it. Some species, rather like cows, have bacteria in their gut to extract more nutrition from their diet. Reefs offer limited space for algal growth and with so many herbivores competition for the available food is fierce. Many herbivores, such as damselfish and surgeonfish, aggressively defend territories, where they farm their own algae by pecking back the corals, encouraging the algae to grow up to seven times faster than outside their 'gardens'. Species that are not large or aggressive enough to hold territories have an effective strategy to gain access. By schooling they can raid the gardens using sheer weight of numbers to overwhelm the territory holder, and feast in their gardens in the confusion. Both farming and raiding strategies have evolved in many different herbivorous species on both the Atlantic and Indo-Pacific reefs. The balance between the two allows several species to thrive on the same food sources, promoting diversity in the community.

Plankton provides another important food source for both reef fish and invertebrates. By feeding on plankton from the open ocean the community is concentrating production from a wide area on the reef. Plankton feeders

form their densest aggregations on reef walls exposed to the prevailing currents. Invertebrates often feed on smaller plankton than do reef fish, which tend to pick crunchy zooplankton, like copepods. Sponges feed mainly on tiny, but plentiful bacterioplankton as well as the smaller species of phytoplankton, by filtering massive volumes of water. A sponge strains a volume equivalent to its own body every 5 to 20 seconds. Soft corals feed on a wide variety of plankton and dissolved organic matter. Many species of soft coral and some sponges also contain photosynthetic symbiotic algae that, when present, are their dominant source of nutrition. Nearly all the major invertebrate groups have species that feed on plankton.

Many families of reef fish also contain planktivores and, despite being unrelated, these fish share several morphological and behavioural adaptations. These are examples of convergent evolution, where unrelated species independently come up with similar solutions to the same set of problems. The best pickings of plankton are found slightly removed from the reef, but feeding in the open is a risky business, increasing vulnerability to predation. For protection, therefore, planktivorous fish feed in groups and are designed for speed. Indicators of speed are a streamlined body and a deeply forked tail. Planktivores from different families (*Caesio* fusiliers, *Anthias* basslets, *Chromis* damselfish, *Clepticus* wrasse) have shapes that are more similar to each other than to members of their own families. Larger planktivorous fish, such as fusiliers, are less vulnerable to predation and can feed further from the reef, thus getting the first pick of plankton.

Despite all their defensive ruses, planktivorous fish are eaten by reef predators, but probably the major path of energy is through their faeces settling on the reef. When the pickings are rich, planktivores eat and eat. And the more they stuff in, the more that comes out. At these times food passes through them so quickly it is hardly digested and the bulk of the nutrition is passed on to fish grazing on the reef below. To save you from looking, I have, and can assure you that banana-shaped faeces litter the reef below dense populations of planktivores!

The remaining majority of reef species eat each other, feeding on sessile invertebrates, moving invertebrates (both on the reef and in surrounding sandy areas) or fish. The variety of ways that the community is able to harness energy is another reason for the richness of life on coral reefs.

Beautiful, fascinating, productive, biodiverse, important: these adjectives accurately describe coral reefs. But if I am being honest there is one more that must be added to this list: threatened. Sadly, it is impossible to write about coral reefs and not deal with their degradation. The facts speak for themselves. Twenty per cent of the world's reefs have been effectively destroyed in the last 100 years, and mostly in the last 30 years. A further 50 per cent are facing collapse (source: Status of Coral Reefs of the World – Wilkinson, 2004).

As I have already mentioned, coral reefs survive and, over longer time scales, almost certainly thrive in the face of natural disturbance. Disease, hurricanes, volcanic eruptions, plagues of coral predators and so on, can be devastating in the short term, but tend to be localized and infrequent. Human impacts are very different because they often occur in synergy and subject the community to widespread, long-lasting and rapid environmental changes. Coral reefs have evolved to deal with the characteristics of natural disturbances. The signs for how well they will cope with the increasing impact of our species are not encouraging.

Coastal development brings many threats to reefs. Problems include direct physical damage, such as that from dredging and mining reef environments for building materials. Indirect effects are usually worse. Deforestation increases sediment runoff, which smothers the reef and clouds the water, reducing photosymbiosis and reef building. Sewage and agricultural runoff add nutrients, changing the environment from an ocean desert that suits coral to a high-nutrient system that suits seaweeds.

Coastal population growth also increases the fishing pressure on reefs, which brings a variety of problems. Over-fishing of reef herbivores removes their control on the coral/seaweed balance, resulting in less coral cover and little or no reef growth. Most damaging are the destructive fishing methods used on reefs, which remain widespread. Dynamite fishing is popular because it yields lots of fish for little effort, but each explosion destroys the reef. A healthy reef might take 40 years to recover fully and be able to produce the same fish stock again. It is like being an orange farmer, who instead of picking fruit, cuts down all his trees. Sharks make particularly poor fisheries because they have low reproductive outputs and long generation times. However, this group is heavily targeted on reefs owing to the demand for shark-fin soup. The Great Barrier Reef is probably the best managed reef ecosystem and even here shark populations have been reduced by as much as 97 per cent compared with unfished levels. Other areas are worse still.

In May 1998 while photographing the vibrant marine life of the Maldives, I witnessed a spectacular and, as it turned out, tragic change on the reefs. Over the course of just a couple of days all the reef-building corals turned bright white. The reefs looked as if they had just received a fresh snowfall. I later learned that this was coral bleaching and I was in the middle of the largest bleaching event ever seen at that time, which is estimated to have killed up to 90 per cent of coral on 16 per cent of all reefs. We now know that the primary cause of mass bleaching is increased sea temperature; usually no more than 1–2°C above the long-term average maximum is enough to set it off. High temperatures disrupt photosymbiosis and the zooxanthellae either break down or are expelled, revealing the corals' white calcium carbonate skeletons that can be seen through the transparent coral tissue. Bleached corals do not die immediately but unless conditions change and they can reacquire zooxanthellae, they starve to death within a few weeks.

Mass coral bleaching is a new phenomenon. There are very few records of mass bleaching before 1979, and the 1998 event killed many corals that were more than 1,000 years old. Very few people doubt that global warming is causing the increasing occurrence of bleaching. Eleven of the last twelve years rank among the warmest twelve years since detailed records began in 1850. Wherever I travel I meet people who comment that their weather is not what it used to be and, sadly, I have seen many more bleached reefs since 1998.

In February 2007 the Intergovernmental Panel on Climate Change (IPCC, formed in 1988 with scientists from 130 countries) released its fourth assessment report stating that it is 'very likely that climate change is caused by human activities'. Global warming is caused by the greenhouse effect, the result of increased concentrations of greenhouse gases (particularly carbon dioxide) in the atmosphere. The current atmospheric carbon dioxide levels (>380ppm) far exceed the natural range over the last 650,000 years (180–300ppm) prior to the Industrial Revolution, and the IPCC concluded that the primary source is our burning of fossil fuels. The IPCC predicts that global average temperatures will rise by between 2°C and 4.5°C by 2100.

Forecasting the response of complex natural systems is never straightforward, but a 1°C rise is predicted to cause 80 per cent of reefs globally to bleach. A 1.5°C rise is thought to be enough to cause the Great Barrier Reef to lose 95 per cent of its reef-building corals. On a more positive note, 40 per cent of the reefs that were severely damaged in the 1998 bleaching event are recovering well or have recovered. Furthermore, recent studies show that corals may be able to adapt to bleaching by changing their blend of zooxanthellae species toward those that can take the heat.

Increased carbon dioxide concentrations in the atmosphere also lead to acidification of the ocean, which has the potential to stop corals laying down their skeletons. Doubled concentrations of carbon dioxide reduce coral calcification rates by between 5 and 50 per cent. This could tip the balance between reef building and reef erosion in favour of the latter. As reefs are washed away, the carbon dioxide they have locked away in their skeletons is released, and global warming will intensify. Global warming is also forecast to intensify hurricanes, also exacerbating reef deterioration.

Global warming will make bleaching events more severe and more frequent and it remains the most serious threat to reefs, especially as it threatens reefs over large areas, possibly globally.

This should be the great age of discovery of reef life; scientists are continuing to find ever more biodiverse reefs. In September 2006, a team from Conservation International published a survey from the reefs of the southern Bird's Head Peninsula in West Papua, reporting 52 new species and dive sites with the highest ever recorded coral and fish diversity. I was lucky enough to visit this remarkable area in November 2006 as part of the final stage of photography for this book. Scientists are even discovering major new reefs. For example, in 2005 a new 100-kilometre-long reef system was found in the Gulf of Carpentaria, in Australia. Unfortunately, human actions are destroying reefs at a much faster rate.

Tropical coral reefs can seem distant wonderlands from our daily lives. This is when taking a stroll on the Moon helps. Looking at the Earth from the Moon, national and political boundaries are gone, humanity is united and it is easier to appreciate the interdependency of all life on our planet. Life on coral reefs is characterized by complex inter-relationships and at this global scale, humanity's own symbiotic relationship with reefs is revealed. Reefs shape and protect our coastlines, provide us with food and medicines and reward anyone who has been lucky enough to visit. The view from the Moon also allows us to understand how human actions both near and far from reefs are seriously threatening this remarkable ecosystem.

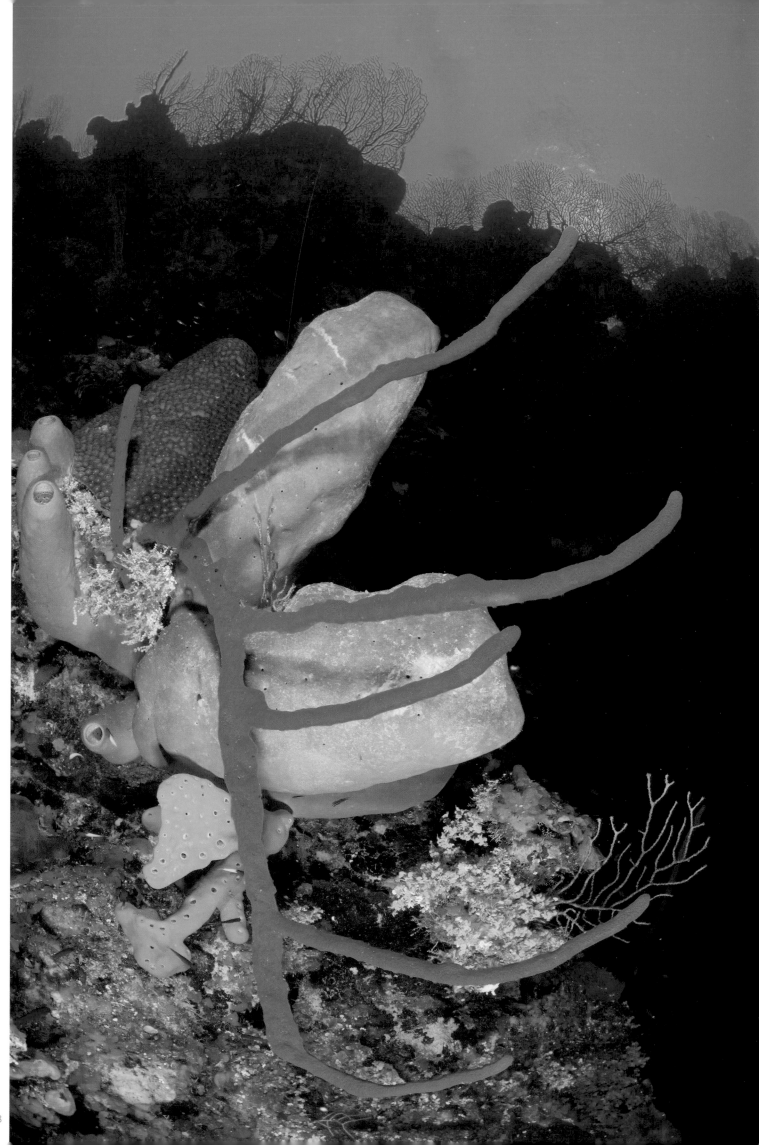

∧ Spawning pair of hamlets

A pair of barred hamlets *Hypoplectrus puella* clasp together while spawning to ensure successful fertilization of their eggs. Hamlets, small groupers about the size of your hand, are found only on the reefs of the west Atlantic.

Curiously, hamlets are one of the few vertebrates that are simultaneous hermaphrodites. Many reef fish change sex during their lives, but hamlets remain sexually active as both males and females throughout adulthood. When spawning at dusk they follow a 'little-but-often' approach with the pair exchanging sexual roles several times, called egg trading, to ensure each partner plays an equal role.

Although it may seem strange to us, this tactic makes great sense, with both individuals devoting energy to producing eggs. It is such a good strategy that I often wonder why hermaphroditism is not more common in reef vertebrates.

George Town, Grand Cayman, Cayman Islands. Caribbean Sea.
Nikon D2X + 105 mm. 1/15th @ F7.1

Colourful sponges

Large and colourful brown tube sponges *Agelas conifera* and erect rope sponges *Aplysina cauliformis* grow into extravagant shapes deep on a reef wall. Sponges were the first multi-cellular animals and still thrive on reefs today. They are second only to corals in their dominance of sessile reef life.

Despite their juicy-looking appearance sponges make an unappetizing meal as their bodies are filled with hard spicules and chemical toxins. Nevertheless, the alkaloid chemicals found in them make sponges a medical treasure trove: many compounds are extracted from sponges for pharmaceutical uses, for example in antibiotics and cancer drugs.

North Wall, Grand Cayman, Cayman Islands. Caribbean Sea.
Nikon D2X + 10.5 mm. 1/80th @ F11

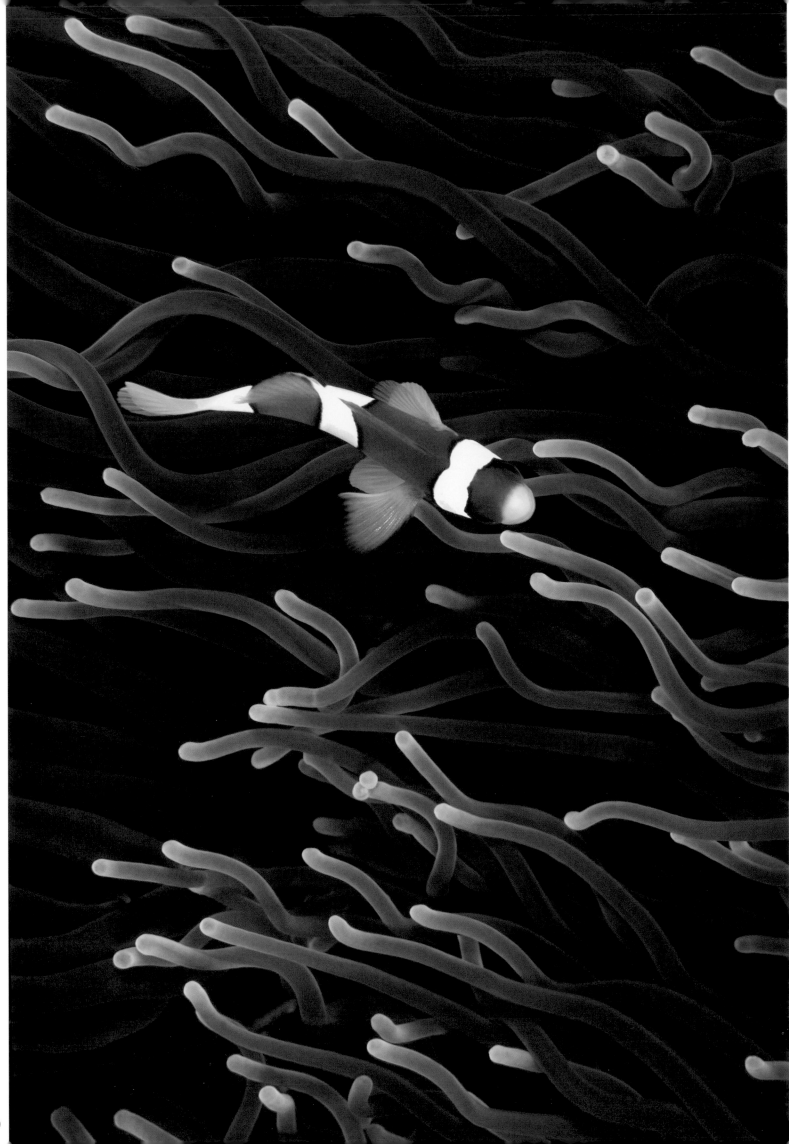

Coral boundary

Living space is at a premium on coral reefs and here an organ pipe coral *Tubipora musica* (right) and a staghorn coral *Acropora* sp. have grown to an overlapping boundary.

Reef-building corals obtain nearly all their nutrition from their photosynthetic zooxanthellae (single-celled algae) and as they grow they try to spread out to maximize exposure to light. Corals are colonial animals, founded by a single polyp that grows and replicates itself continuously.

The tentacles of most coral polyps are withdrawn during the day, only opening at night to snare plankton. Organ pipe coral keeps its polyps open during the day. They are filled with zooxanthellae and greatly increase the photosynthetic surface area of this species.

Nuweiba, Gulf of Aqaba, Egypt. Red Sea.
Nikon D2X + 105 mm. 1/80th @ F11

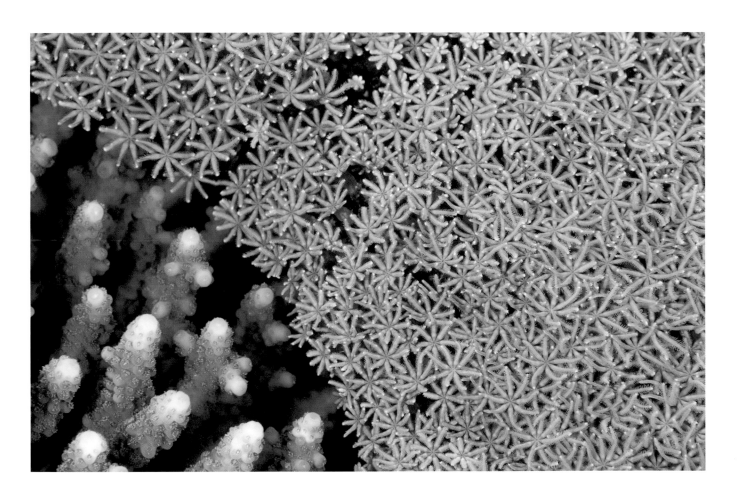

Anemonefish over purple tentacles

An anemonefish *Amphprion clarkii* (10cm) swims above the protective purple tentacles of its host anemone. Anemones are found in all seas, but only in the coral seas has this symbiotic relationship with anemonefish developed.

Symbiotic, or mutually beneficial, relationships are a common feature of coral reefs. The reef structure exists because corals have symbiotic zooxanthellae (single-celled algae) living within their tissues that provide them with nutrition and quicken reef-building. Anemones have zooxanthellae too, which provide them with food, so this photo actually shows two examples of symbiosis.

Lembeh Strait, Sulawesi, Indonesia. Molucca Sea.
Nikon D100 + 60 mm. 1/180th @ F22

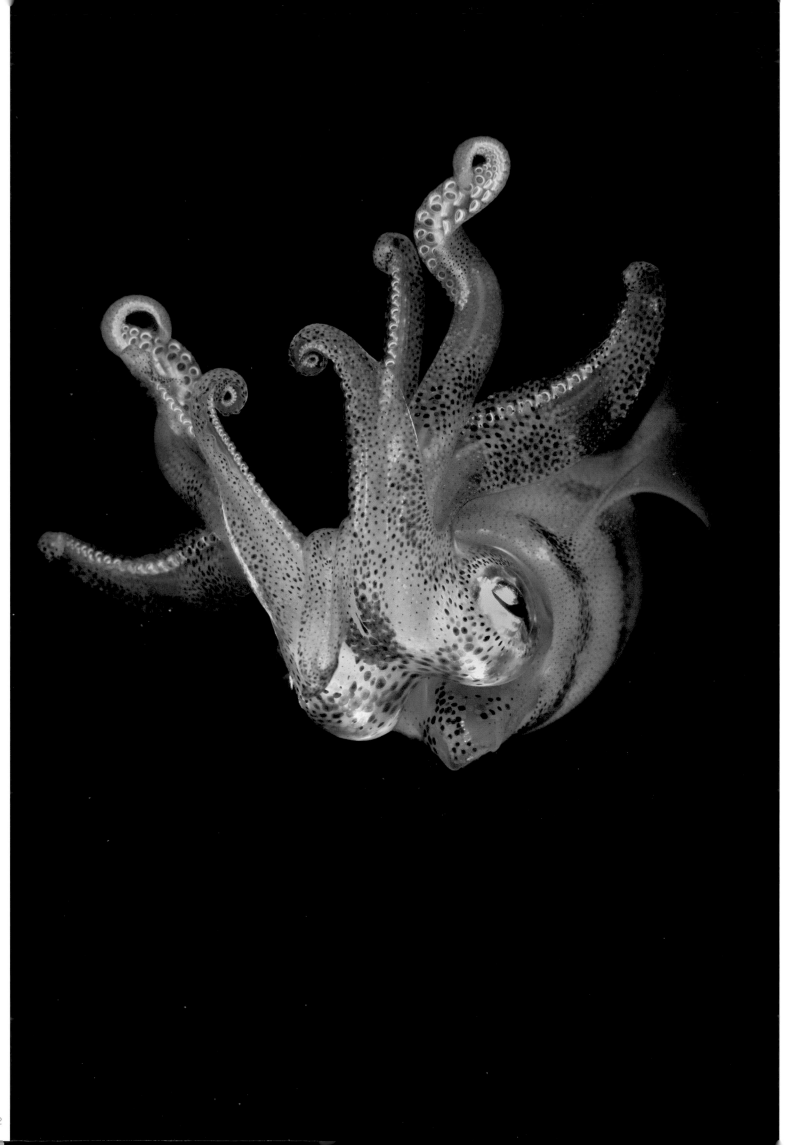

˅ Reef shark

The sleek Caribbean reef shark *Charcharhinus perezi* occupies the top of the reef's food chain and is a highly adapted hunter. Sharks are armed with keen senses, particularly smell, electro-reception and an acute ability to detect low-frequency sounds, such as those produced by struggling fish. This species mainly feeds on reef fish and octopus, and once in range strikes with a bite that lasts just 380 milliseconds.

Reef sharks are caught in large numbers, but they do not make good fishery species because they reproduce too slowly. This species takes several years to reach maturity, gives birth to just four to six young at a time and its pregnancy lasts longer than a human's.

Little Bahama Bank, Bahamas. West Atlantic Ocean.
Nikon D2X + 17–35 mm. 1/60th @ F9

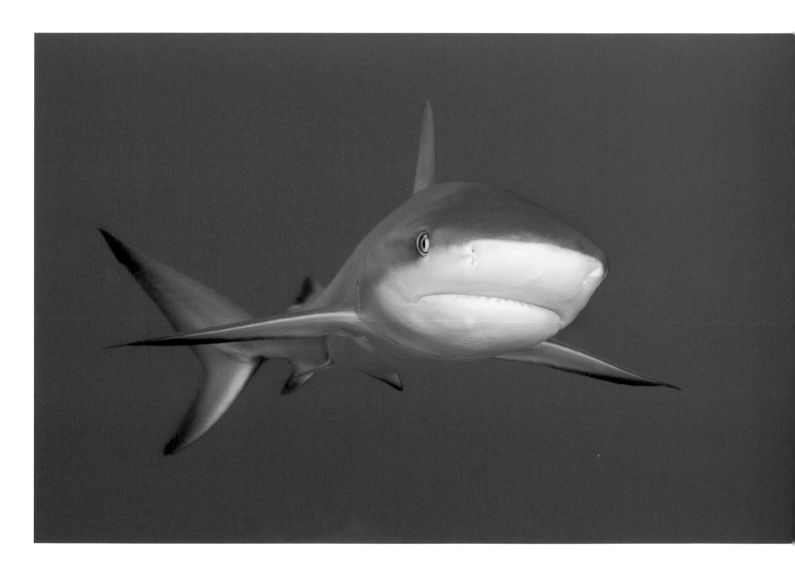

‹ Squid at night

Like an extraterrestrial visitor, a bigfin reef squid *Sepioteuthis lessoniana* descends from open water to the reef at night. Squid are molluscs, like snails and bivalves, and are close relatives of octopus and cuttlefish. Reef squid are less streamlined and bulkier than other squid, and are easily confused with cuttlefish, hence the first part of their scientific name.

These squid live by the mantra of 'live fast and die young'. They have a voracious appetite, devouring about half their body weight a day in small fish, shrimps and crabs. Squid, themselves, are an important prey item for many fish, such as jacks, groupers and reef sharks. Their reproductive strategy is consistent with their general lifestyle, as squid usually die soon after mating.

Kaimana region, South Bird's Head peninsula, West Papua, Indonesia.
Nikon D2X + 60 mm. 1/250th @ F16

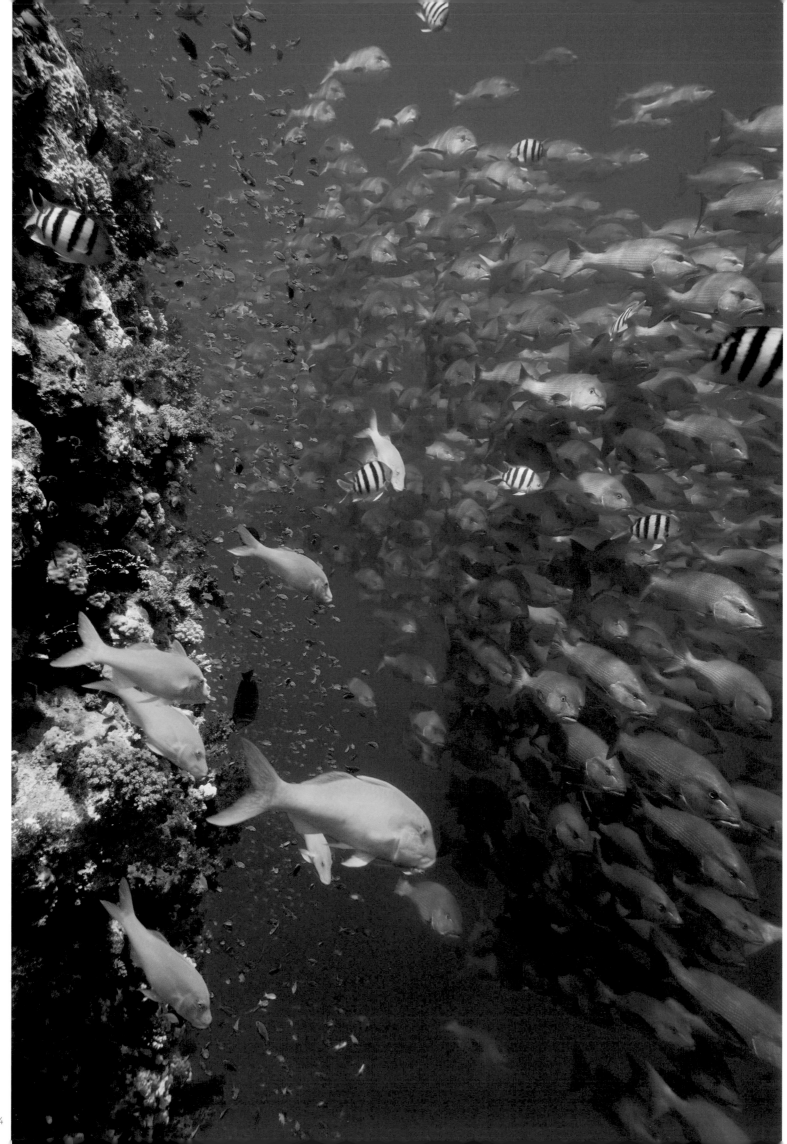

A hotbed of life

The reef provides a home for a great diversity of life. In this photograph yellow goatfish *Parupeneus cyclostomus* are roaming the reef hunting small fish, while orange anthias *Pseudanthias squamipinnis*, and striped sergeant major damselfish *Abudefduf vaigiensis* swim into the current to feed on plankton. In the background a school of large bohar snappers *Lutjanus bohar* has gathered.

And these are just the stories visible at first glace. Swim closer and even more stories are revealed ...

Ras Mohammed, Sinai, Egypt. Red Sea.
Nikon D2X + 12–24 mm. 1/80th @ F5.6

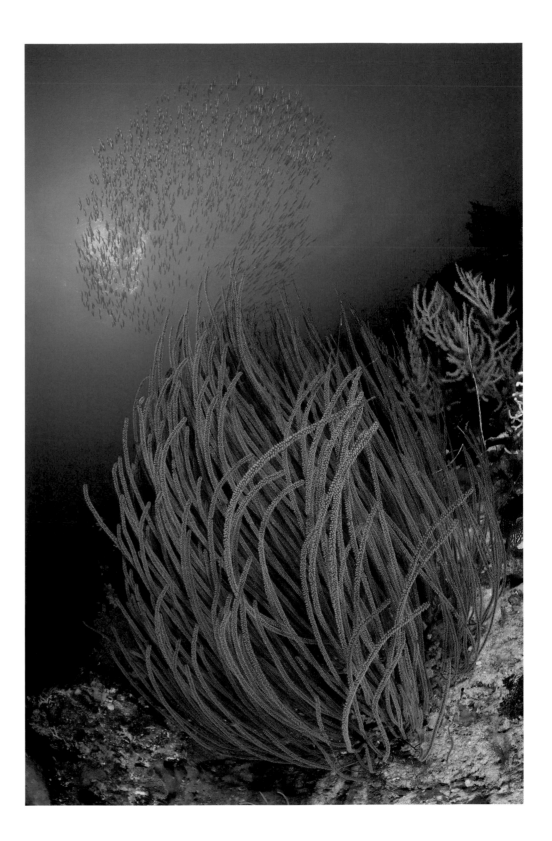

∧ Whip coral and school of fish

A colourful whip coral *Ellisella* sp. thrives deep on a reef slope, while a school of fish passes overhead. Not all corals rely for their nutrition on zooxanthellae (single-celled algae), and the colourful gorgonians and soft corals feed by snaring plankton and particles from the open water. Often these slower growing species are found deeper on reef slopes and walls, where there is less competition from reef-building corals and more exposure to currents, providing a constant supply of food.

As always on the reef there are exceptions to every rule. Many species of soft corals and gorgonians do contain zooxanthellae, which provide the bulk of their nutrition. These species can be easily identified by their drabber greenish-brown colours.

Misool Island, Raja Ampat, Indonesia. Ceram Sea.
Nikon D2X + 10.5 mm. 1/80th @ F8

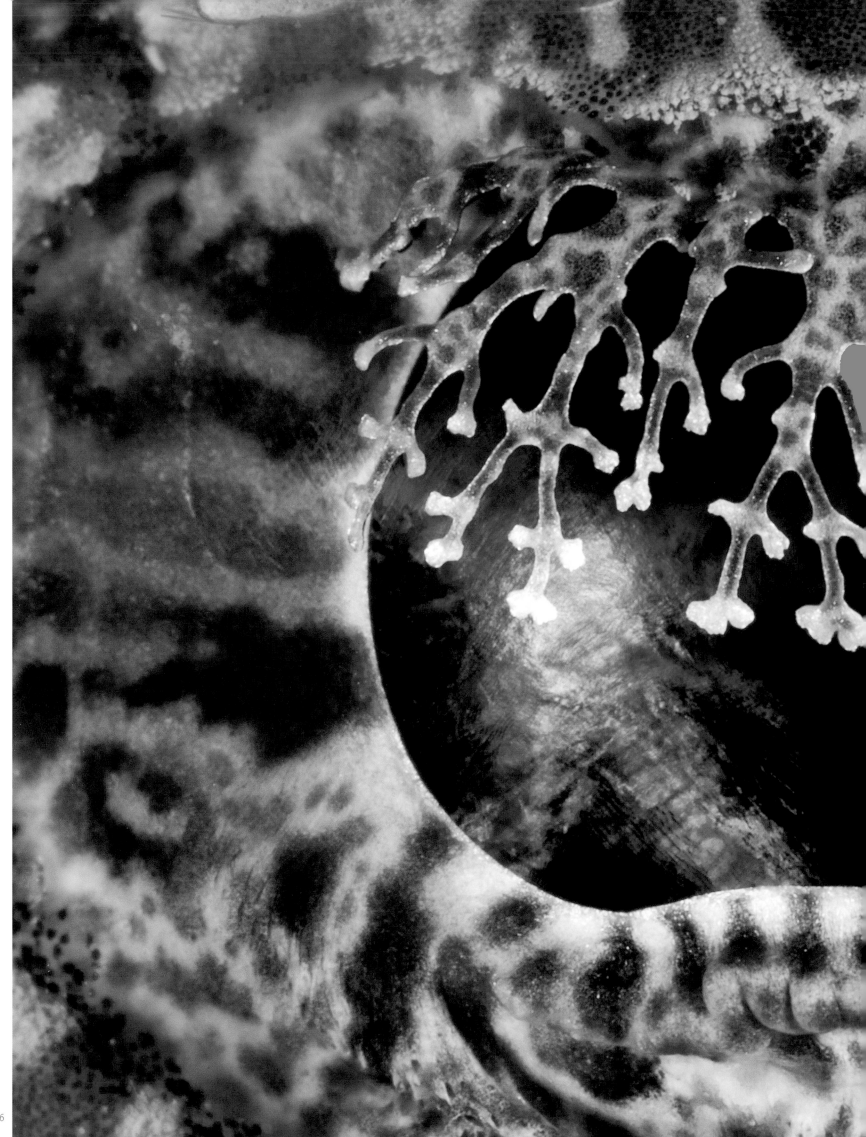

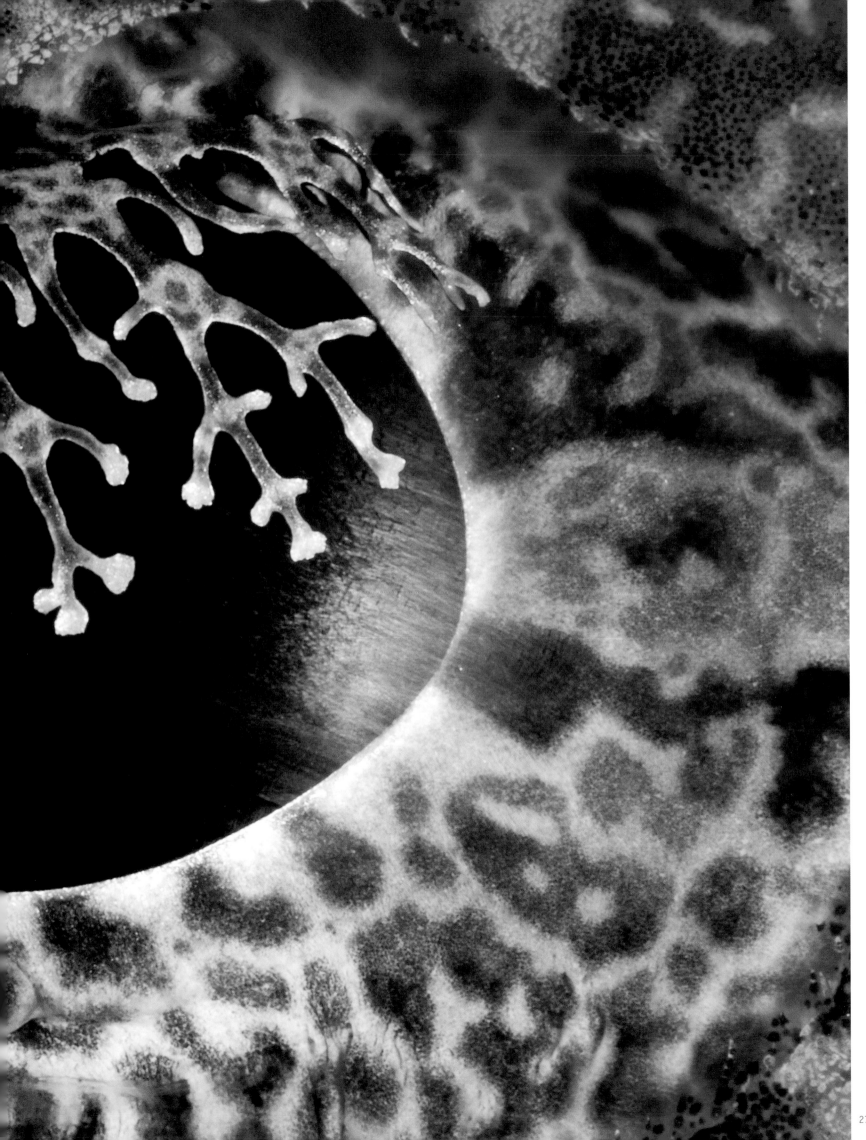

<< Eye of a crocodilefish

Long, branched eyelashes disguise the eye of a crocodilefish *Cymbacephalus beauforti*. The crocodilefish is able to expand and contract these lacy skin flaps as camouflage. Many reef creatures attempt to hide their eyes as they are too readily identifiable to predators or prey. Some species hide their eyes in stripes whereas others, such as butterflyfish, even have false eye spots on the rear of their bodies to deflect attacks.

When you look at the pictures of camouflaged fish in this book, note how often their eye is the first feature you are able to recognize.

Mabul Island, Sabah, Malaysia. Sulawesi Sea.
Nikon D2X + 150 mm. 1/250th @ F20

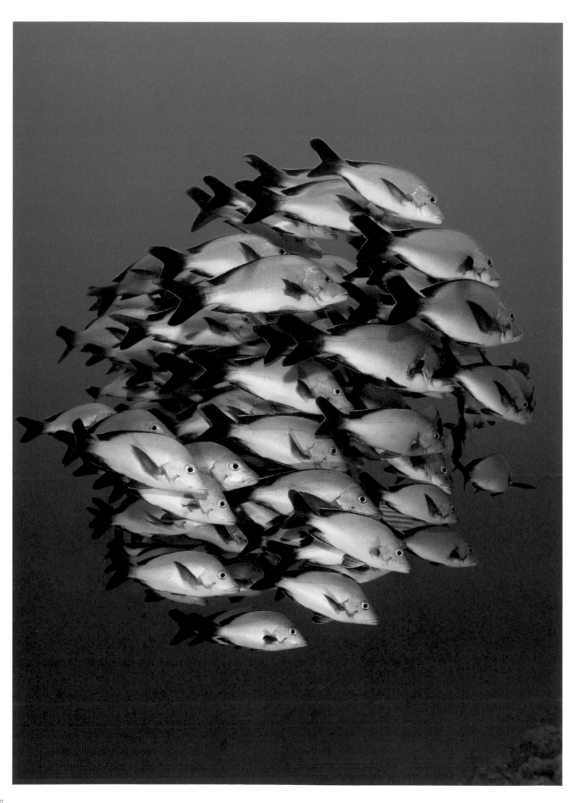

< Snappers in a defensive ball

A school of paddletail snappers *Lutjanus gibbus* forms into a tight defensive ball when exposed on the outer wall of an atoll. Schooling is a common fish behaviour and about half of all species spend part of their life schooling. Schools provide safety in numbers because there are more senses looking out for danger and it is harder for predators to single out a target.

While photographing this school, I watched it morph continuously. I even have a photo of this school of snappers in the shape of France!

South Male Atoll, Maldives. North Indian Ocean.
Nikon D2X + 17–35 mm. 1/100th @ F6.3

> Sea snake in soft corals

A banded sea krait *Lauticauda colubrina* slithers through orange soft corals searching for fish. Sea snakes are slow swimmers and this species hunts by trapping prey, particularly small moray eels, in cracks and crevices. Most species of sea snakes give birth to live young in open water, but sea kraits return to land to lay eggs.

Sea kraits are related to cobras, and have similar fangs and venom, although the sea krait's venom is four times more powerful; one of the reasons I chose a top view for this photograph.

Kaimana region, South Bird's Head peninsula,
West Papua, Indonesia.
Nikon D2X + 17–55 mm. 1/160th @ F9

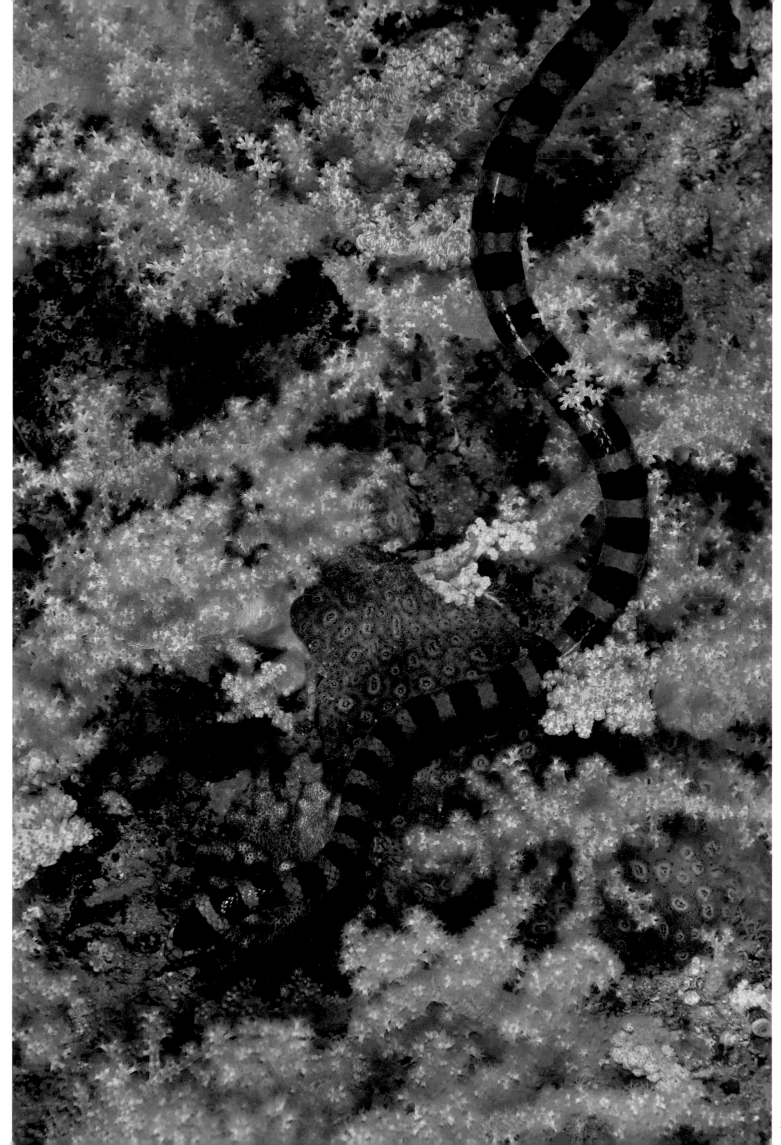

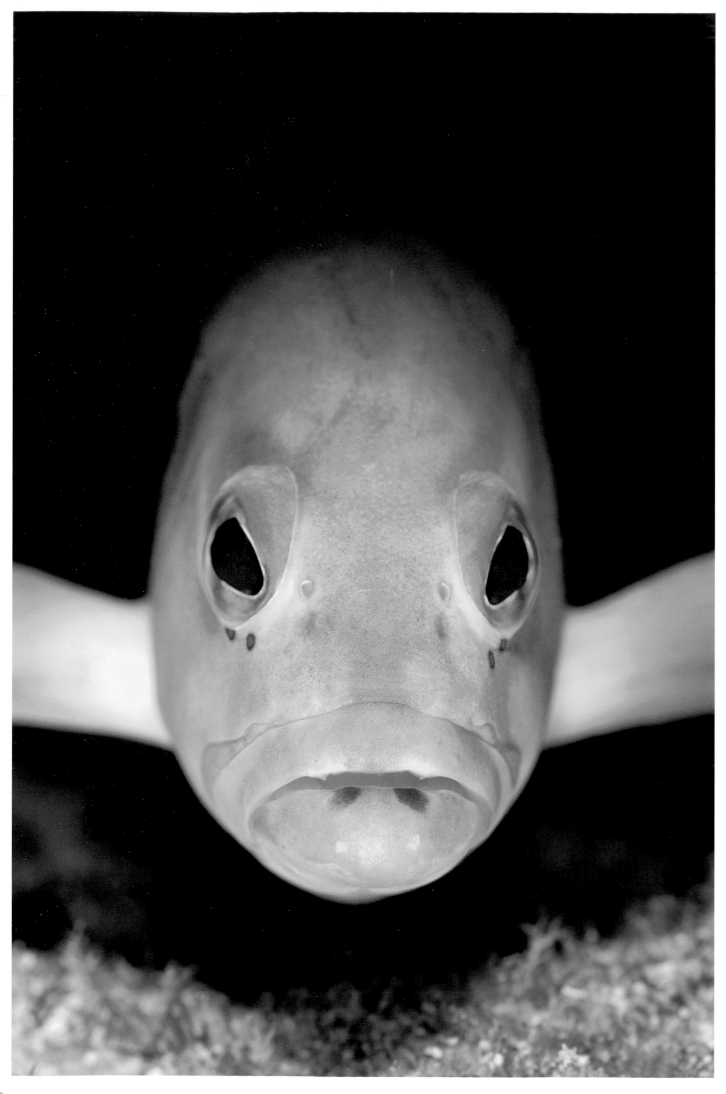

Black grouper blur

A metre-long Caribbean black grouper *Mycteroperca bonaci* offers a fleeting glimpse as it races along the reef. There are 150 species of grouper worldwide, the largest being the mighty Queensland grouper *Epinephelus lanceolatus* that grows to 3 m and 400 kg. Queensland groupers are now rare, having been over-fished on many reefs, but I recently had the chance to dive with some intimidating, full-grown individuals in West Papua, which were probably 20 years older than I am.

For many people grouper means high in protein, low in saturated fat and particularly tasty on the barbecue. Groupers account for about 40 per cent of the USA's reef fish catch. But, as divers know, groupers have the most engaging personalities. Unsurprisingly, scores of individual groupers have been given pet names.

Little Bahama Bank., Bahamas. West Atlantic Ocean.
Nikon D2X + 10.5 mm. 1/18th @ F16

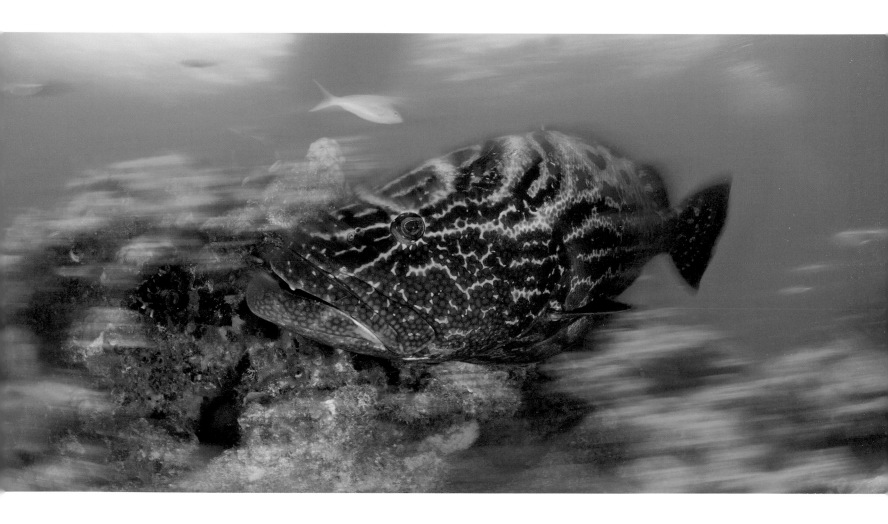

Golden grouper

One of many species of groupers, this golden-phase coney *Cephalopholis fulvus* is a mid-sized (20–30 cm), but well-built predator that feeds on small fish and crustaceans on west Atlantic reefs. Coneys are usually red with many blue spots, looking very similar to the well known coral trout *C. miniata* of the Indo-Pacific, and the lesser known African hind *C. taeniops* of the east Atlantic.

Coneys and coral trout are very territorial, living in harems where a dominant male controls several females. Larger groupers tend not to live in harems and aggregate in large numbers to spawn just once or twice a year. Individuals may migrate several hundred kilometres to join in.

East End, Grand Cayman, Cayman Islands. Caribbean Sea.
Nikon D2X + 105 mm. 1/160th @ F9

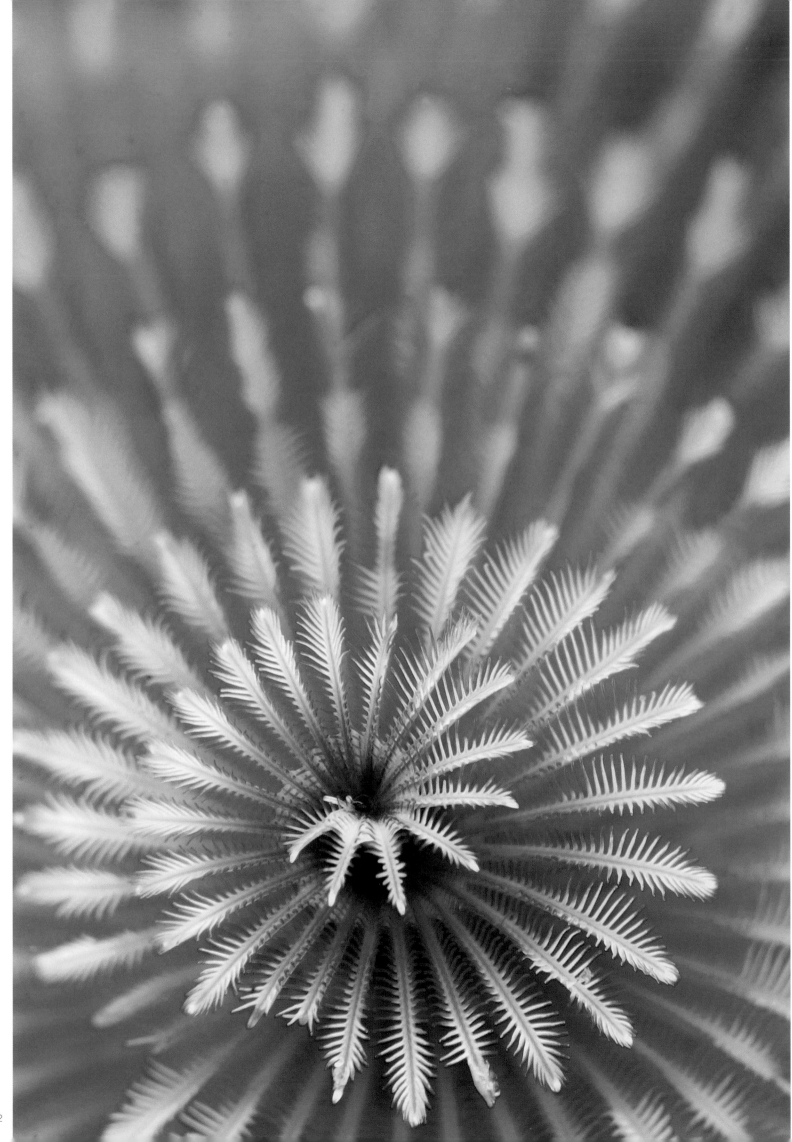

Flower coral polyps

A high magnification view of the polyps of a flower coral *Goniopora* sp. Unusually, for most polyps open at night, this coral's polyps remain open during the day.

Kaimana region, South Bird's Head peninsula, West Papua, Indonesia.
Nikon D2X + 105 mm. 1/250th @ F14

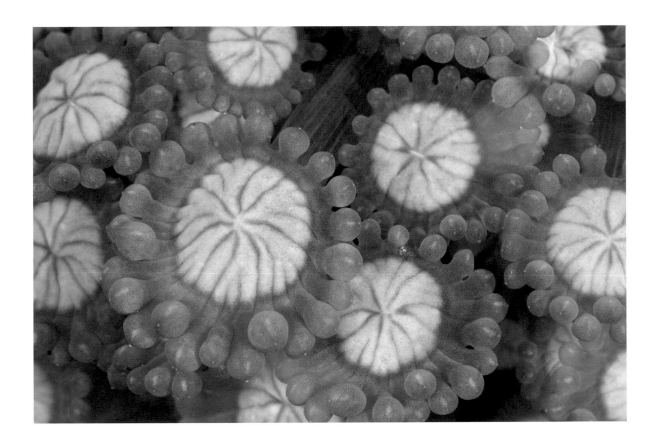

Christmas-tree worm detail

A Christmas-tree worm *Spirobranchus giganteus* feeds by filtering plankton through its spiral appendages. Christmas-tree worms come in nearly all imaginable colours and are found on reefs in both the Atlantic and Indo-Pacific, but they all belong to just one species.

Usually seen growing out of corals, Christmas-tree worms do not bore into the coral. Instead they build their tube at the same rate as the coral growth. Their spawning often coincides with coral spawning in a particular region, meaning they breed in late December on the Great Barrier Reef, although I have watched them spawn in the late summer in the Caribbean.

West Bay, Grand Cayman, Cayman Islands. Caribbean Sea.
Nikon D2X + 105 mm. 1/250th @ F32

The golden-brown stalk of this searod *Pseudoplexaura* sp. shows that it contains zooxanthellae (single-celled algae), which provide much of its nutritional needs. These photosynthetic soft corals are characteristic of Atlantic coral reefs.

Given that this species takes so much of its nutrition from symbiotic algae, I have always wondered at its thin body structure, which is covered in mouths and apparently more adapted to capturing plankton. Soft corals are not voracious predators, and on average each polyp of this species catches a single plankton only every four to five days. Despite the low rate, this predatory feeding provides important nutrients that the coral cannot obtain from its algae.

North Wall, Grand Cayman, Cayman Islands. Caribbean Sea.
Nikon D2X + 28–70 mm. 1/30th @ F9

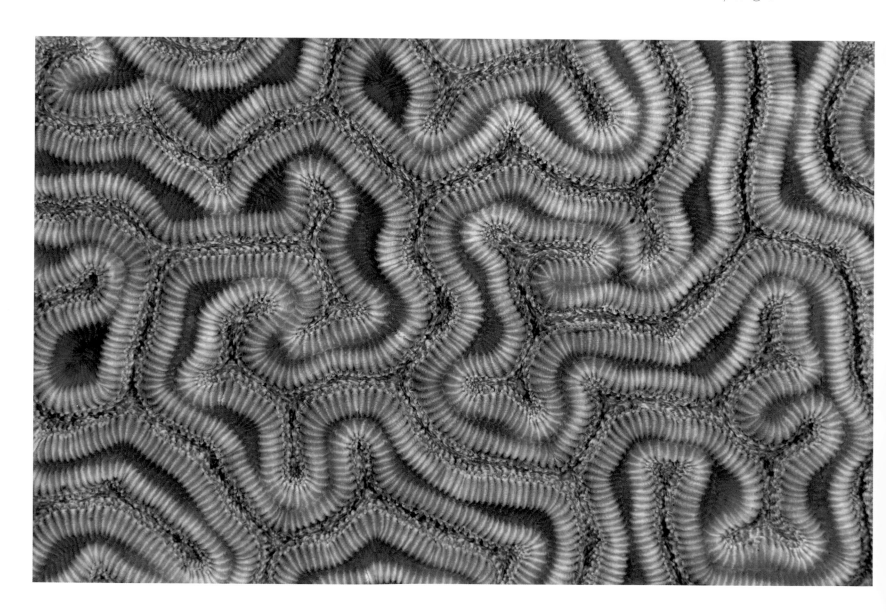

⌃ Brain coral detail

This aptly named brain coral *Diploria labyrinthiformis* is one of a number of species from several families that share the name. Brain corals are formed by polyps dividing and forming walls along their sides but not between the mouths in each row.

East End Wall, Grand Cayman, Cayman Islands. Caribbean Sea.
Nikon D2X + 150 mm. 1/250th @ F18

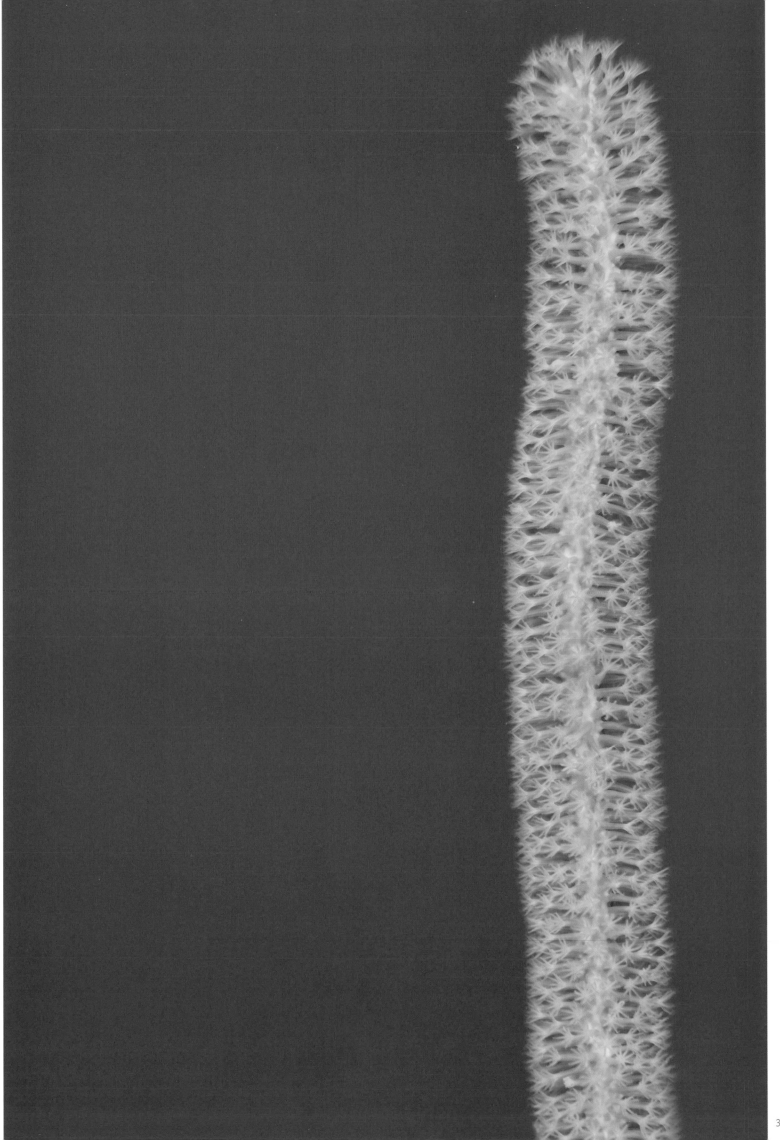

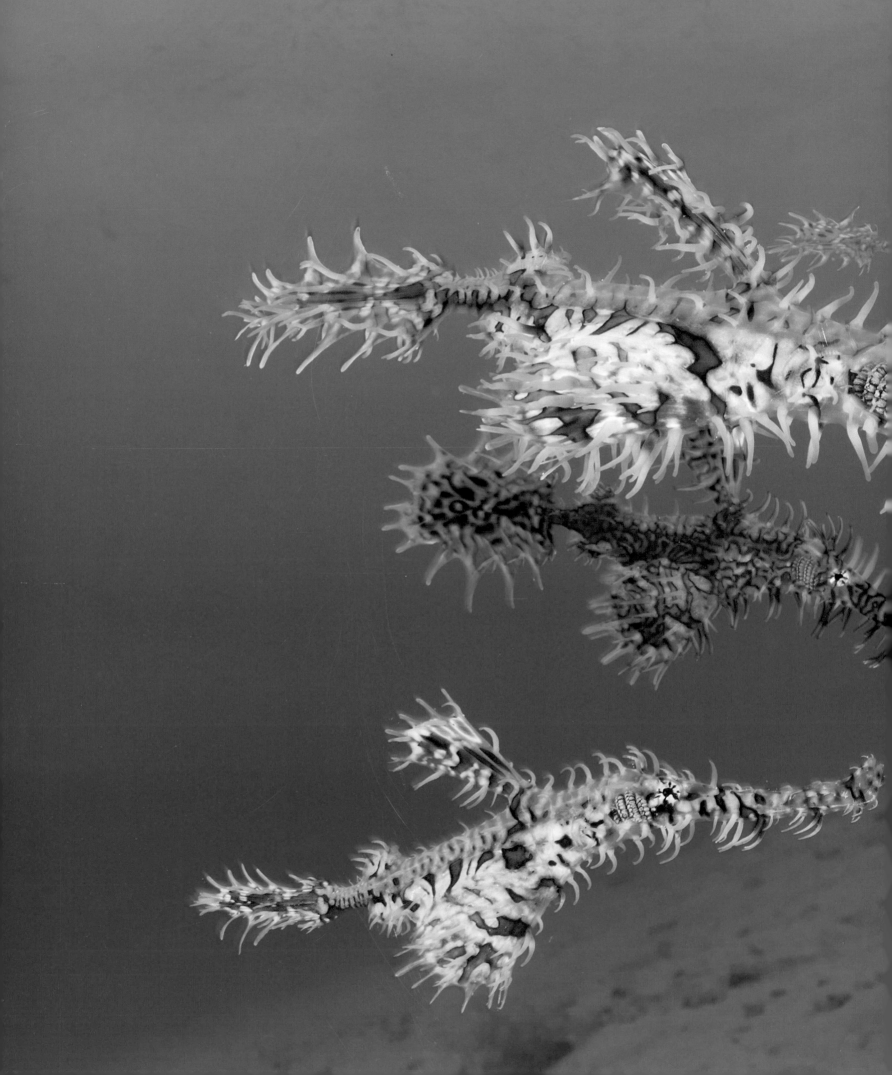

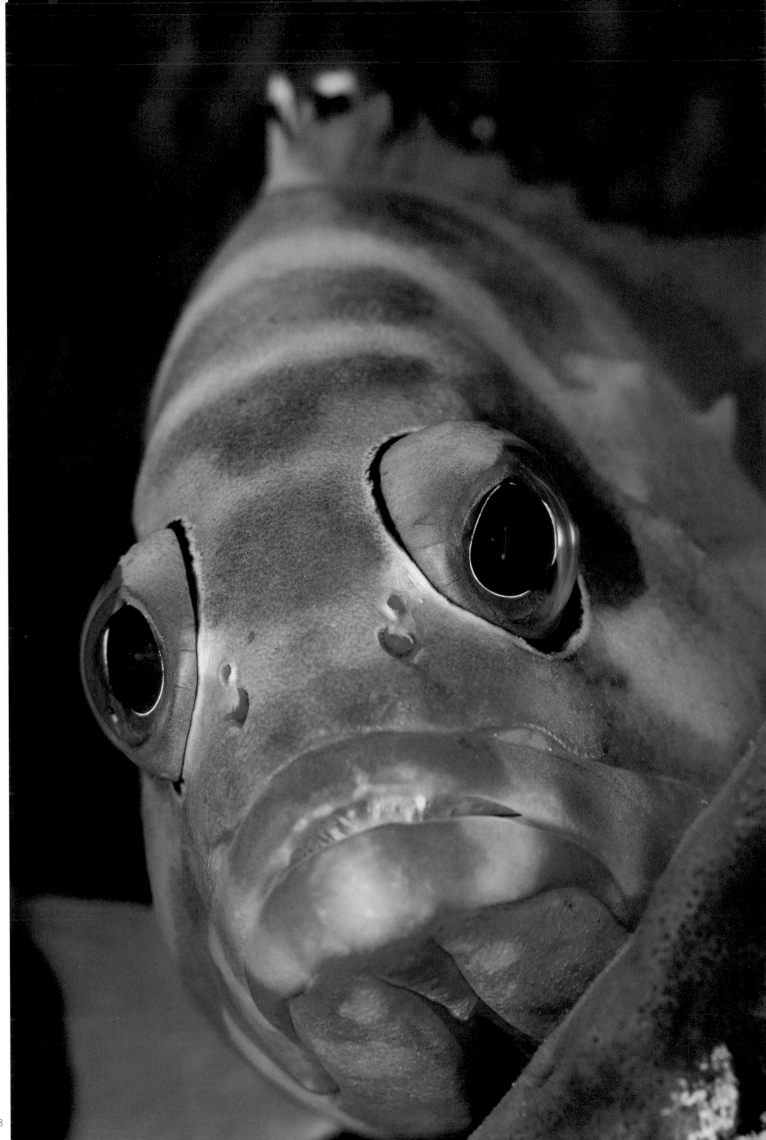

⟨⟨ Ghostpipefish shoal

A shoal of ornate ghostpipefish *Solenostomus paradoxus* parades below a black coral bush *Antipathes* sp. The extraordinary camouflage of these small (8 cm) slow-moving fish both protects them from predators and allows them to stalk their own prey of small crustaceans.

Unlike their relatives, seahorses and pipefish, it is the female ghostpipefish that looks after her young, carrying the silvery eggs in a pouch between her clasped pelvic fins. In this picture there are four females and one male, second from the top, who I cannot help thinking looks rather contented with life.

Pisang Islands, West Papua, Indonesia. Ceram Sea.
Nikon D2X + 10.5 mm + 1.5x TC. 1/15th @ F10

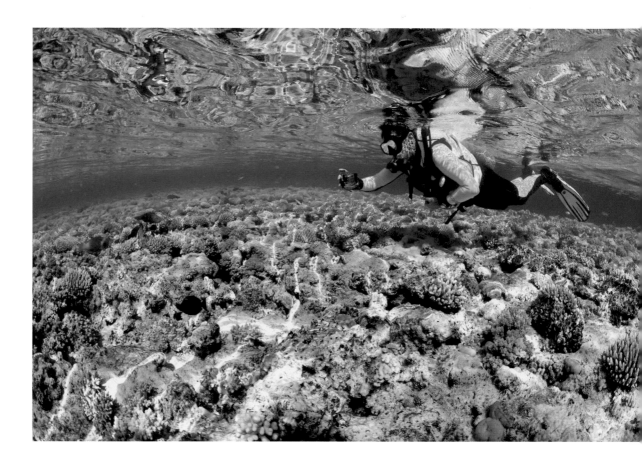

∧ Diver exploring reef flat

A diver explores a shallow reef flat in the Red Sea. This area of the reef flat is dominated by calcareous algae and isolated coral colonies. Herbivorous fish, such as parrotfish and surgeonfish, are common here.

Strait of Tiran, Gulf of Aqaba, Egypt. Red Sea.
Nikon D2X + 10.5 mm. 1/125th @ F8

Blacktip grouper

A blacktip grouper *Epinephelus fasciatus cruentatus* rests on a purple sponge. This grouper can change colour rapidly between a pinkish base with a reddish-brown cap, to a much redder fish with stripes down its body.

The blacktip grouper is one of the few species of reef fish that is divided into subspecies: *E. fasciatus fasciatus* from the Indian Ocean and Red Sea, and the subspecies shown here from south-east Asia and the west Pacific. Personally, having seen this species in both areas, I am not convinced by this subdivision.

Mabul Island, Sabah, Malaysia. Sulawesi Sea.
Nikon D2X + 105 mm. 1/250th @ F11

CORAL SPAWNING

∧ Giant star coral spawning

A giant star coral *Montastrea cavernosa* 'smokes' as it releases sperm during annual spawning. Mass coral spawning is one of the most spectacular sights in the ocean, a moment when corals, which spend most of the year impersonating rocks, explode into effervescent life. Most species spawn for just a few minutes each year, so ensuring my camera is pointing at the right place at the right time is a challenge.

Most corals are hermaphrodites, but giant star coral has separate sex colonies with a near 1:1 ratio of males to females on each reef, to facilitate successful fertilization.

East End, Grand Cayman, Cayman Islands. Caribbean Sea.
Nikon D2X + 16 mm. 1/250th @ F14

∧ Mountainous star coral spawning

A mountainous star coral *Montastrea faveolata* releases egg-sperm bundles at night. The majority of corals are hermaphrodites and release buoyant bundles that contain both the eggs and sperm from an individual. The bundles break up on reaching the surface, where the motile sperm seek out eggs from another colony to fertilize as they are incompatible with eggs from their own colony.

The fertilized egg develops into a free swimming, planula larva, which swims in the plankton for a few days before descending to the reef and settling on available substrate.

East End, Grand Cayman, Cayman Islands. Caribbean Sea.
Nikon D2X + 16 mm. 1/250th @ F11

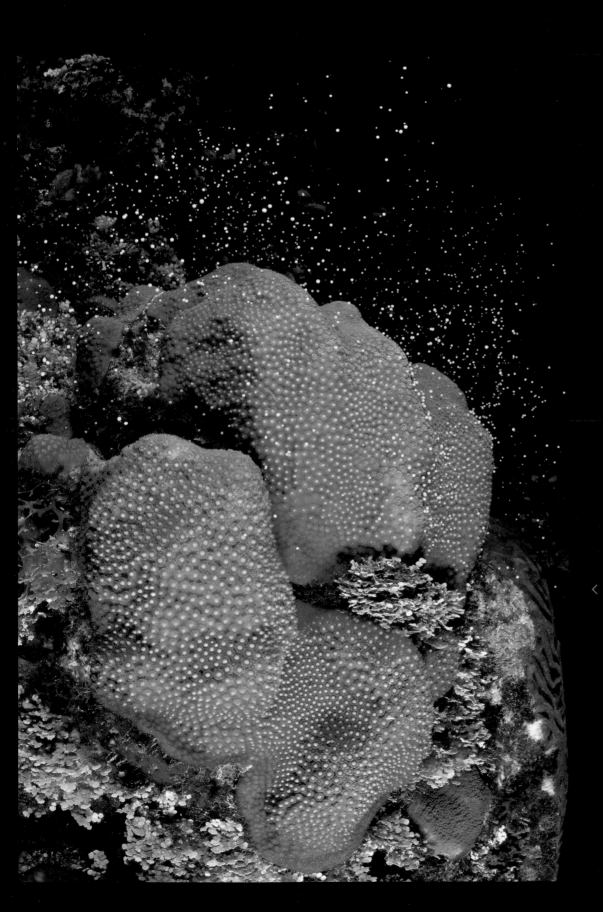

< Lobed star coral spawning

A lobed star coral *Montastrea annularis* releasing egg-sperm bundles. Note that there are still many bundles set in the polyps. The exact timing of spawning is controlled by cycles – of annual temperature, lunar tides and daily light.

In 2003 I made predictions that allowed mass spawning in the Cayman Islands to be witnessed for the first time, and since then the predictions have been almost minute-perfect every year. It is not clear how corals sense these environmental cues and respond to them, but, however it is done, the results are spectacular. The most impressive spawning is probably on the Great Barrier Reef, where up to 130 species go off over a few nights. But mass coordinated spawning does not occur everywhere; on night dives in south-east Asia I have seen several coral species spawning in isolation.

East End, Grand Cayman, Cayman Islands. Caribbean Sea.
Nikon D2X + 16 mm. 1/250th @ F14

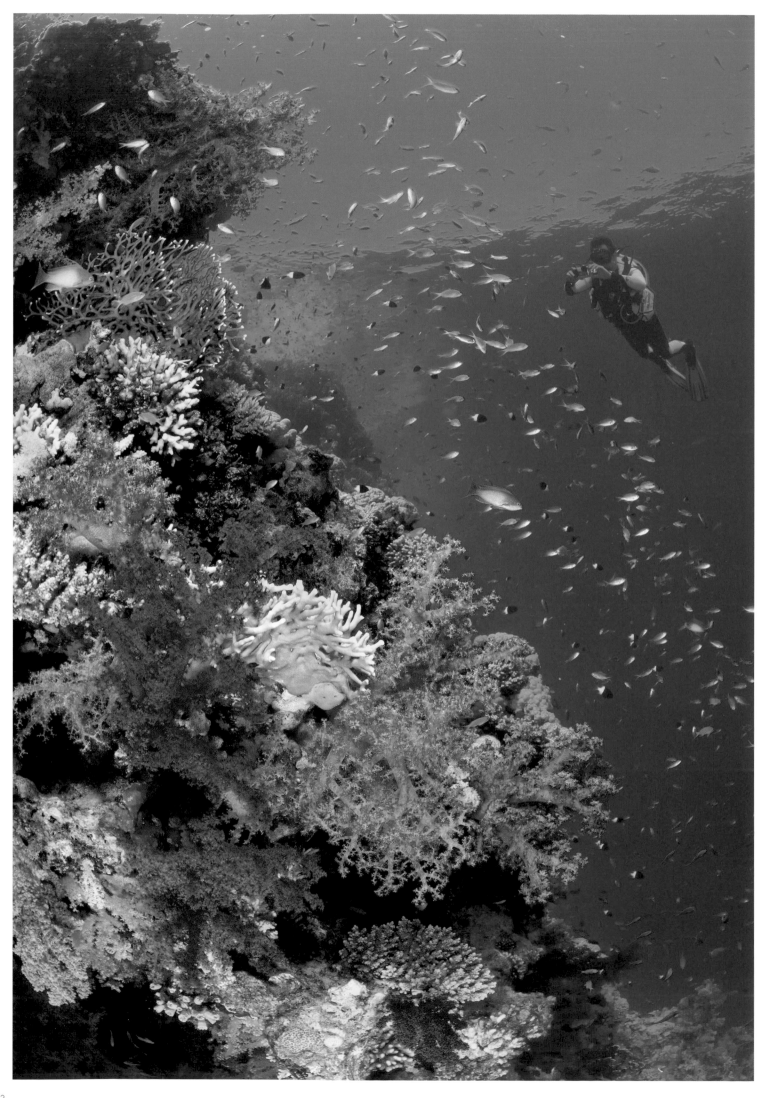

A vibrant reef wall

A reef wall bustles with activity and life, packed with hard corals, soft corals *Dendronephthya* spp. and anthias *Pseudanthias squamipinnis*. It looks like an idyllic home. But before young coral larvae can settle and grow into an adult colony it must negotiate its way past many hungry predators waiting to pick it off.

All the species in this photo, save for the diver, started life in the plankton community before settling into their adult lives on the reef. The planktonic larval stage is one of the reasons for the broad distribution of many reef species.

Strait of Tiran, Gulf of Aqaba, Egypt. Red Sea.
Nikon D2X + 10.5 mm. 1/180th @ F9 [m]

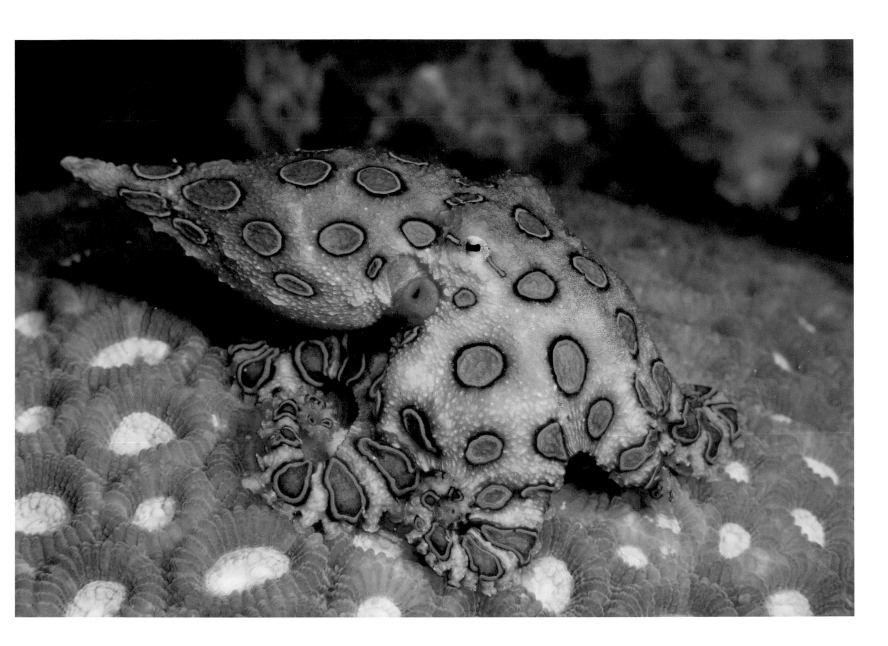

⌃ Blue ring octopus

This blue ring octopus *Hapalochlaena lunulata* is not much bigger than your thumb, and very dangerous. Most octopuses can deliver a venomous bite, but generally it is a mild weapon. However, this inoffensive-looking species is one of the most venomous creatures in the ocean – its bite injects a neurotoxin that paralyses its victim. In fact, it carries at least three kinds of venom, not only in its saliva but also in its tentacles, intestines, eggs and ink-sac. These poisons are manufactured by symbiotic bacteria. It flashes its blue rings to warn it is not to be trifled with.

Kapalai Island, Sabah, Malaysia. Sulawesi Sea
Nikon D2X + 60 mm. 1/250th @ F18

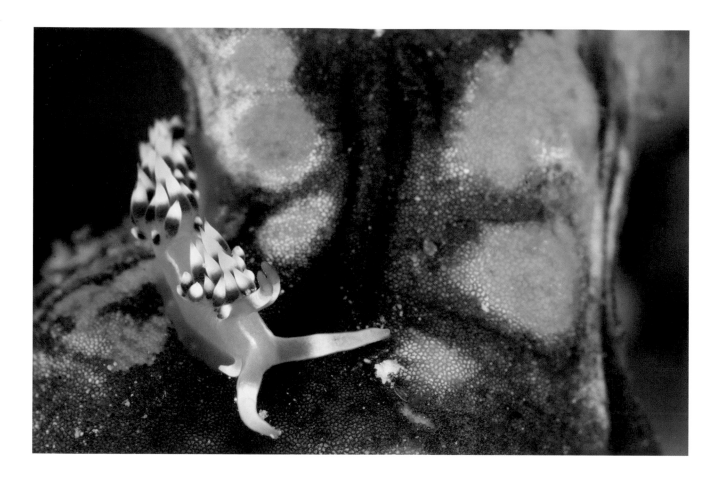

⌃ Nudibranch on sea squirt

A nudibranch or sea slug *Phidiana indica* crosses a sea squirt *Polycarpa aurata*. The bright colours of this nudibranch alert predators to the stinging cerata (horns) along its back. The nudibranch reuses the nematocysts (stinging harpoons) from its prey: hydroids, anemones and corals. Some of the nematocysts remain un-discharged as the nudibranch feeds, and these are passed to extensions in its gut that continue into the cerata, where they are concentrated in the white tips.

Sea squirts are widespread members of the coral community and particularly characteristic of west Pacific Ocean reefs. Both species in this photo are simultaneous hermaphrodites.

Misool Island, Raja Ampat, Indonesia. Ceram Sea.
Nikon D2X + 105 mm. 1/250th @ F25

> Moray eels fighting

A pair of giant moray eels *Gymnothorax javanicus* (1.5 m) form the shape of a heart as they tussle on the reef. Quarrels between individuals are common and are usually the result of disputes over territory or mates. Most disagreements are settled without violence, with ritualized behaviour and posturing. Such behaviour allows most arguments to be settled without risking injury or wasting valuable energy.

At first impression a coral reef is a bewildering sight, with such a variety of life so densely packed in such a small area. But for many species it is divided up into well-defined territories and home ranges.

Ras Mohammed, Sinai, Egypt. Red Sea.
Nikon D100 + 17–35 mm. 1/90th @ F8

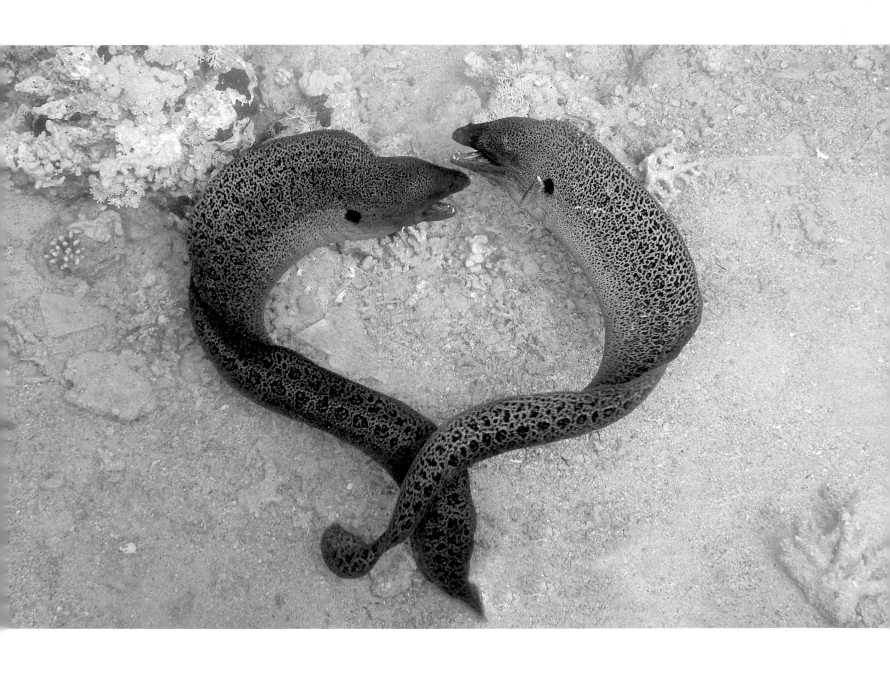

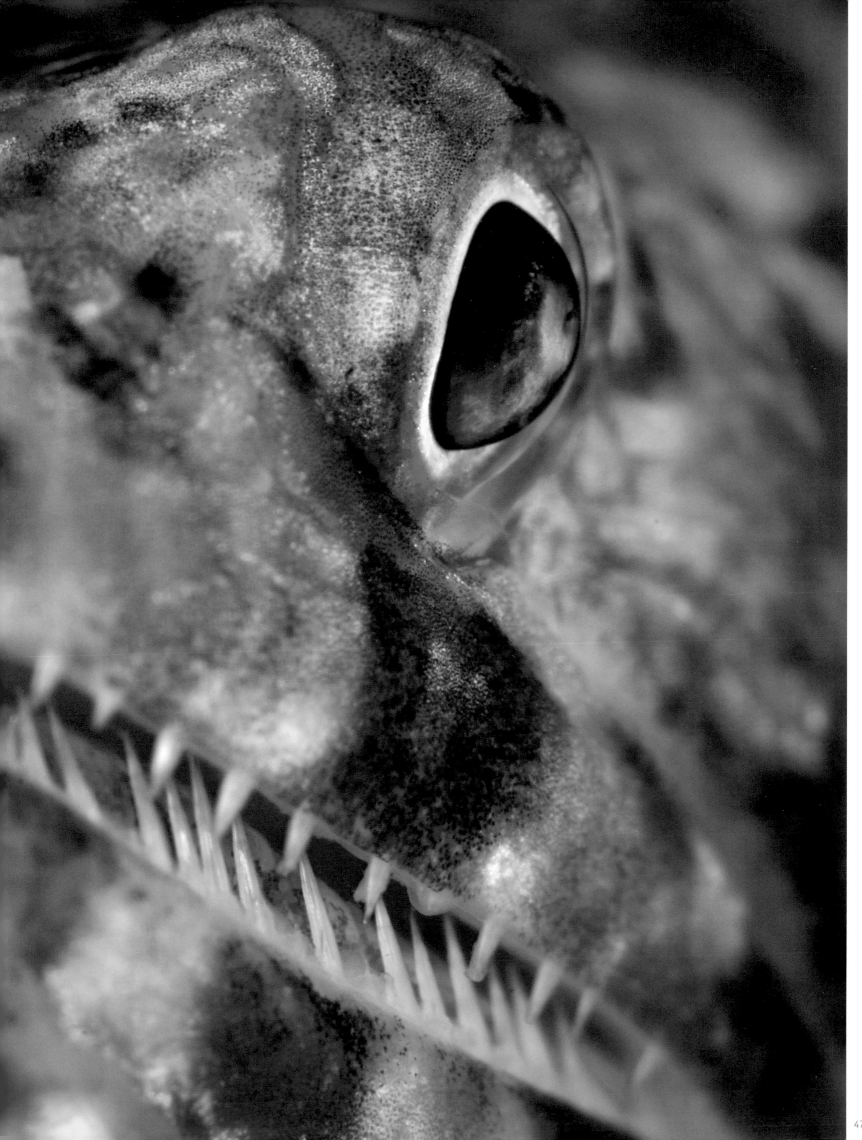

<< Lizardfish face

The wide mouth and fearsome reptilian grin of a lizardfish *Synodus variegates*. This ambush-favouring predator grows to around 28 cm. Its conical, sharp teeth are inward-pointing and are adapted for gripping struggling fish in its jaws.

Tulamben area, Bali, Indonesia. Java Sea.
Nikon D2X + 150 mm. 1/250th @ F13

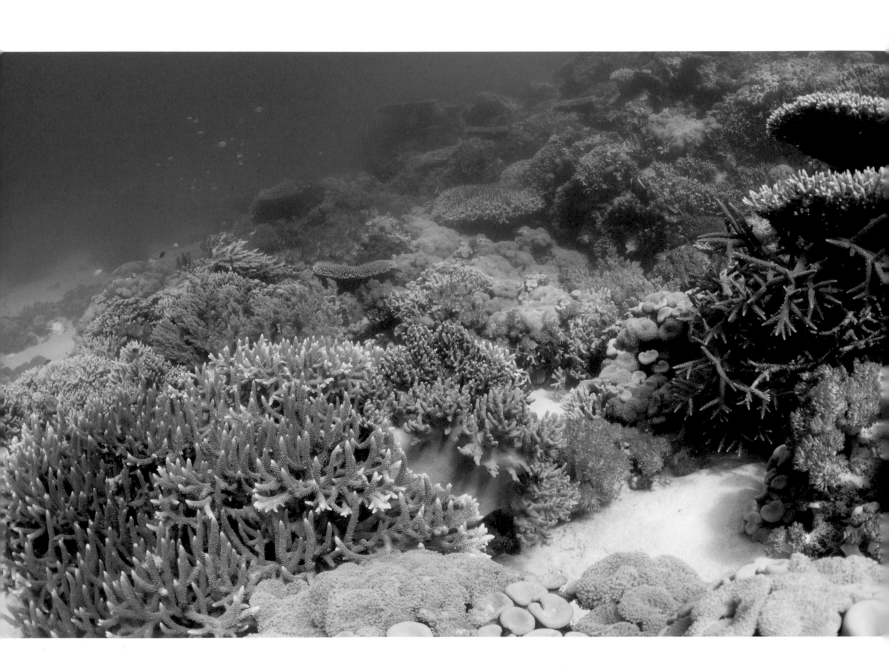

∧ Coral garden

The diversity of a shallow coral garden. Shallow reefs are called gardens because the coral growth resembles plants. Like plants, reef-building corals grow into these shapes to catch light, which they need to photosynthesize for food. Of course, most corals do not feel like leaves or petals to the touch, but are hard and immovable rock. Reef-building corals are an intriguing mix of animal, vegetable and mineral.

Menjangan Island, Bali, Indonesia. Java Sea.
Nikon D2X + 16 mm. 1/50th @ F6

A mushroom coral fights for space

Space on the reef is at a premium and corals and other sessile creatures are in constant battle for prime real-estate. Fast-growing branching corals can overgrow and shade other species, and encrusting corals can grow right across other species. But many corals bring more destructive weapons to the fray. Some species extrude digestive filaments through their mouths and eat their rivals. Others produce long sweeper tentacles, several times longer than normal and packed with stings. Soft corals even use chemical weapons, releasing toxic compounds into the surrounding water.

Here, a mushroom coral *Fungia* sp., a large single polyp about the size of a plate, has cleared a no-man's-land between it and a large bed of *Xenia* sp.

Nusa Penida, Lombok Strait, Indonesia. Indian Ocean
Nikon D2X + 16 mm. 1/100th @ F7.1

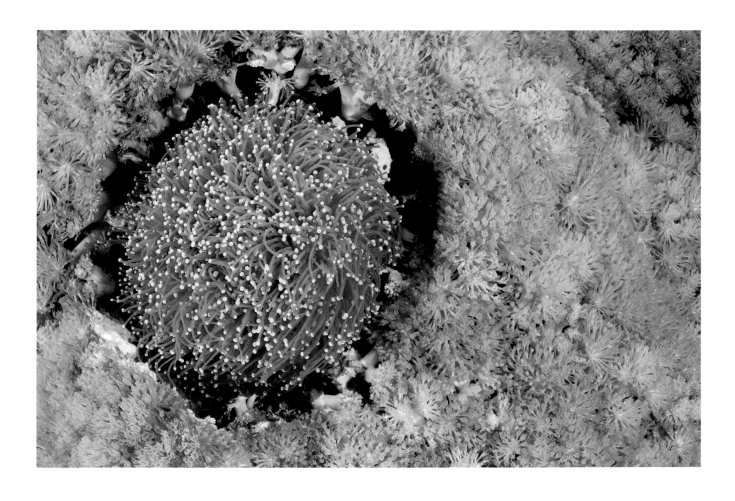

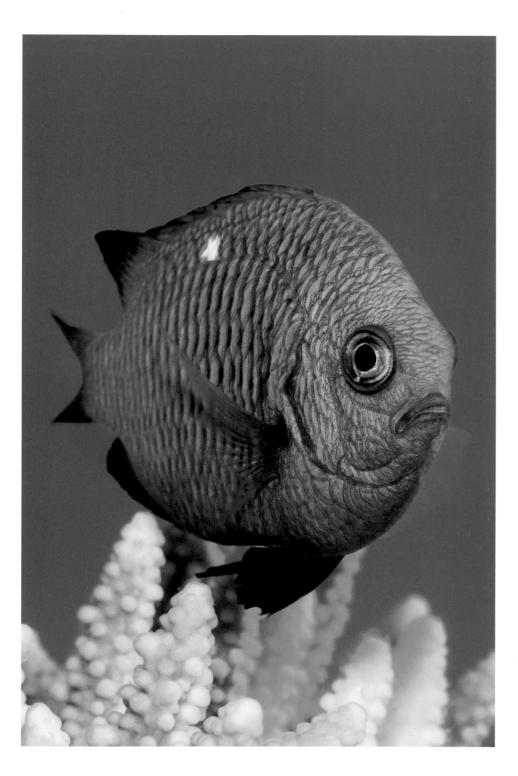

> Branching corals everywhere

Branching corals *Acropora sp.* cover up to 80 per cent of shallow reefs in the Indo-Pacific, and dominated the Caribbean too until they were ravaged by white band disease in the early 1980s. The disease reduced their cover by as much as 98 per cent. Encouragingly, they are coming back strongly in some areas and I have seen both elkhorn *A. palmata* and staghorn *A. cervicornis* coral spawning in the last few years.

Acropora comes in many shapes and is known as the protean coral, after the Greek sea-god Proteus, famed for his shape-shifting ability. Its dominance is due to its very fast growth rate – 15–20 cm a year – which it achieves by building its skeleton in a light, but strong, honeycomb structure.

Sipadan Island, Sabah, Malaysia. Sulawesi Sea.
Nikon D2X + 16 mm. 1/80th @ F3.5

∧ Domino damsel hovers over protective coral

A domino damselfish *Dascyllus trimaculatus* hovers above the protective branches of an *Acropora* coral, which provide a safe retreat from threat. Branching gives the coral more access to space and its polyps more exposure to water currents.

The branches also create a micro-habitat; it is common to see clouds of damselfish and anthias above *Acropora* corals, and between the branches you will find shrimps, crabs, gobies and more. The threespot damselfish *Stegastes planifrons* farms algae on the dead lower branches, aggressively defending its territory. It is even prepared to give a diver's finger a nip.

Sharm El Sheikh, Gulf of Aqaba. Egypt. Red Sea.
Nikon D2X + 105 mm. 1/100th @ F11

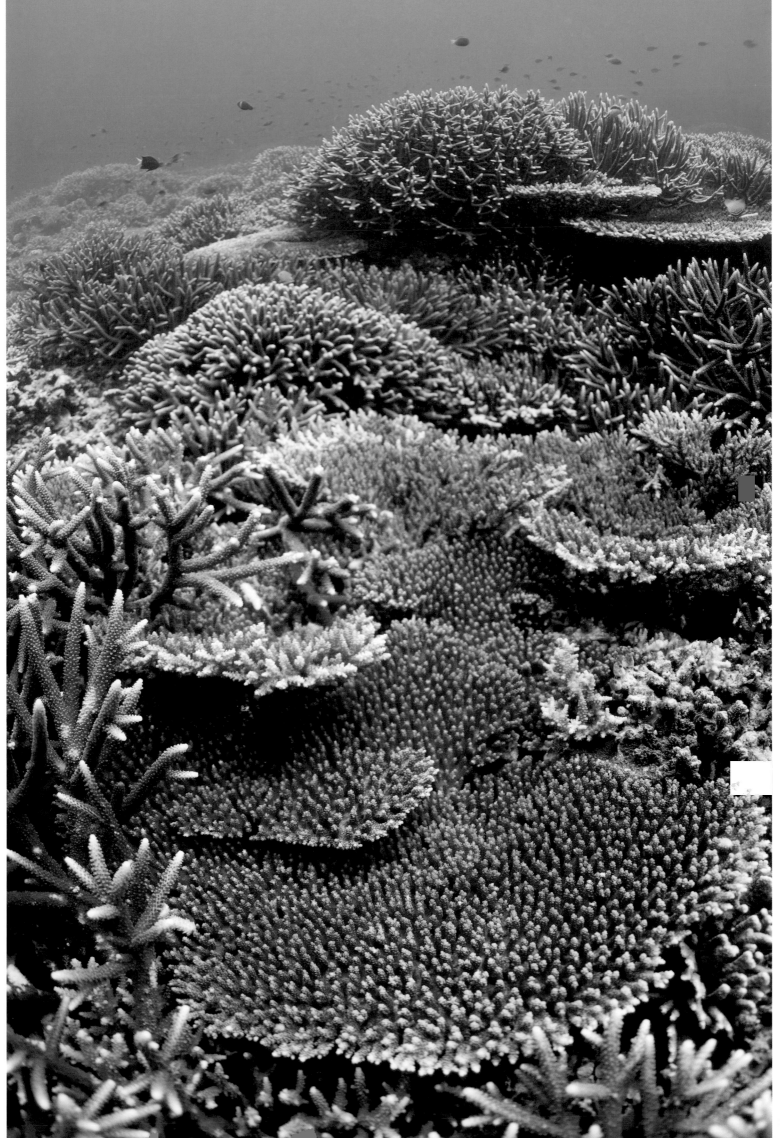

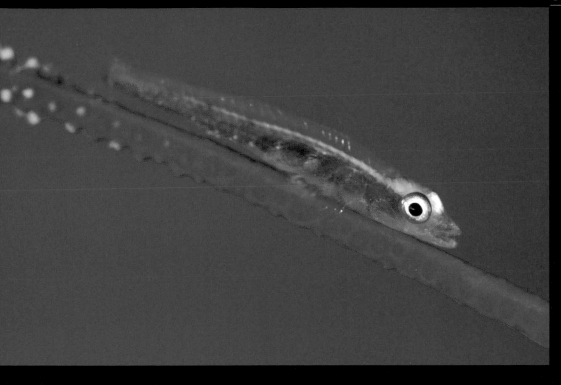

Sea whip goby

A red whip goby *Bryaninops sp.* on a whip coral *Ellisella sp.* Several species of sea whips *Cirrhipates* and *Ellisella* are favourite homes for goby species. Gobies' pelvic fins are fused together to form a perch. In whip gobies these paired fins on the belly are fused into a suction cup, which holds the precariously perched fish fast to the whip coral, even in strong currents.

Menjangan Island, Bali, Indonesia. Java Sea.
Nikon D2X + 105 mm. 1/20th @ F13

Sponge goby

A sponge goby *Pleurosicya elongata* on a sponge *Ianthella basta*. This sponge goby is about 4 cm long, but the smallest gobies measure less than a centimetre. One species of pygmy goby, *Eviota sigillata*, holds the record for the shortest-lived vertebrate, its whole life lasting less than 60 days, including three weeks drifting in the ocean during the larval stage. This sponge is the source of many compounds isolated for pharmaceutical use.

Mabul Island, Sabah, Malaysia. Sulawesi Sea.
Nikon D2X + 105 mm. 1/250th @ F25

Goby on sponge

A many-host goby *Pleurosicya mossambica* (2 cm) on an orange sponge. Gobies lack swimbladders, the buoyancy compensation device of most fish, and therefore live life on the bottom. Many species live on particular corals or sponges, while others have looser relationships. The orange sponge selected by this goby is also home to an unusual colonial spionid worm *Polydorella smuroyi* with long white antennae.

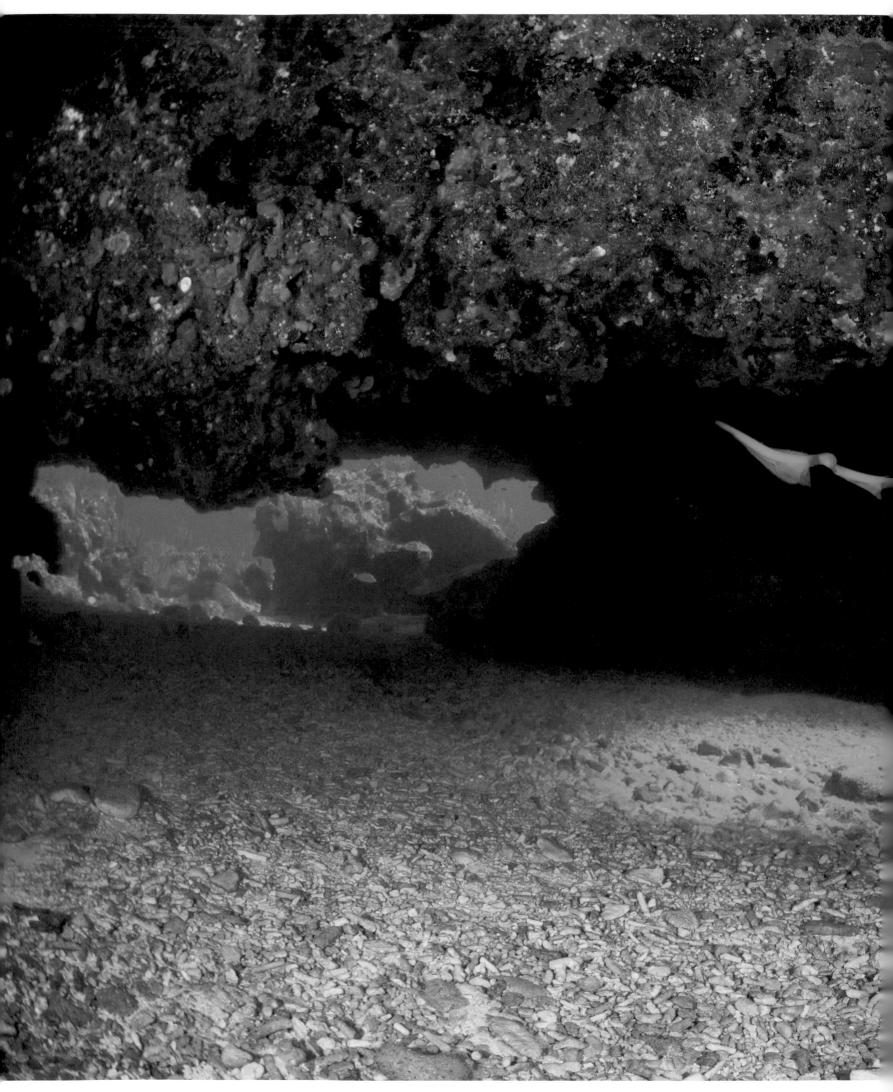

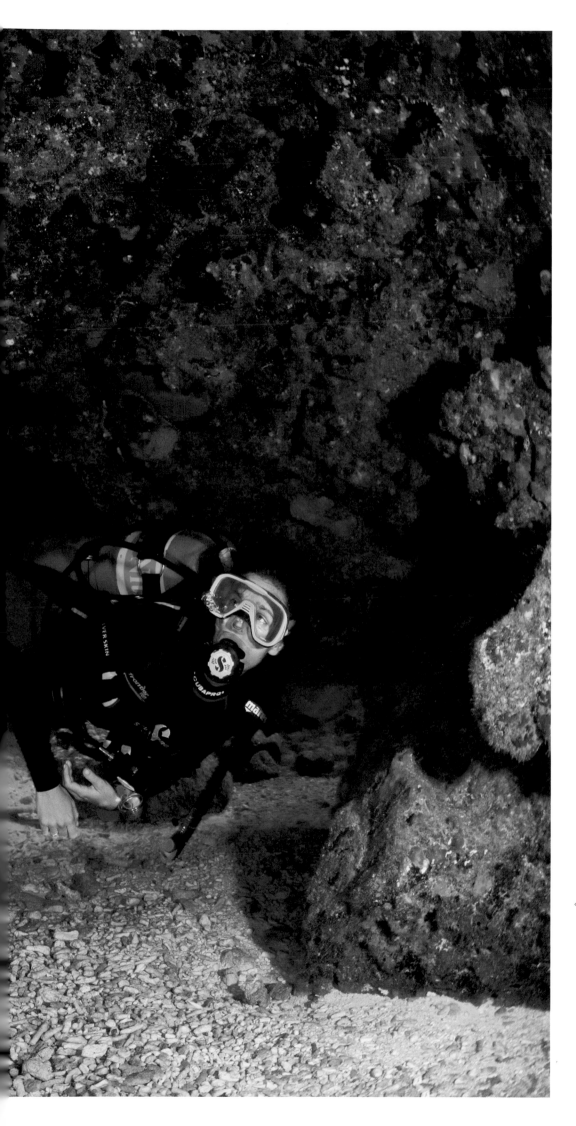

< A diver explores a coral cavern

Caves and caverns are common, and offer habitat diversity to the reef ecosystem's many specialized or preferential cave-dwelling species. Caverns are formed by a variety of processes, including from the overgrowth of spur and grove reef structures to the erosion of more ancient reef platforms during times of lower sea level.

Swimming into a dark cavern from the bright reef outside is always an exciting and adventurous feeling for a diver.

East End, Grand Cayman, Cayman Islands, Caribbean Sea.
Nikon D2X + 10.5 mm. 1/20th @ F5.6

Lush corals under an overhang

Orange soft corals *Scleronephthya* sp. and cup corals *Tubastraea* sp. grow lushly under an overhang. These corals lack zooxanthellae (photosynthesizing algae) and often thrive beneath overhangs or deeper on the reef, where there is less competition from photosymbiotic corals. Some research has suggested that plankton also aggregate in caves, increasing the food available for these predatory corals.

FakFak region. South Bird's Head peninsula. West Papua, Indonesia.
Nikon D2X + 16 mm. 1/60th @ F6.3

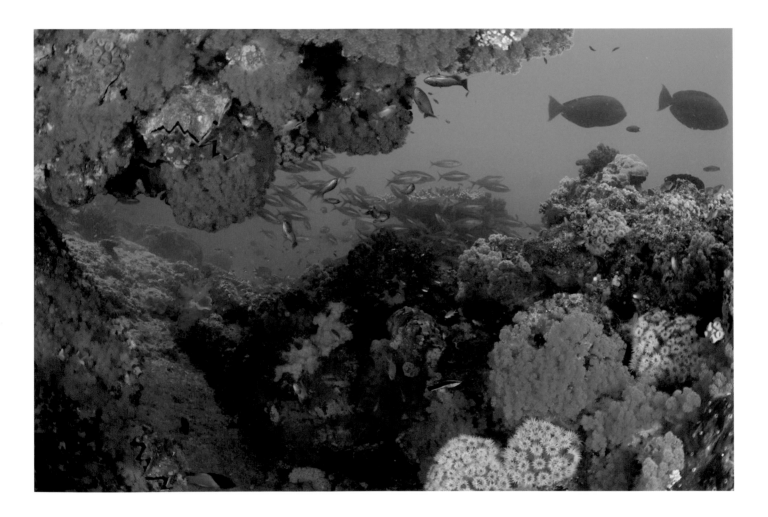

> White-eyed moray eel

A white-eyed moray eel *Siderea prosopeion* appears from the darkness in a crevice in the reef. Morays are most active at night when they leave the protection of their lairs and hunt in the open, sniffing out their prey before striking. Morays have an acute sense of smell, shown by the large inlet nostrils and nasal cavities of this individual.

The largest moray is the common giant moray *Gymnothorax javanicus*, which grows to 3 m long and thicker than a rugby player's leg. This white-eyed moray is much shorter and only as thick as three fingers.

Seraya, Tulamben area, Bali, Indonesia. Java Sea.
Nikon D2X + 150 mm. 1/250th @ F11

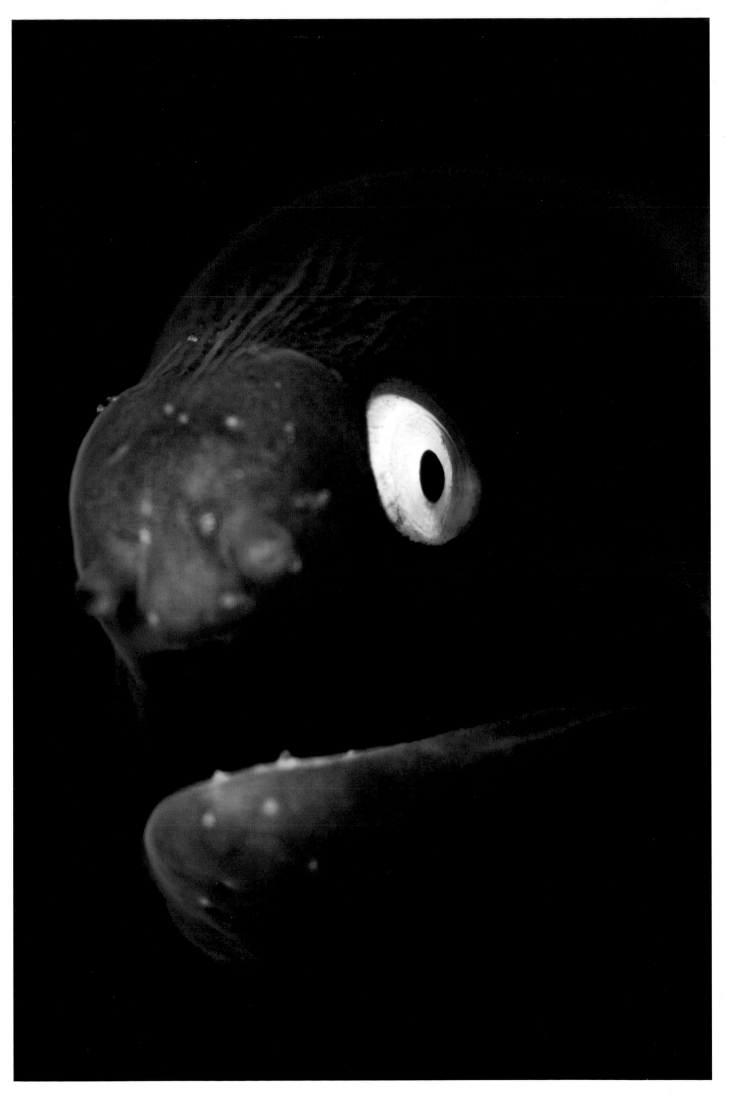

Divers over coral cavern

Two divers explore a cavern in a coral reef. Large caves are common on reefs and greatly increase the habitat diversity of the ecosystem. There are many species specifically adapted to spend all or part of their lives in this environment. For divers coral caves are a highlight of reef exploration providing an exciting challenge of an overhead environment and revealing a host of new species.

East End, Grand Cayman, Cayman Islands. Caribbean Sea.
Nikon F100 + 16 mm. 1/250th @ F11 [m]

A pair of tarpon

Tarpon *Megalops atlanticus* (1 m) are among the most spectacular large fish species on Atlantic reefs, their bodies shining like polished chrome. Tarpon hunt at dusk and during the night, spending the day in schools hanging in caverns and canyons. They come from a more ancient lineage of fish than most reef dwellers and have a larval stage similar to eels. The larva, which can be seen on night dives, looks like a short ribbon, with a tiny head.

Some tarpon hunt inshore of reefs, over seagrass beds and in mangroves. Rotting vegetation in these waters depletes oxygen, making fish sluggish. Tarpon can swallow air at the surface and absorb the oxygen through their swimbladder, giving these predators a turbo boost.

East End, Grand Cayman, Cayman Islands, Caribbean Sea.
Nikon D2X + 105 mm. 1/80th @ F5.6

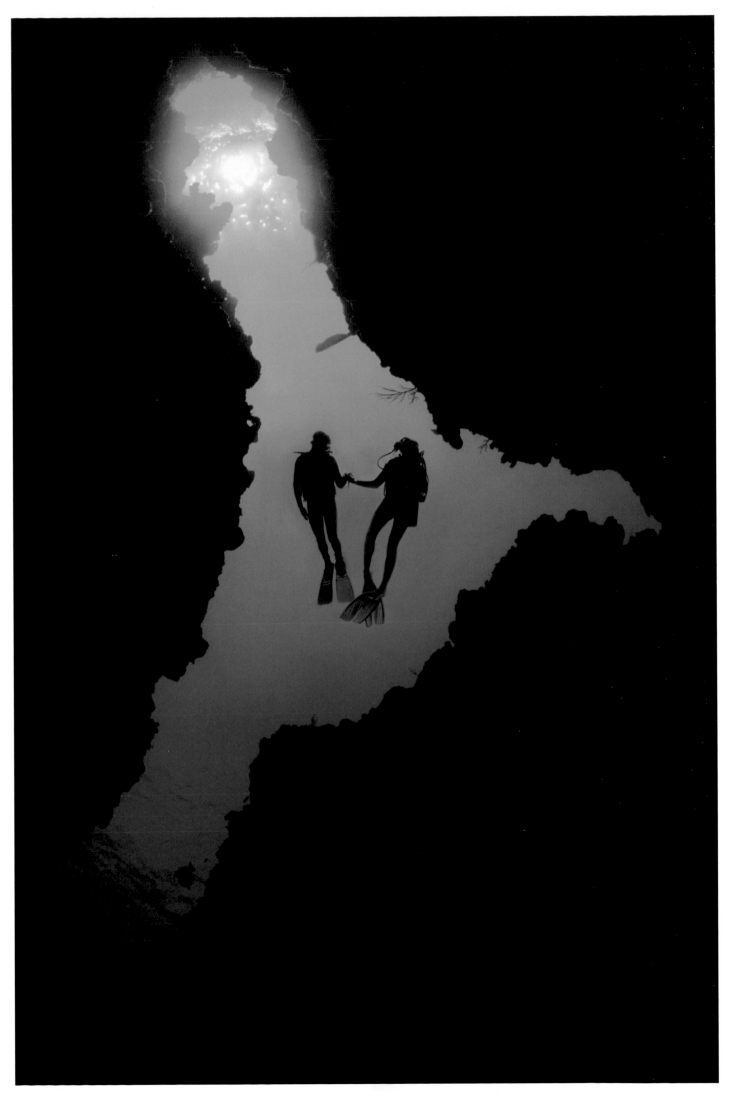

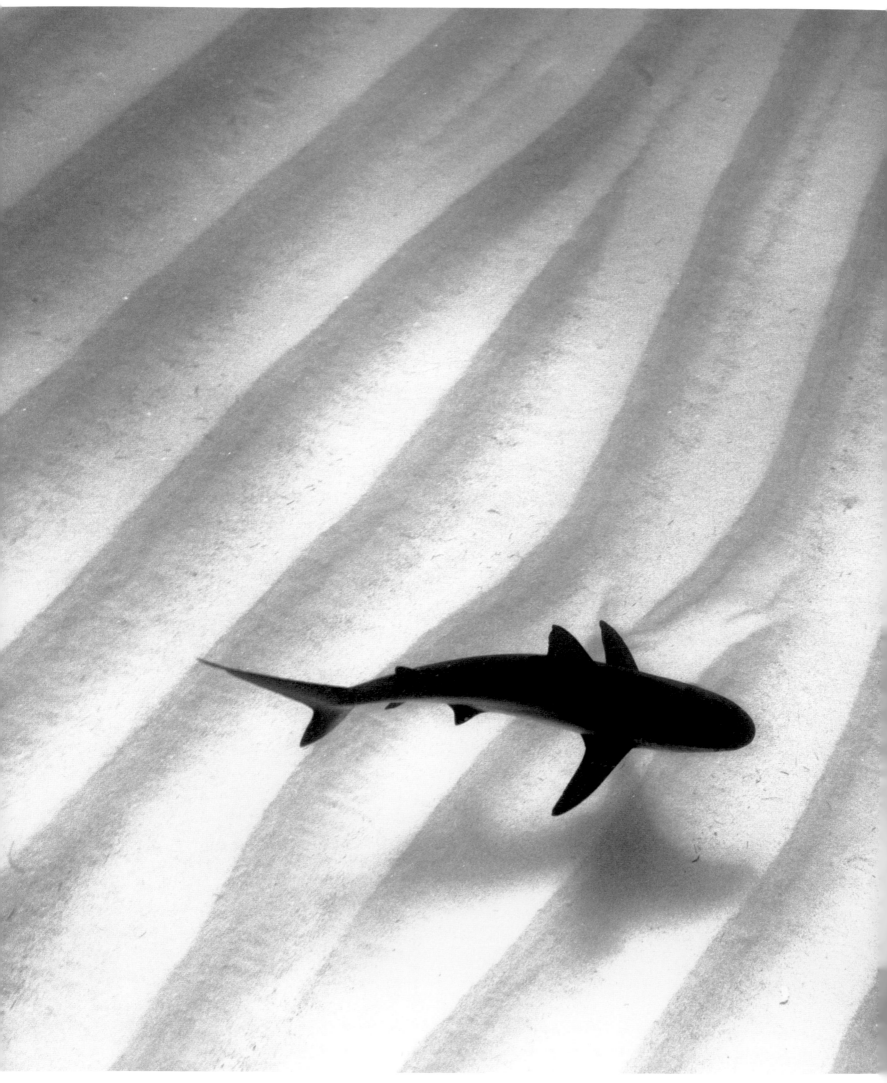

Reef shark and ripples

A Caribbean reef shark *Carcharhinus perezi* (1.5 m) cruises over sand ripples in a channel through a reef. Sharks do not have the swimbladders of bony fish and therefore must swim continuously. In a few places, such as in caves in Isla Mujeres, Caribbean reef sharks rest on the seabed panting to keep oxygen flowing over their gills. In the Indo-Pacific white-tip reef sharks *Triaenodon obesus* are commonly seen lying about on the reef.

Walkers Cay, Bahamas. West Atlantic Ocean.
Nikon D2X + 12–24 mm. 1/125th @ F11

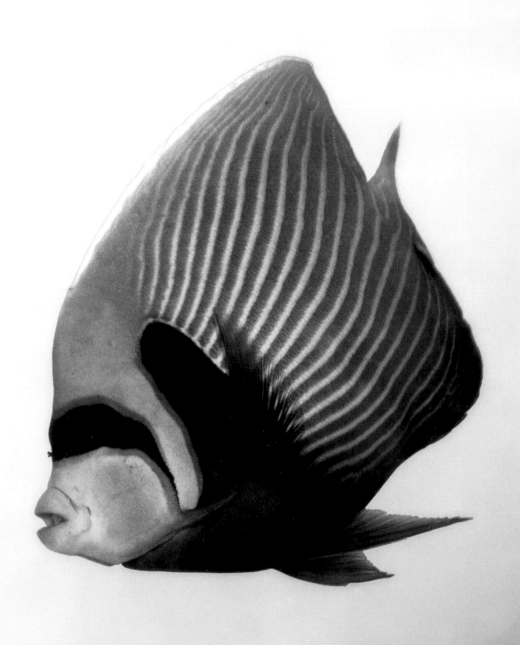

Soldierfish with parasitic isopod

A parasitic cymothoid isopod, like a marine woodlouse, sinks its claws into the head of a blackbar soldierfish *Myripristis jacobus*. Cymothoid isopods are common, with different species targeting specific hosts with different points of attachment. One type of parasitic isopod clings to the tongue of reef fish, feeding on the flesh as it grows larger, eventually replacing the tongue and its function.

Cymothoid isopods live as mated pairs on soldierfish. The first isopod to attach develops rapidly as a large female and emits pheromones that keep subsequent individuals as males, which are small and hard to see. The females brood their young in a marsupium pouch underneath their bodies.

I can't help feeling sorry for fish so obviously infected by parasites. How would you feel with a cat-sized woodlouse stuck to your head? Grotesque as parasites appear, they are rarely terminal, because if the host dies then so do they.

South Wall, Grand Cayman, Cayman Islands. Caribbean Sea.
Nikon D100 + 28–70 mm. 1/60th @ F16.

Emperor angelfish

The dramatic pattern of an emperor angelfish *Pomacanthus imperator*. Emperor angels feed on sponges, sea squirts and algae, and are highly territorial, presumably to ensure they have enough of these slow-growing foods.

Juveniles have a strikingly different colour pattern, and are not subjected to the same aggression as adult conspecifics, as they have a different diet. I have noted from watching them spawn that males can easily be distinguished from females by their larger size and darker faces.

Bright colour patterns might attract the attention of predators, but the large size of angelfish and their awkwardly shaped, laterally compressed bodies protect them. Many juvenile angels act as cleaners, which gives some additional protection.

Kapalai Island, Sabah, Malaysia. Sulawesi Sea.
Nikon D2X + 60 mm. 1/100th @ F16

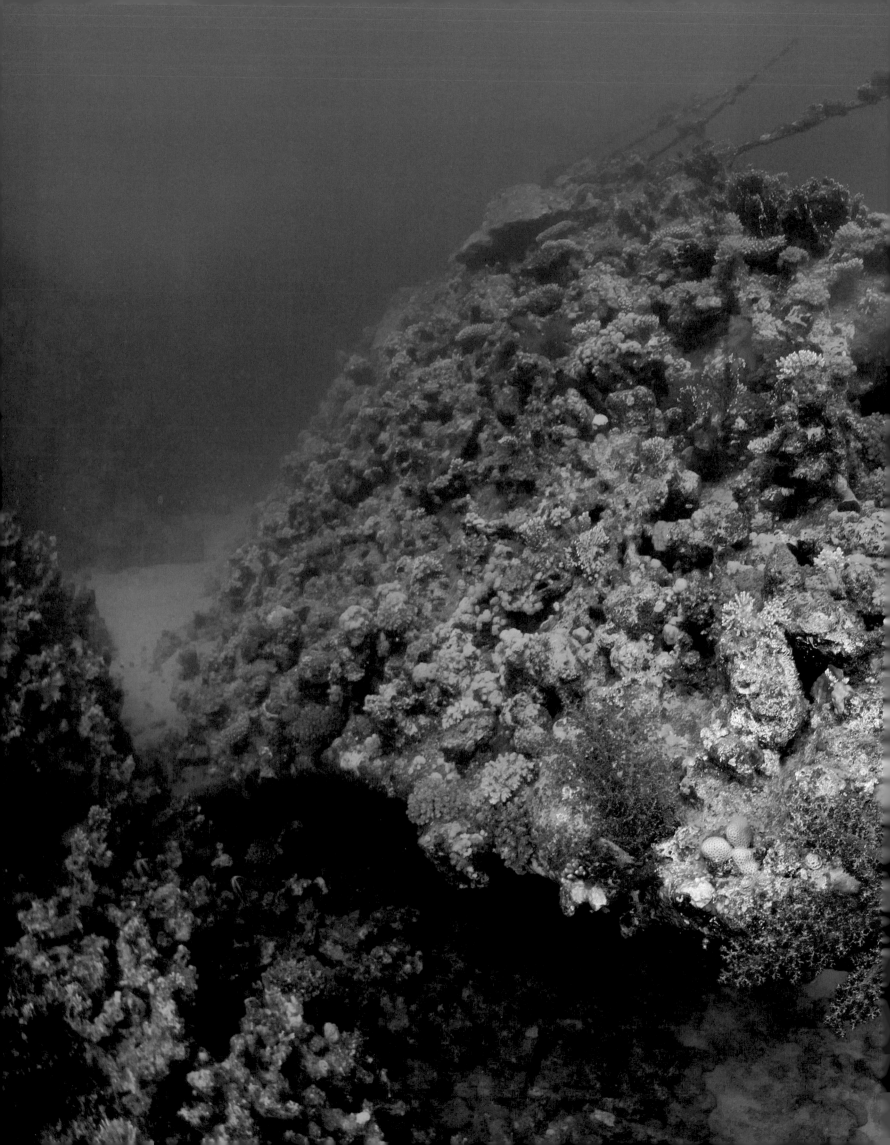

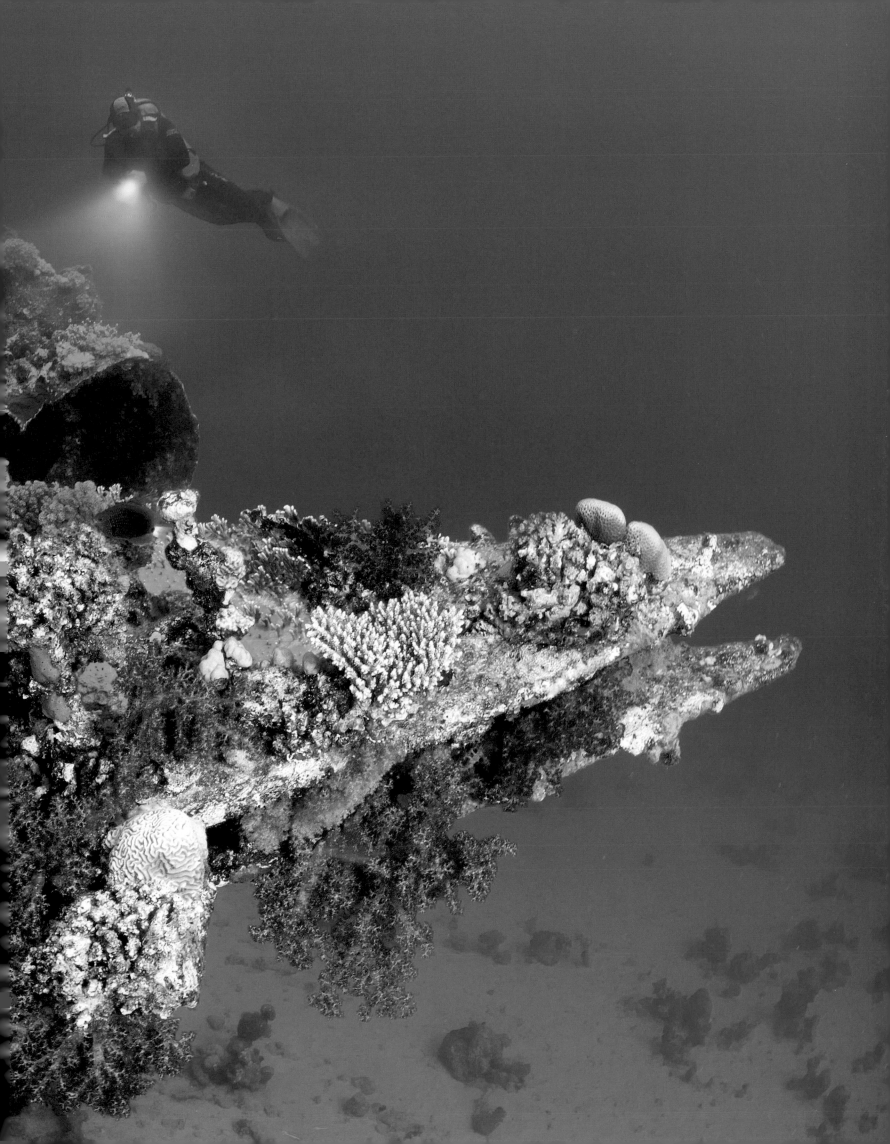

<< Wreck of the *Carnatic*

The bow of the *Carnatic* covered in red soft corals *Dendronephthya* sp. The *Carnatic* was a British-built square-rigged cargo and passenger steamer sunk by the same reef as the *Chrisoula K* (see below) but more than 100 years earlier, in 1869. The *Carnatic* lies deeper than the *Chrisoula K* and has been down longer, so it supports very different marine life.

On shallow wrecks the large flanks of metal are first colonized by algae and attract lots of herbivorous fish. Deeper wrecks are often quilted in soft corals and gorgonians, which enjoy ideal feeding conditions on the ship's structure.

Sha'ab Abu Nuhas, Gulf of Suez. Egypt. Red Sea.
Nikon D2X + 10.5 mm. 1/30th @ F7.1

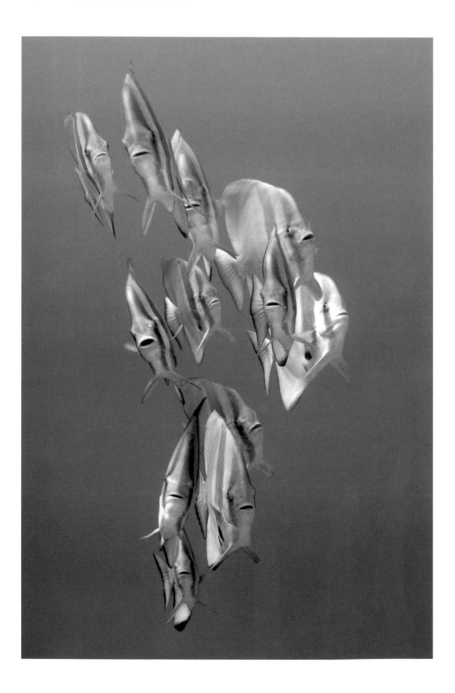

< School of batfish

A small school of circular batfish *Platax orbicularis* (45 cm) swims in open water. Batfish often seem to congregate at popular divesites, such as shipwrecks. Batfish can be inquisitive and even tame, often accompanying groups for an entire dive. They are curious fish and make use of a variety of food sources from large plankton, such as jellyfish, to benthic invertebrates.

Batfish change greatly in appearance during their lives. Juveniles have long dorsal and anal fins, many times the width of the body, and some species have beautiful colouration. The adults are more circular, as those here, and usually more plainly coloured.

South Male Atoll, Maldives. North Indian Ocean.
Nikon D2X + 28-70 mm. 1/40th @ F6.3

> Wreck of the *Chrisoula K*

The bow of the wreck of the *Chrisoula K*, which sank in August 1981 in the Red Sea, while carrying a cargo of floor tiles bound for Jeddah. Coral reefs are serious shipping hazards and claim many vessels. Collisions can cause major physical damage to reefs in the short term, but over time the ships themselves are colonized by reef life. The complex three-dimensional structure of shipwrecks is irresistible to marine creatures, and many wrecks seem to concentrate far more life than the reef that claimed them.

Sha'ab Abu Nuhas, Gulf of Suez. Egypt. Red Sea.
Nikon D2X + 10.5 mm. 1/50th @ F5.6

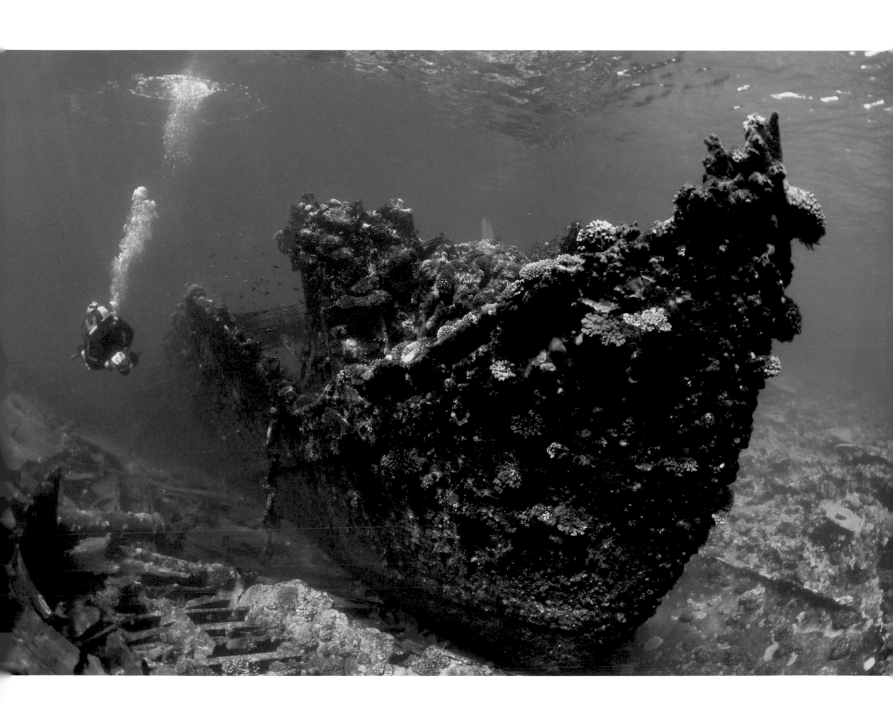

The stripes of a ribbon sweetlips

The ribbon sweetlips *Plectorhinchus polytaenia* is my favourite member of this Indo-Pacific family, and this photo shows a detail of the stripes that cover its body. Many fish change colour patterns during their lives, often to help protect vulnerable young from predation, or to limit intra-species aggression.

Juvenile sweetlips look very different from adults, commonly displaying large disruptive patterns on their bodies. The juveniles also dance, gyrating frantically. Some suggest that they are mimicking a flatworm or a nudibranch, although to my eyes their exaggerated swimming seems to act simply to disguise their features.

Misool Island, Raja Ampat, Indonesia. Ceram Sea.
Nikon D2X + 150 mm. 1/125th @ F9

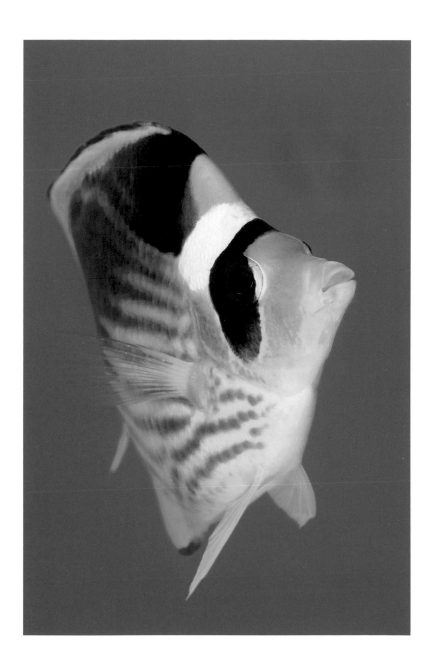

Racoon butterflyfish

Butterflyfish, like this Red Sea racoon butterflyfish *Chaetodon fasciatus*, have elongated snouts for probing the crevices of the reef for food. Butterflyfish also provide a good example of the higher diversity on Indo-Pacific reefs. Atlantic reefs support just eight species, while there are more than 80 in the large Indo-Pacific region. This species is one of several endemic to the Red Sea.

Butterflyfish are often seen in pairs, and I have often read that they form a stable monogamous pairing. However, when I have photographed butterflyfish I frequently see males desert their female partners after spawning and attempt to spawn with other females, which sometimes leave their partners and accept these rogue males.

Sharm El Sheikh, Gulf of Aqaba. Egypt. Red Sea.
Nikon D2X + 105 mm. 1/125th @ F10

> A diver with sponges and gorgonians

A diver inspects large growths on the reef wall, including brown tube sponges *Agelas conifera*, erect rope sponges *Amphimedon compressa* and gorgonian seafans *Iciligorgia schrammi*. The reef wall is the ideal location for filter feeders, which can benefit from plankton brought to the reef from the open ocean and also upwelled from deeper water.

Sponges are extremely efficient fine filter feeders, straining as much as 99 per cent of all bacterioplankton from the water that passes through them. Their tubes act like chimneys; as currents flow past the holes they suck more water through the sponge. Sponges can filter a volume of water equal to their own body every 5–20 seconds.

North Wall, Grand Cayman, Cayman Islands. Caribbean Sea.
Nikon D2X + 10.5 mm. 1/50th @ F7.1

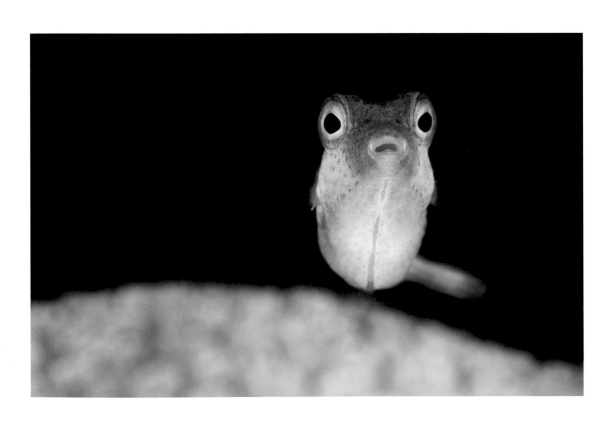

∧ A sharpnose puffer

The startling yellow eyes of this sharpnose puffer *Canthigaster rostrata* stand out against a dark background. Small puffers are widespread on reefs, although they often go unnoticed. This species lives in territorial harems of one to six females to a larger dominant male. Non-haremic males have smaller territories or roam widely. Each female prepares an algae nest, where the dominant male fertilizes her eggs.

The coral reef is often divided into many territories, whose boundaries are invisible to us, but very clearly defined to the resident fish.

North Wall, Grand Cayman, Cayman Islands. Caribbean Sea.
Nikon D2X + 150 mm. 1/250th @ F14

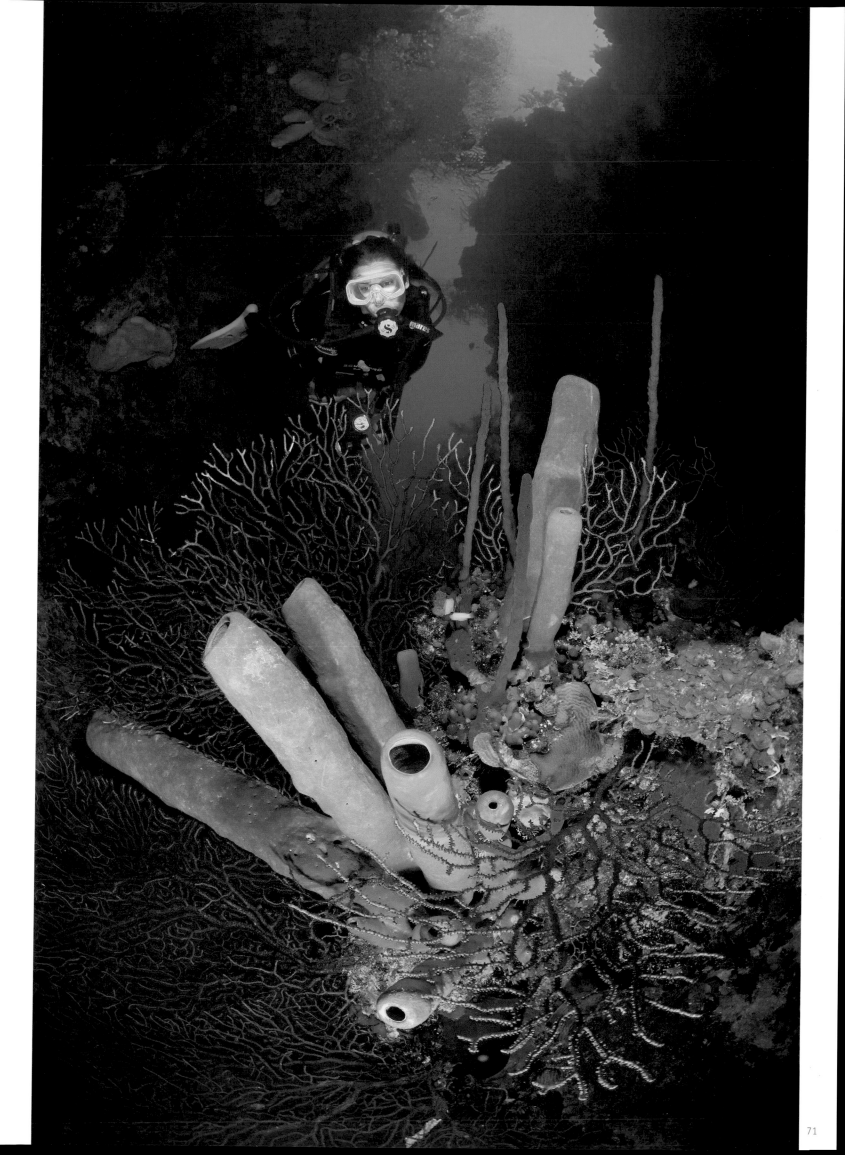

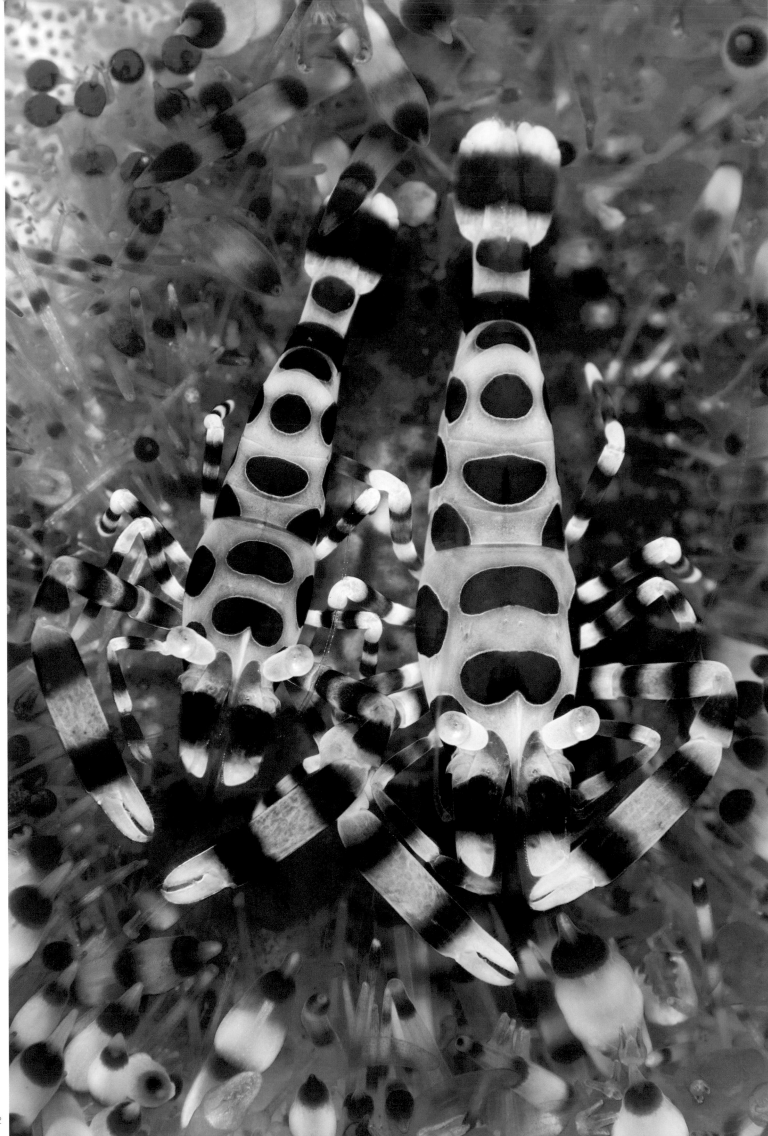

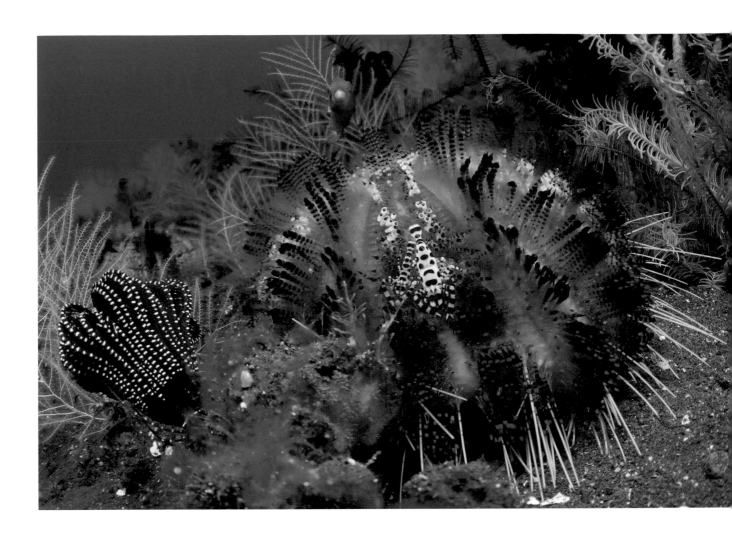

A fire urchin *Asthenosoma varium* with a pair of
Coleman shrimps *Periclimenes colemani*. Fire urchins
are one of the largest and most venomous urchins,
their bright colours a warning of their toxicity. Like
feather stars, they are echinoderms, so-called for
their spine-covered skin.

Seraya, Tulamben area, Bali, Indonesia. Java Sea.
Nikon D2X + 10.5 mm + 1.5x TC. 1/5th @ F8

Coleman shrimps on a fire urchin

A pair of tiny Coleman shrimps *Periclimenes colemani* (2 cm) living commensally on
a fire urchin *Asthenosoma varium*. Reefs are typified by a huge variety of close
interactions between species. This is the sign of a mature ecosystem that has existed
long enough for such complex relationships to evolve. On reefs we find many
commensal species that benefit from living on other species, usually acquiring
protection and sometimes food, but without significant harm, or help, to their host.

This mated pair of Coleman shrimps (the female is the larger) clear a space to live
among the venom-tipped spines of the fire urchin. These shrimps are so
commonly infected with internal parasites that bloat their sides that this parasite-free
pair is considered unusual.

Seraya, Tulamben area, Bali, Indonesia. Java Sea.
Nikon D2X + 105 mm. 1/250th @ F22

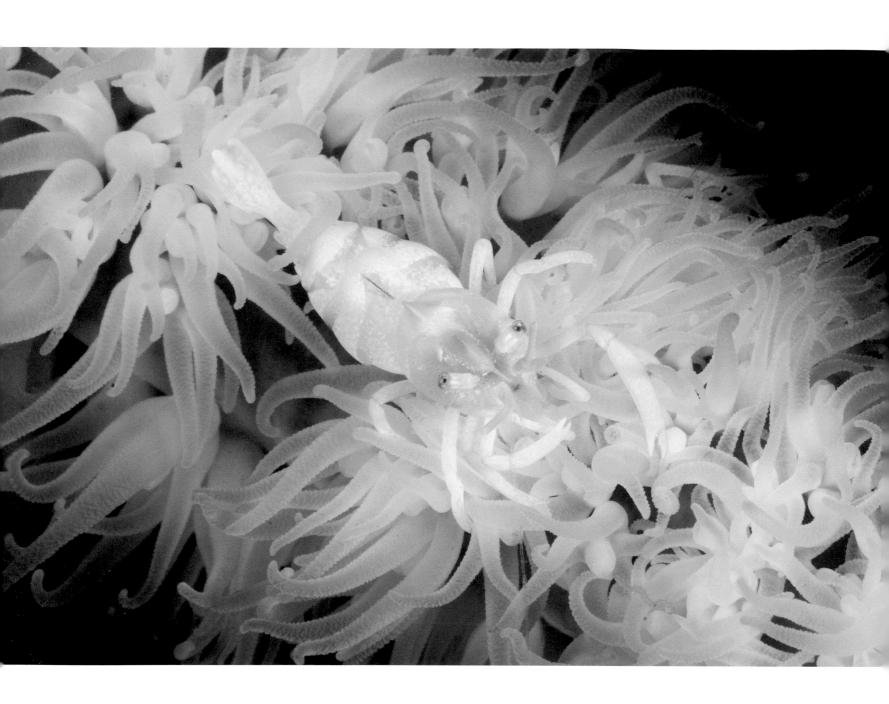

⌃ Whip coral shrimp

A high magnification shot of a white whip coral shrimp *Dasycaris zanzibarica* scuttling along a *Cirripathes* sp. whip coral. This species of shrimp is able to match its colour to the whip coral's for concealment. Whip corals are commonly orange, brown or yellow, but this particularly large colony was white. The colour of the shrimp is determined by the colour of the host it settles on as a larva.

This whip coral shrimp was quite large (1.5 cm), bigger than a thumbnail, and was probably a female, the larger sex.

Misool Island, Raja Ampat, Indonesia. Ceram Sea.
Nikon D2X + 105 mm. 1/250th @ F32

Emperor shrimp on sea cucumber

An emperor shrimp *Periclimenes imperator* explores the alien-looking landscape of its host sea cucumber *Bohadschia argus*. Emperor shrimps are commensals on many hosts, including several species of sea cucumber, starfish and nudibranch. Charmingly, they often feed on the faeces of their host, providing the ultimate recycling facility and an essential service in the reef's ecosystem.

FakFak region, South Bird's Head peninsula,
West Papua, Indonesia.
Nikon D2X + 60 mm. 1/250th @ F16

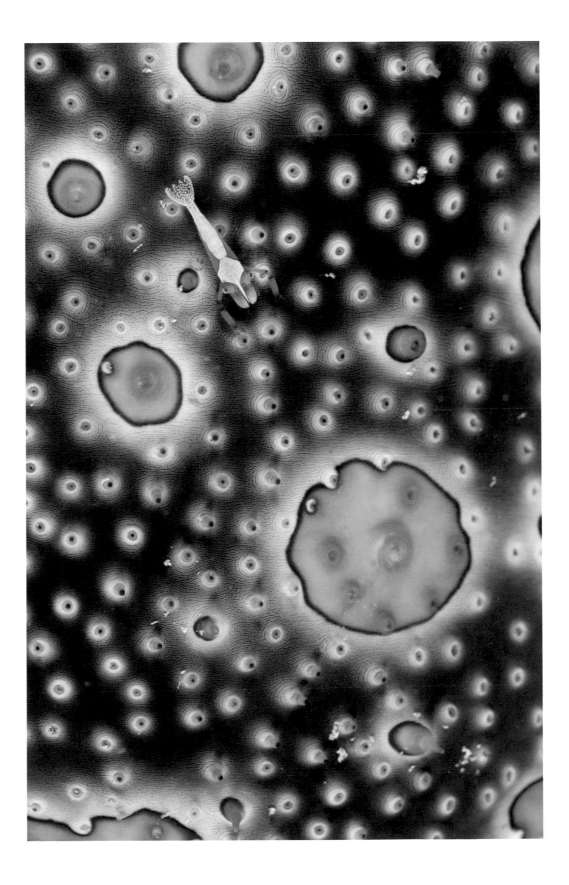

A shrimp *Periclemenes commensalis* explores the arms of its host crinoid. Like many commensal species these shrimps can vary their colours to match their host.

Lembeh Strait, Sulawesi, Indonesia. Molucca Sea.
Nikon F100 + 105 mm. 1/250th @ F16

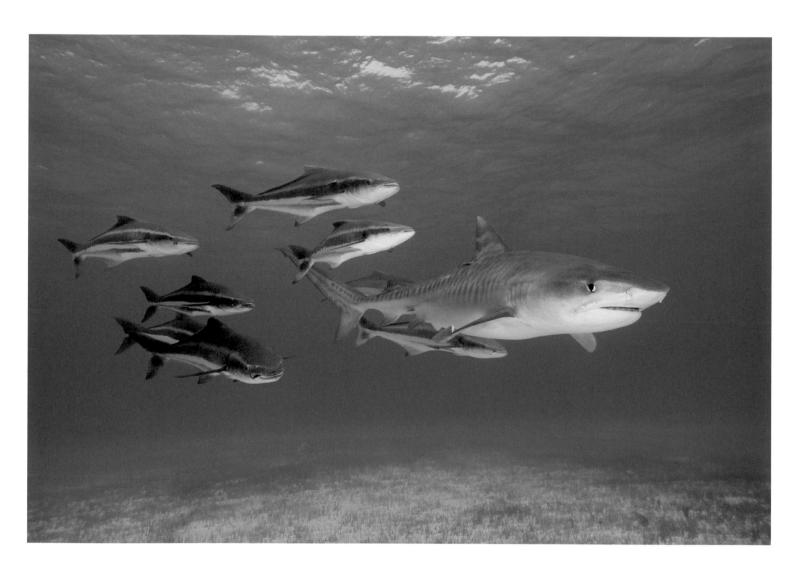

∧ Cobia accompany a tiger shark

Even at the large end of the size scale, species live together: a group of cobia *Rachycentron canadum* accompanies a tiger shark *Galeocerdo cuvier*. Cobia are often mistaken for sharks because of their large size and similar ultra-streamlined shape, but they are not related, and their resemblance is the result of convergent evolution for a fast and efficient swimming predator. The hydrodynamic demands of life in the ocean demand similar designs, and even ichthyosaurs, giant marine lizards that became extinct 90 million years ago, had a similar body structure.

Cobia often accompany large sharks, particularly whale sharks *Rhincodon typus*. These cobia were big (1.5 m) and make this large tiger shark (3.5 m) look smaller than it was.

Little Bahama Bank, Bahamas, West Atlantic Ocean.
Nikon D2X + 12–24 mm. 1/100th @ F10

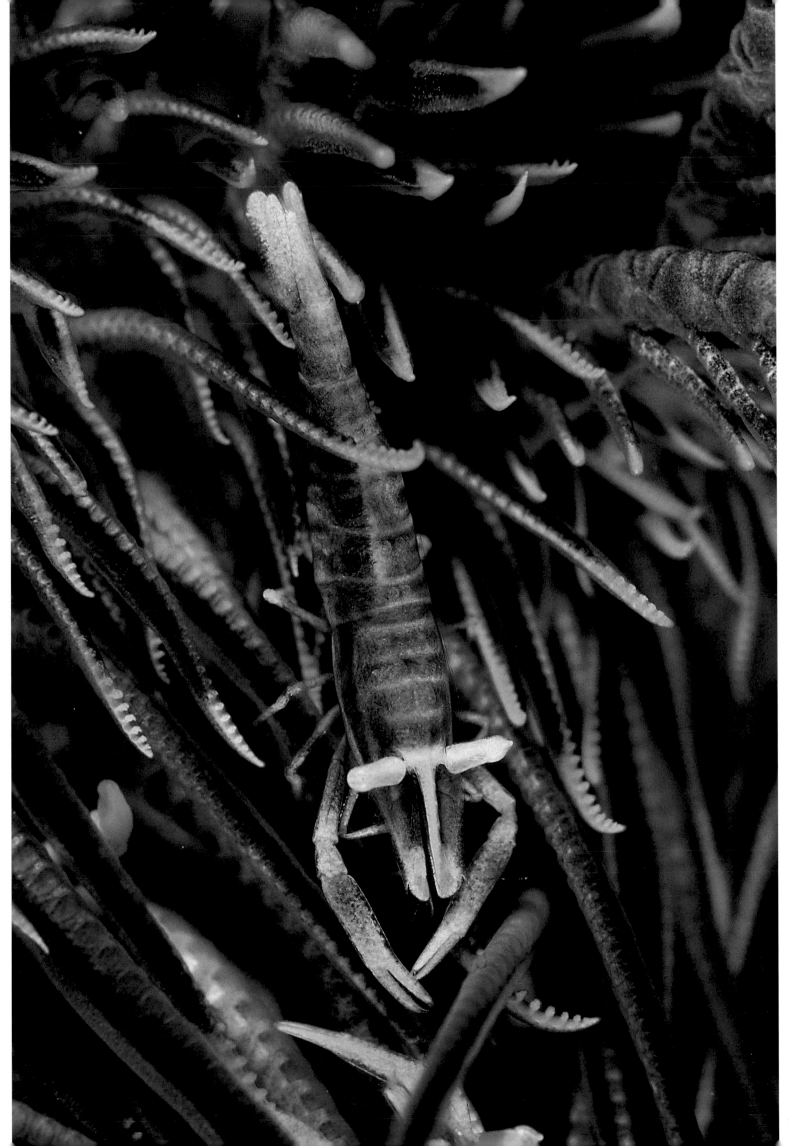

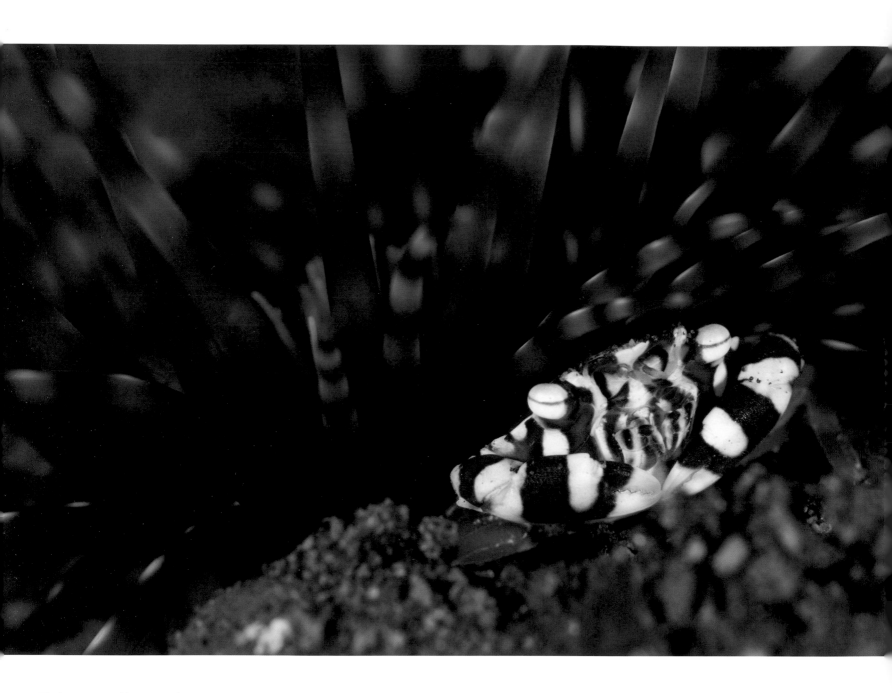

⌃ Tube guardian crab

A tube guardian crab *Lissocarcinus laevis* sits on the sand below the tentacles of its host tube anemone *Cerianthus* sp. Tube anemones can withdraw entirely inside their tubes, often leaving the crabs exposed on the sand, waiting for them to reappear. This crab is found living with a variety of anemones and soft corals.

Seraya, Tulamben area, Bali, Indonesia. Java Sea.
Nikon D2X + 105 mm. 1/250th @ F18

Yellow goatfish

A yellow goatfish *Mulloidichthys martinicus* hovers symmetrically in a current deflected up from the reef. Goatfish feed in the sediment, controlling their long chemosensory barbels independently to root around in the sand and rubble for invertebrate prey. However, the barbels may have another use: I have also seen male goatfish spinning their barbels when trying to attract females.

Although many reef fish have highly evolved feeding adaptations, they will switch strategy to take advantage of fortuitously abundant food. This mixture of specialist and generalist allows reef fish to feed as much as possible while expending the least amount of energy.

West Bay, Grand Cayman, Cayman Islands. Caribbean Sea.
Nikon D2X + 105 mm. 1/60th @ F11

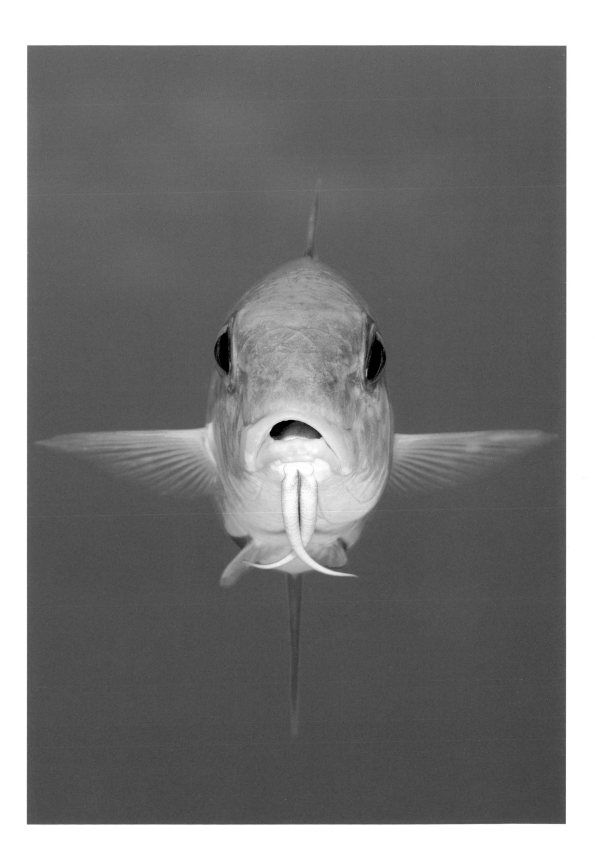

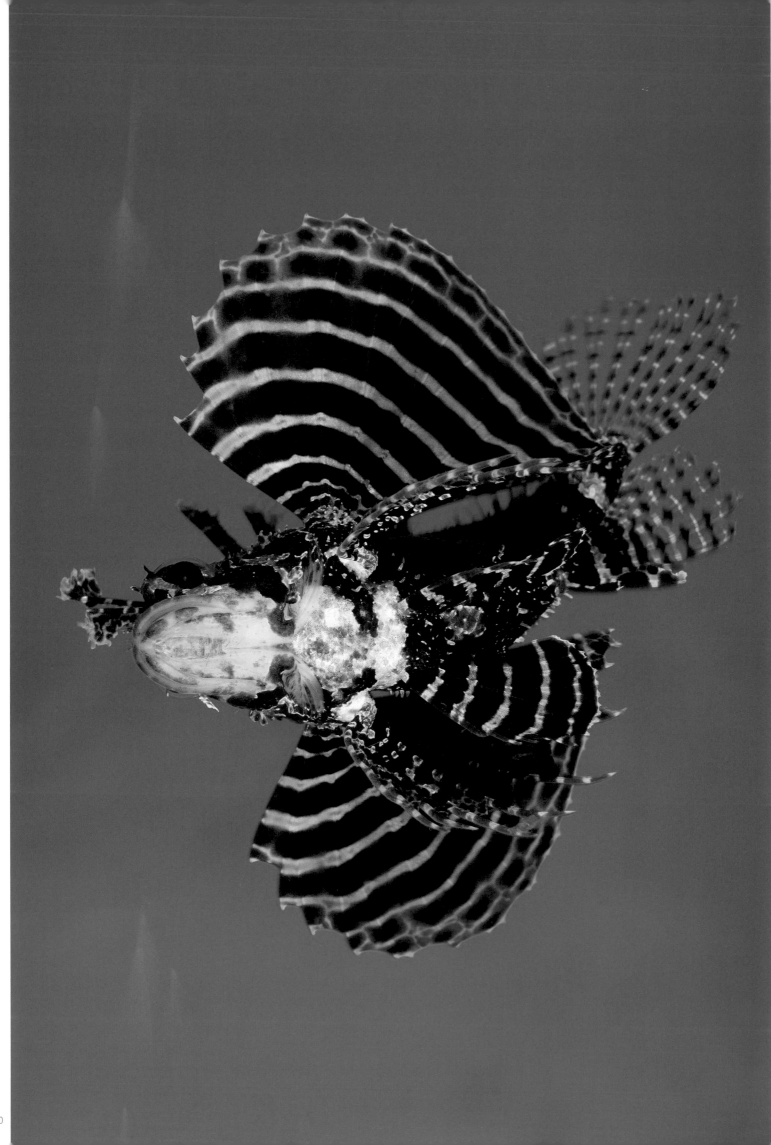

❮ Dwarf lionfish from below

A dwarf lionfish *Dendrochyrus brachypterus* opens its 'wings' (in fact enlarged pectoral fins) as it flits across a small gap of open water. This species generally lives on the seabed and favours coastal reefs. It also seems particularly drawn to man-made structures in the shallows and is common around jetties.

I was able to get this unusual underneath view of this lionfish as it swam between two pylons of an artificial reef in shallow water – they are just out of frame on either side. The beautiful background in this photo does not come from the water, which was a murky grey, but from the blue sky.

Seraya, Tulamben area, Bali, Indonesia. Java Sea.
Nikon D2X + 60 mm. 1/60th @ F14

∧ Needlefish reflection

The reflection of hound needlefish *Tylosurus crocodilus crocodilus* in the underside of a wave. Needlefish are hunters that disguise themselves by hiding just below the surface where their counter-shaded white bellies and thin bodies make them almost invisible against the bright sky. If they have to escape from predators they do so by leaping high out of the water.

Ras Mohammed, Sinai, Egypt. Red Sea.
Nikon D2X + 150 mm. 1/160th @ F5.6

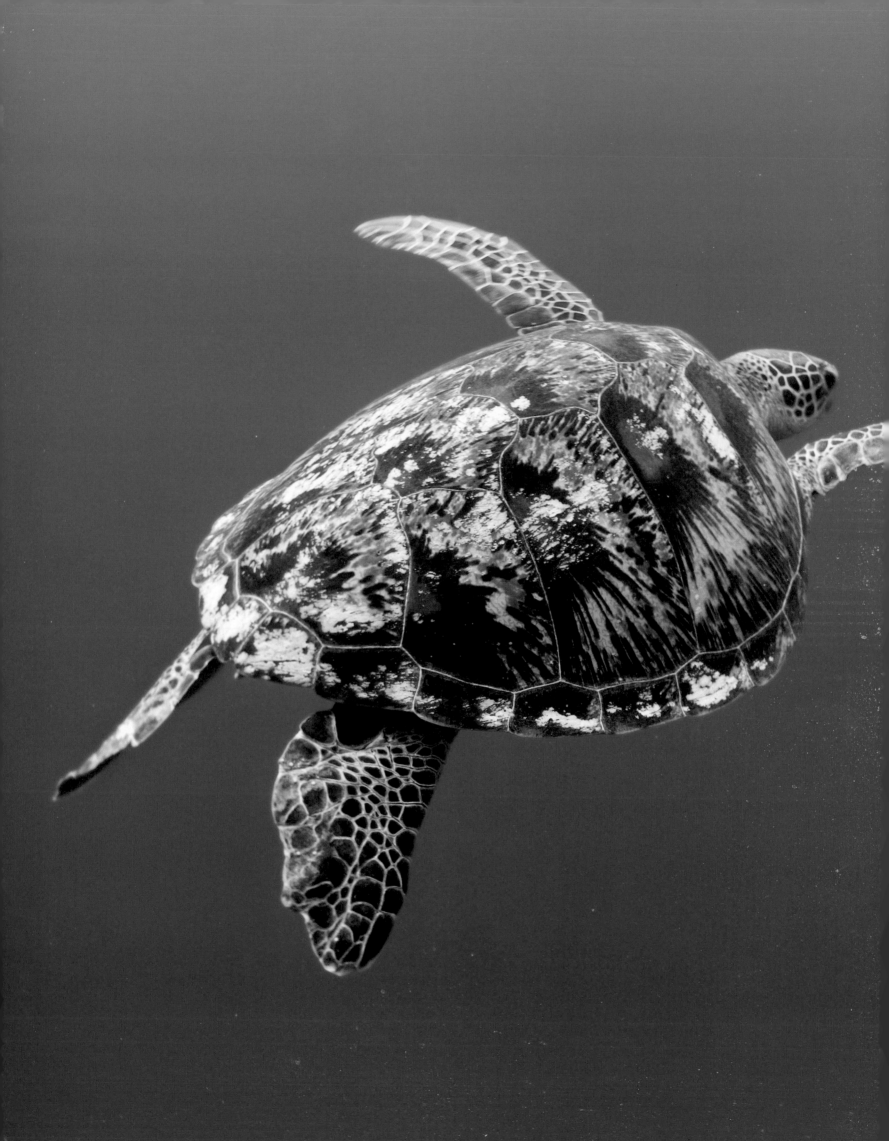

Green turtle in the blue

A female green turtle *Chelonia mydas* glides out into the blue beyond the reef wall at Sipadan Island before heading to the surface for air. Like sea snakes, turtles are descended from land animals that reinvaded the ocean more than 200 million years ago. When they are active, green turtles return to the surface every 10 to 30 minutes to breathe.

Female turtles haul themselves on to beaches at night to lay their eggs in nests they dig in the sand. Female greens probably breed only every 2 to 4 years, but during an active nesting season they will lay between four and seven clutches of eggs. The sex of the hatchlings is determined by the incubation temperature of the eggs while they develop in the sand.

Sipadan Island, Sabah, Malaysia. Sulawesi Sea.
Nikon D2X + 16 mm. 1/150th @ F3.5

Mimic octopus portrait

Officially described by scientists only in 2005, the mimic octopus *Thaumoctopus mimicus* is seen intermittently from New Caledonia, in the west Pacific Ocean, right to the northern Gulf of Aqaba, in the Red Sea.

Mimic octopuses favour shallow sandy or muddy areas, often near small estuaries, where they hunt during the day for small fish and crustaceans.

Puri Jati, Seririt, Bali, Indonesia. Java Sea.
Nikon D2X + 60 mm. 1/80th @ F9

Nudibranch on the move

A small sea slug, the nudibranch *Chromodoris willani*, no bigger than the top of your thumb, explores, searching for food, seemingly oblivious to danger. Nudibranch nonchalance is well founded, as nearly all species are well defended. Nudibranchs gain most of their protection from their food, for example reusing toxins from sponges and stings from hydroids. They are the embodiment of the phrase 'you are what you eat'.

But if you are poisonous it pays to advertise: the nudibranch's bright poster colours and eye-catching patterns deter potential predators. Despite being some of the most beautiful creatures on the reef, nudibranchs lack proper vision and never get to appreciate their own splendour.

Mabul Island, Sabah, Malaysia. Sulawesi Sea.
Nikon D2X + 105 mm. 1/250th @ F29

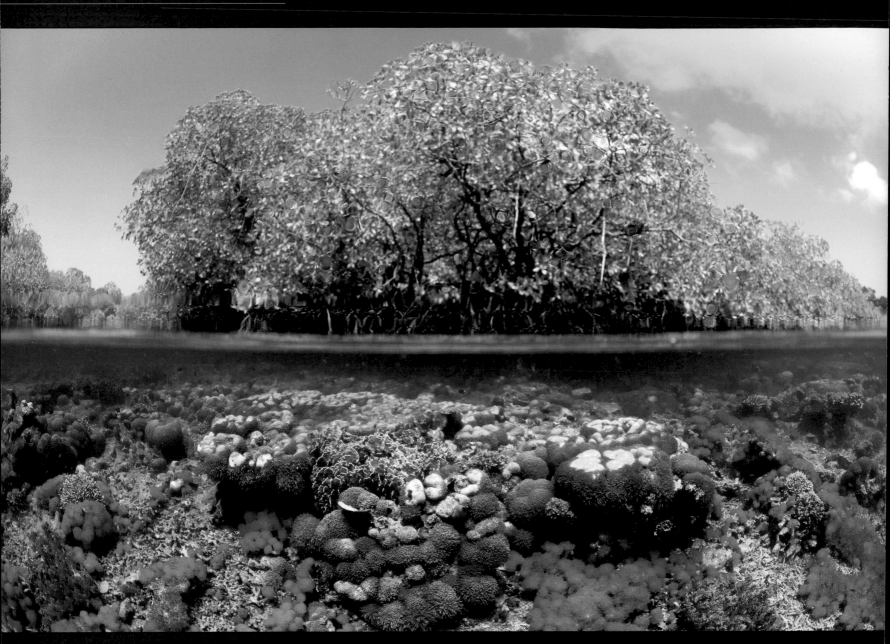

Mangrove roots' reflection

The mangrove forest is based on the adaptation of a number of unrelated tree and plant species to survive with their roots sunk into salt water. Mangrove trees have evolved a variety of rooting solutions to stay anchored in the soft mud and, more importantly, for their roots to get enough oxygen.

This photo shows a mangrove tree with aerial roots, but different species have horizontal cable roots, with upward knee and snorkel-like pencil roots, and downward anchor and nutritive roots. Other species have large buttress roots giving them a wide base in the muddy sediment.

Misool Island, Raja Ampat, Indonesia. Ceram Sea.
Nikon D2X + 12–24 mm. 1/40th @ F4

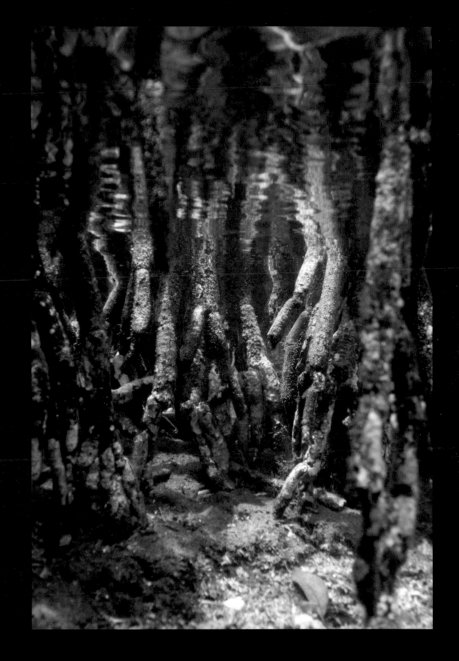

> ## A trio of archerfish

Archerfish *Toxotes* sp. are characteristic of west Pacific Ocean mangroves and are well adapted to this environment, although they swim out to the reef to spawn, to ensure their young are distributed widely.

Archerfish feed on the myriad insects living among the thick foliage of mangroves. They mainly catch them by leaping, but they are also able to shoot insects down by spitting water. Archerfish spit by forming a barrel between their tongue and the roof of their mouth and then snapping their gills closed to shoot a jet of water 2–3 m. Archerfish overcome refraction by either shooting vertically or firing rapidly, changing aim as they go. Older individuals seem to be more skilled at allowing for this bending of light at the surface when they aim.

Misool Island, Raja Ampat, Indonesia. Ceram Sea.
Nikon D2X + 60 mm. 1/40th @ F5.6

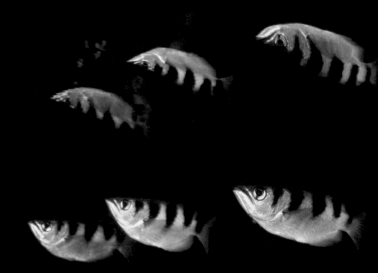

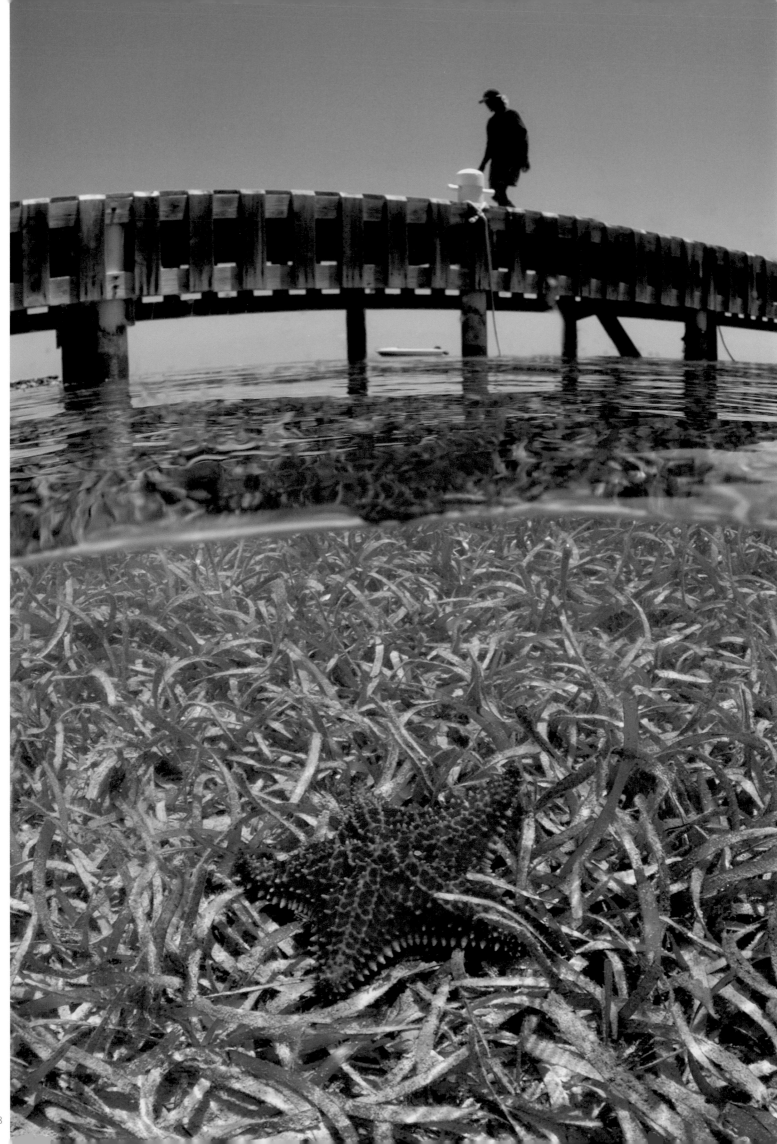

‹ Starfish on a seagrass meadow

A starfish *Oreaster radians* on a shallow seagrass *Thalassia testudinum* meadow around a jetty. Seagrass meadows often develop in the lagoons between the land and fringing or barrier reefs. Like whales, dolphins and turtles, seagrass is an invader from the land that has adapted to life beneath the waves.

Seagrasses are not seaweeds. They are true plants, with roots, leaves, stems and even small flowers and fruit. Like mangroves, seagrass meadows act as a buffer zone between the land and reef, and as a nursery for young fish. Tropical seagrasses grow quickly, and their roots bind sediment, stopping it from smothering reefs.

East End Sound, Grand Cayman, Cayman Islands. Caribbean Sea.
Nikon D100 + 16 mm. 1/100th @ F13

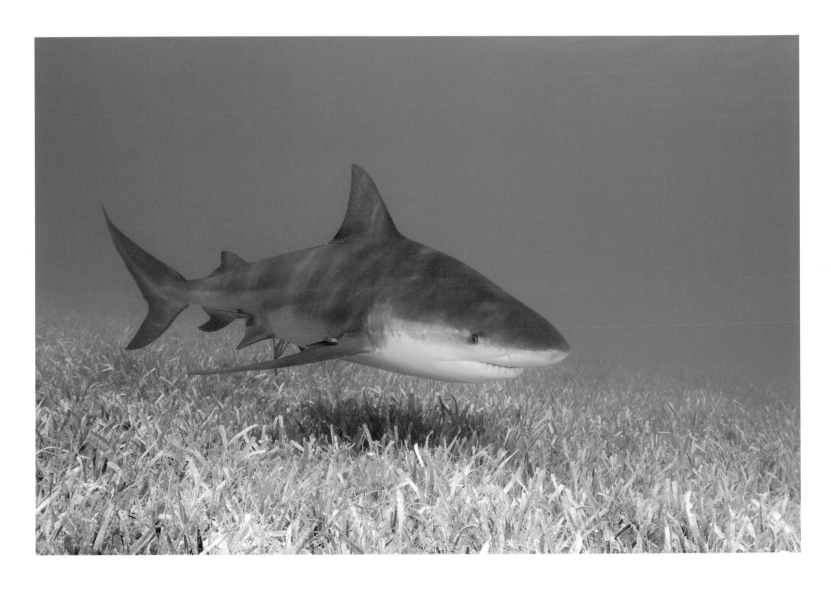

⌃ Bull shark over seagrass

A hefty bull shark *Carcharhinus leucas* (2.5 m) cruises over a seagrass meadow. Bull sharks are powerfully built sharks that inhabit a wide variety of coastal environments in tropical and subtropical waters. I have seen them in both coral reef and seagrass environments, but they are also found in lagoons and are well known for travelling far inland up rivers. I have read that the bull shark has the highest level of testosterone of any animal, although I have not seen this in published data.

Walkers Cay, Bahamas, West Atlantic Ocean.
Nikon D2X + 12–24 mm. 1/160th @ F9

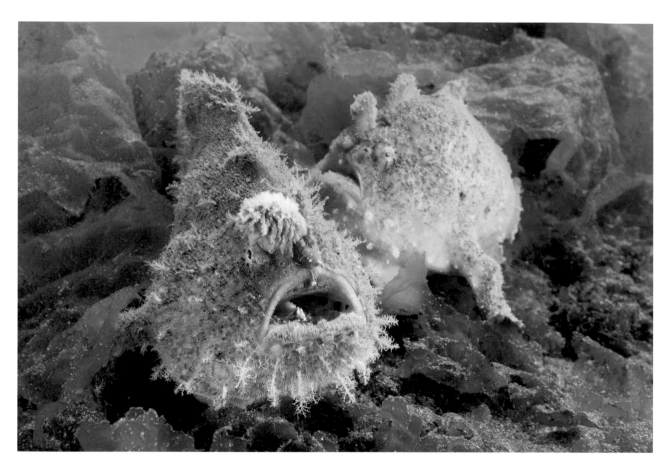

⌃ A pair of frogfish in algae

This pair of frogfish *Antennarius hispidus* are sitting in algae in Gilimanuk Bay in Bali. The small bay is lined with mangroves and supports seagrass meadows, patch reefs and areas of algae all in an area no bigger than a football pitch. In some areas these different ecosystems can be mixed together in a surprisingly small space.

Gilimanuk Bay, Bali, Indonesia. Java Sea.
Nikon D2X + 28–70 mm. 1/15th @ F10

⌐ Soft coral reflections

Soft corals *Dendronephthya* sp. and various species of crinoids are flourishing in very shallow water in the shade at the base of a cliff. Soft corals generally live deeper on reefs or under overhangs, although they can be found right up to the surface where conditions allow.

Kaimana region, South Bird's Head peninsular,
West Papua, Indonesia.
Nikon D2X + 17–55 mm. 1/25th @ F8

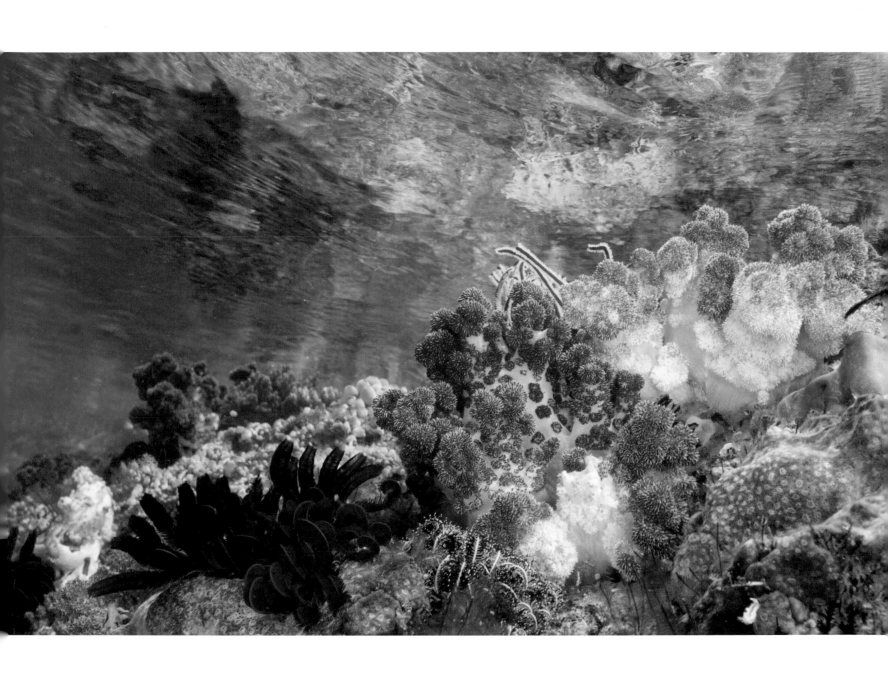

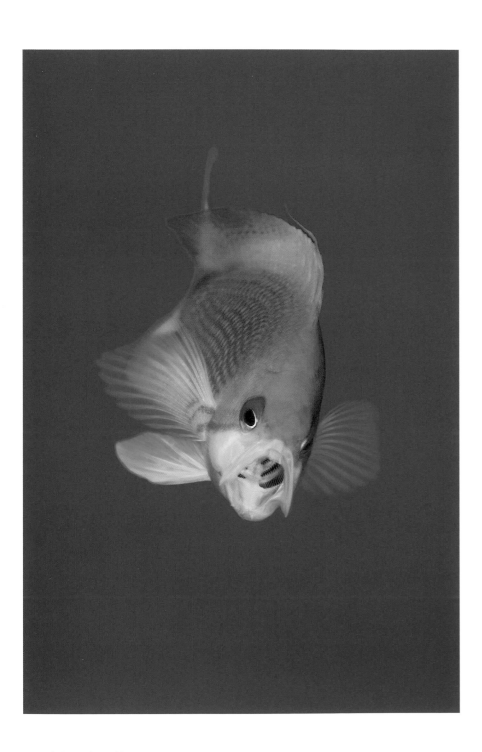

Imagine for a moment that you are drifting out in the blue, beyond the reef. Now imagine that you are smaller than a grain of rice. You are one of the plankton, living suspended in the ocean, your destination controlled by the currents. Suddenly the current shifts and starts washing over the reef. The reef wall supports the densest life, clouds of small fish and thick coral growth – a wall of mouths – all specialized at eating plankton.

The different components of the wall of mouths feed on different-sized plankton: soft corals *Dendronephthya* sp. eat smaller phytoplankton (algae) while the anthias *Pseudanthias squamipinnis* pick crustacean zooplankton. So many fish gather on the reef wall that there is not room for them all to live there, and some have to commute in to feed.

Ras Mohammed, Sinai, Egypt. Red Sea.
Nikon D2X + 10.5 mm. 1/125th @ F5.6

˄ Anthias feeding

A female anthias *Pseudanthias squamipinnis* feeding on zooplankton. Their protrusible mouth enables anthias to engulf their tiny prey and is a feature that evolved independently in other unrelated plankton-feeding fish such as Chromis damselfish. Inside their mouths anthias have closely spaced gill rakers to stop their prey escaping through their gills. Planktivores also tend to have short snouts, which ensures that their eyes are close to the front of their body to give them accurate binocular vision to catch their tiny prey.

Sharm El Sheikh, Gulf of Aqaba, Egypt. Red Sea.
Nikon D2X + 105 mm. 1/160th @ F9

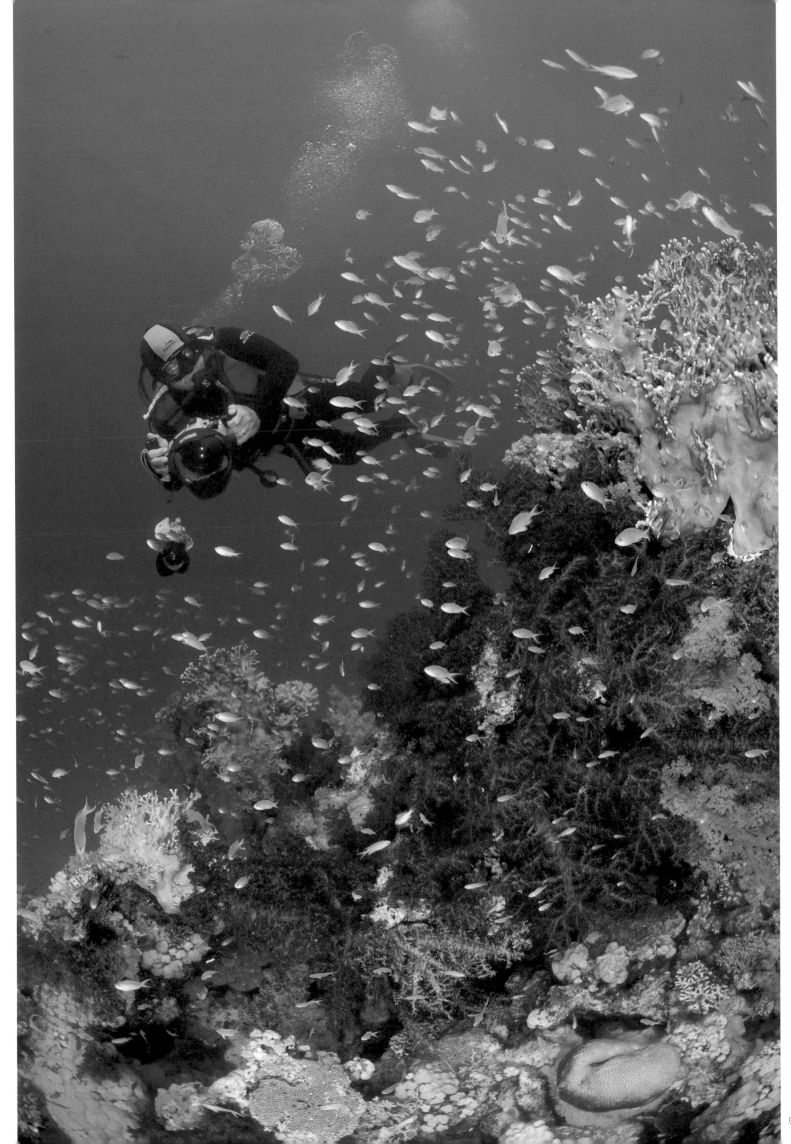

› Stingray and boat

Coral reefs are rarely continuous, even the main section of the Great Barrier Reef is broken into 2,100 separate reefs divided by sandy channels. Most reefs have sandy areas, important components of the wider reef ecosystem.

A southern stingray *Dasyatis americana* glides under a boat on a sandbar in a reef lagoon. Stingrays get their name from a barbed spine, with associated venom gland, on their tail, which is used to defend themselves from sharks. This strategy is not always effective, as one great hammerhead was found with 96 indigestible barbs in its stomach. There are about 340 species of rays worldwide.

North Sound, Grand Cayman, Cayman Islands. Caribbean Sea.
Nikon D2X + 10.5 mm. 1/200th @ F7.1

Mimic octopus on the sand

A mimic octopus *Thaumoctopus mimicus* spreads its arms over the sand. Octopus and cuttlefish are masters of disguise and while many other animals use hormones to change colour slowly over time, these molluscs have nervous control over their appearance and can alter their body size, colour and texture in an instant.

The mimic octopus is thought to take its disguises one stage further and imitate venomous reef creatures as an elaborate anti-predator defence system. Common alleged impersonations include a poisonous sole (flatfish), a free-swimming lionfish and a banded seasnake, achieved by sticking six of its legs down a hole in the sand. Other impersonations have been suggested such as stingrays, jawfish, sand anemones, crinoids, cuttlefish, jellyfish, but most seem due to over-imaginative observers.

Puri Jati, Seririt, Bali, Indonesia. Java Sea.
Nikon D2X + 60 mm. 1/125th @ F11

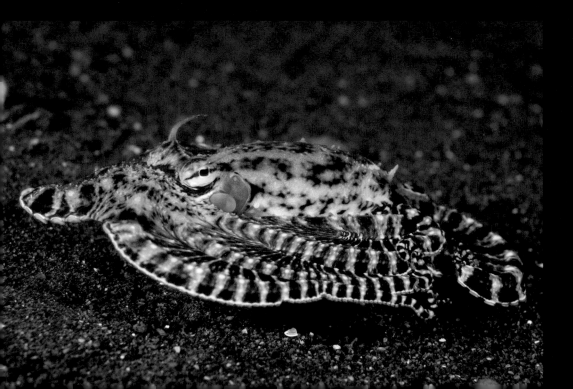

Mimic or gimmick?

I have spent many dives watching the mimic octopus and I remain unconvinced by the dynamic mimicry story. The octopus is clearly capable of rapid and amazing changes to its appearance – both in shape and colour – but these seem fairly random and specific shapes are rarely stable for long. Most examples of mimicry in nature are very accurate – at no point watching this octopus do you confuse it with a lionfish or seasnake. Furthermore, many of the quoted resemblances are often accentuated in photos because of the exact timing or angle of the picture.

I believe that the well-known poisonous sole impersonation, seen in this picture, seems more to do with swimming hydrodynamics than mimicry, and it is a posture seen to various degrees in other octopuses. My opinion is that the other elaborate displays of the octopus are a warning, like the blue rings of *Hapalochlaena*. Most octopuses have a degree of toxicity in their venom, maybe the mimic is warning us of a particularly potent one.

Puri Jati, Seririt, Bali, Indonesia. Java Sea.
Nikon D2X + 60 mm. 1/80th @ F9

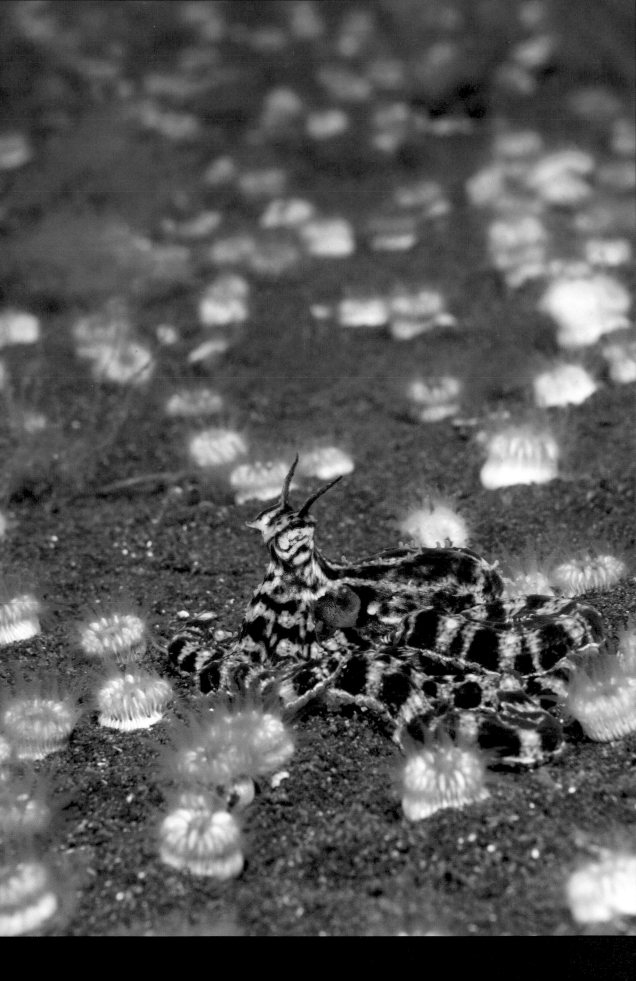

Mimic octopus

A mimic octopus *Thaumoctopus mimicus* rests on the
seabed close to its hole in the heart of its territory.

Puri Jati, Bali, Indonesia. Java Sea.
Nikon D2X + 60 mm. 1/40th @ F13

A shrimp–goby partnership

The odd couple: a goby *Amblyeleotris* sp. and a small shrimp *Alpheus bellulus* live together in a burrow close to the reef. This symbiotic partnership exists between more than 70 species of goby and many species of *Alpheus* shrimps, in both the Indo-Pacific and the Atlantic regions.

The shrimps are charged with maintaining the sizeable burrow (50 cm or more) – the goby rarely lifts a fin to help. The goby's job is to keep a look out: its eyes, set high on its head, can be rotated independently. The goby communicates danger to the shrimp, which has poor eyesight, by flicking its tail. Whenever the shrimp leaves its hole to excavate sand, it always keeps an antenna in contact with the goby to pick up these messages.

FakFak region, South Bird's Head peninsular, West Papua, Indonesia.
Nikon D2X + 150 mm. 1/250th @ F9

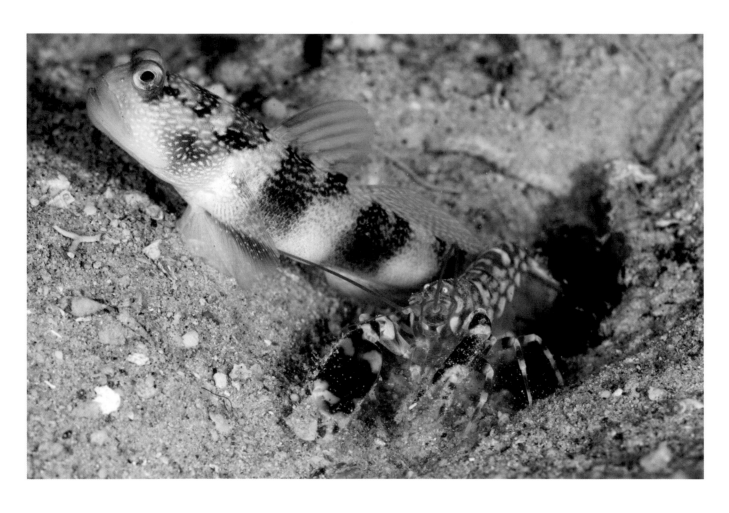

Stargazer face in the sand

A stargazer's face *Uranoscopus* sp. is framed in the sand like a Balinese mask. Stargazers are fish that bury their surprisingly bulky body in the sand, waiting to ambush prey. Usually just their ghastly face is exposed, with their large upward-facing mouth disguised by slender tentacles, called cirri, that look rather like teeth.

In case their ugly features are not enough to dissuade predators, stargazers have a single, large venomous spine behind each gill cover and an electric-shock producing organ above each eye. Some species of temperate-water stargazers waggle their tongues out of their mouth to attract their prey.

Puri Jati, Seririt, Bali, Indonesia. Java Sea.
Nikon D2X + 60 mm. 1/165th @ F14

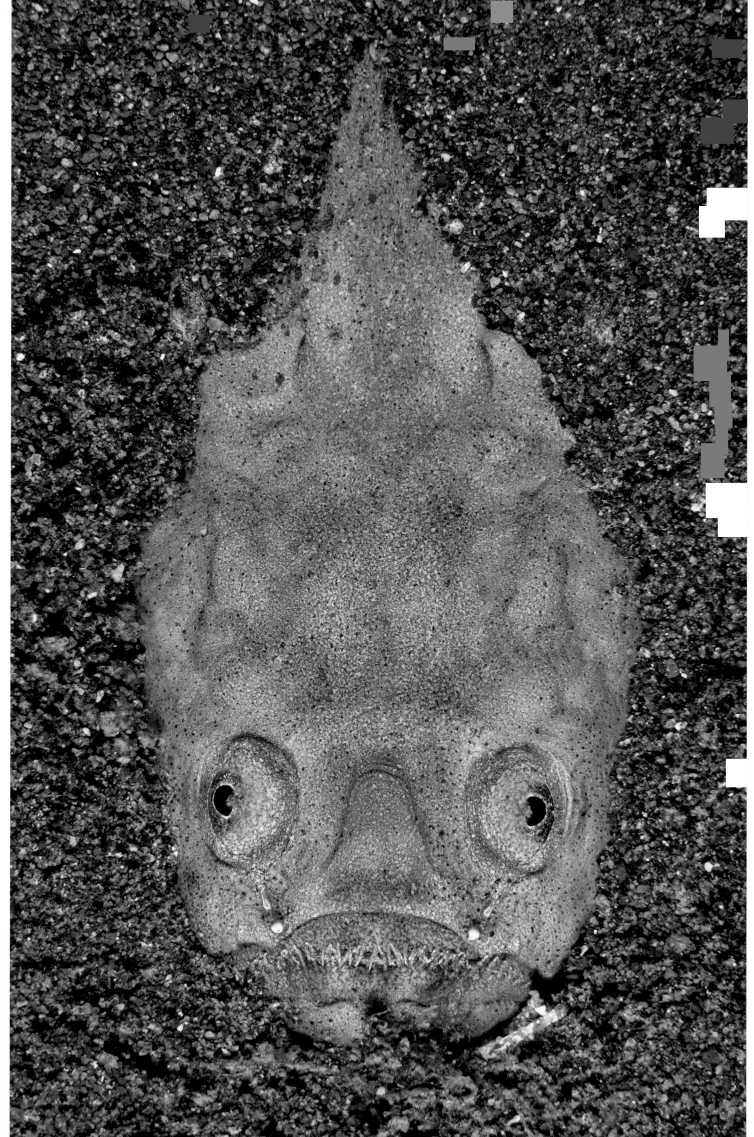

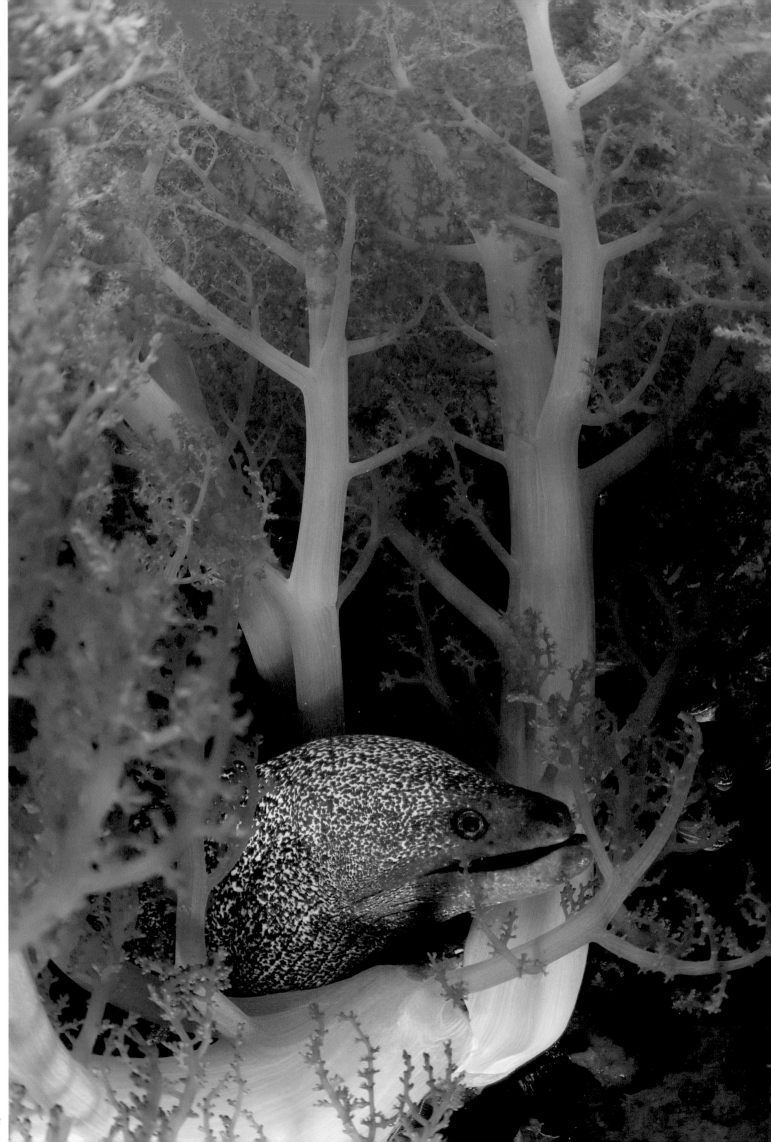

Sand ripples at dusk

Sandy areas vary from small pockets of sand in depressions in the reef to large plateaus between patch reefs. Reefs are also cut with sand channels; these rivers of sand often look immobile, but during large storms they 'flow', transporting large volumes of calcium carbonate sand over the drop off and into deep water.

Sand flats are often textured with ripples, and at first glance can appear lifeless, but they are transformed at night when many creatures emerge to forage under the cover of darkness.

North Sound, Grand Cayman, Cayman Islands. Caribbean Sea.
Nikon D2X + 10.5 mm. 1/80th @ F8

Marbled snake eel

A marbled snake eel *Callechelys marmorata* erupts from the sand. Snake eels are nocturnal hunters that emerge from their burrows to hunt on the open sand at night. Snake eels have long cylindrical bodies and pointed tails, which help them to burrow into the sand. I photographed this individual on a dusk dive in the Red Sea, where it suddenly popped up out of the sediment, disturbing a cloud of sand.

Nuweiba, Gulf of Aqaba, Egypt. Red Sea.
Nikon D2X + 105 mm. 1/80th @ F14

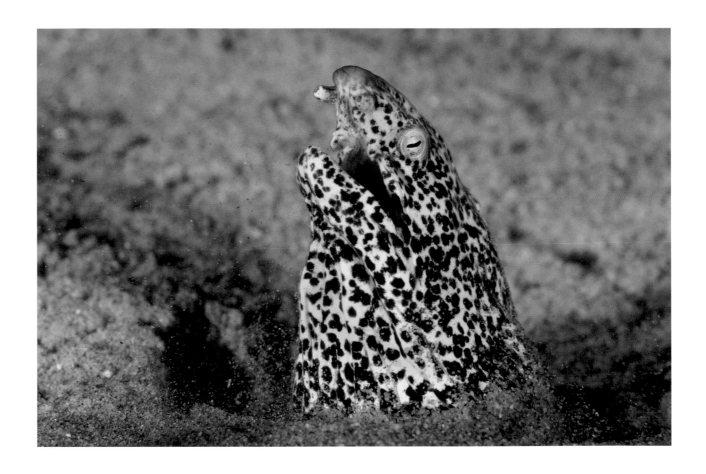

< A moray eel in soft corals

Although it is the stony corals that construct the reef, all the sessile invertebrates contribute to the complex biological structure, creating micro-habitats for many species. Soft corals, for example, do not create a solid record in reef construction, but still generate important habitat, in this case for a moray eel *Gymnothorax flavimarginatus*.

Nuweiba, Gulf of Aqaba, Egypt. Red Sea.
Nikon D2X + 10.5 mm + 1.5x TC. 1/20th @ F9

A ribbon sweetlips hovering

This ribbon sweetlips *Plectorhincus polytaenia* (45 cm) hovers in the current flushing through the wreck of USAT *Liberty*. Many three-dimensional structures seem to attract or aggregate fish. Add a bit of current to a jetty, a shipwreck or a natural reef and you can expect it to be packed with fish.

Sweetlips get their name from their thick, pouting lips, which help them feed on their diet of benthic invertebrates and small fish.

Tulamben Bay, Bali, Indonesia. Java Sea.
Nikon D2X + 105 mm. 1/25th @ F7

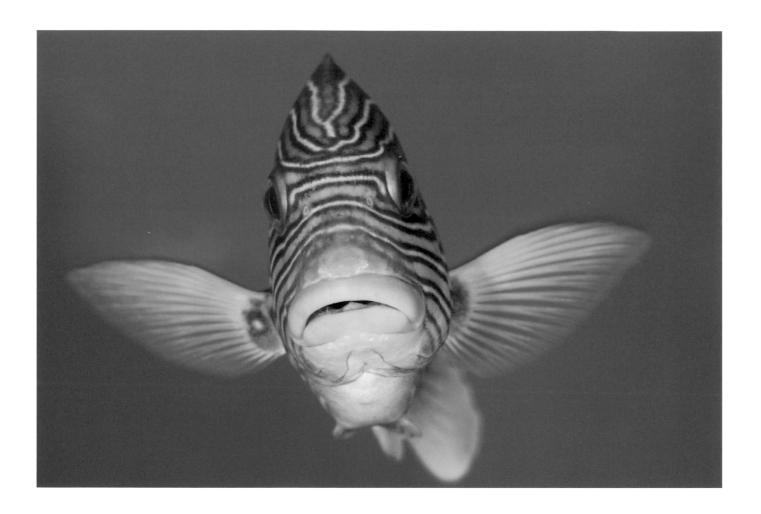

Regal demoiselles and soft corals

A school of regal demoiselles *Neopomacentrus cyanomos* pick plankton in front of lush soft corals. This is another example of the wall of vertebrate and invertebrate mouths waiting for plankton on the face of reefs exposed to corals. As I moved closer and the demoiselles felt threatened, they retreated and hid in the dense blanket of soft corals.

Kaimana region, South Bird's Head peninsular, West Papua, Indonesia.
Nikon D2X + 12–24 mm, 1/25th @ F7

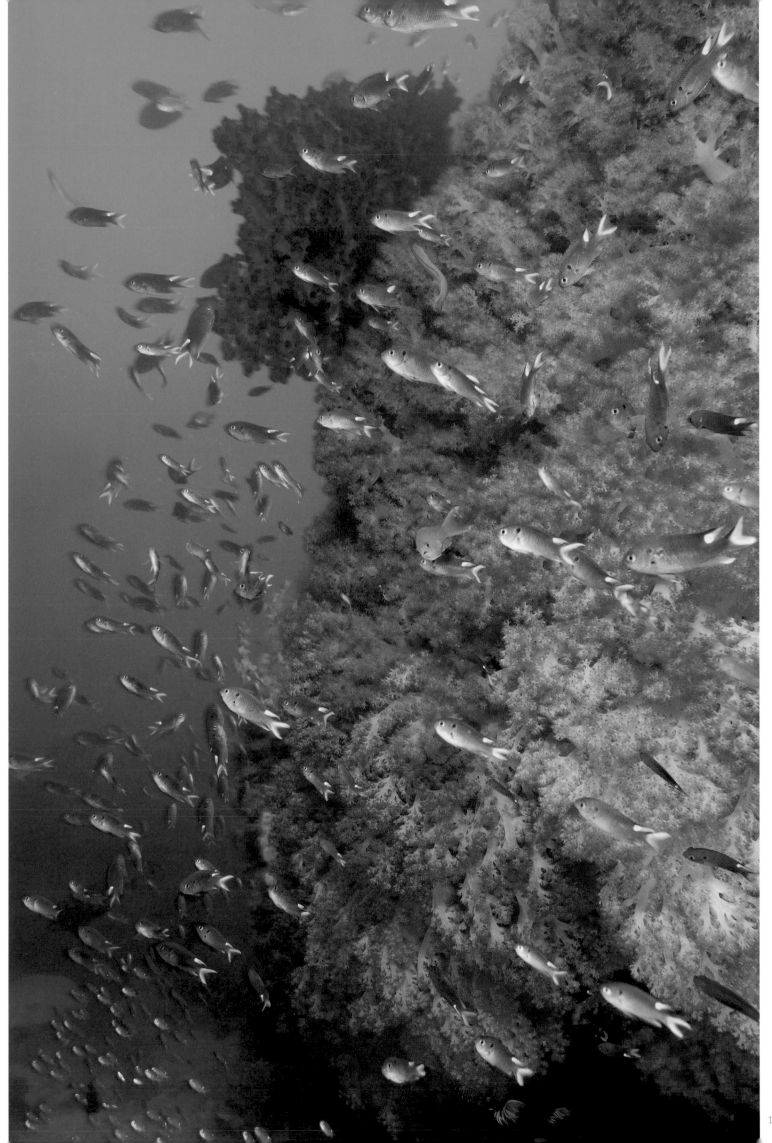

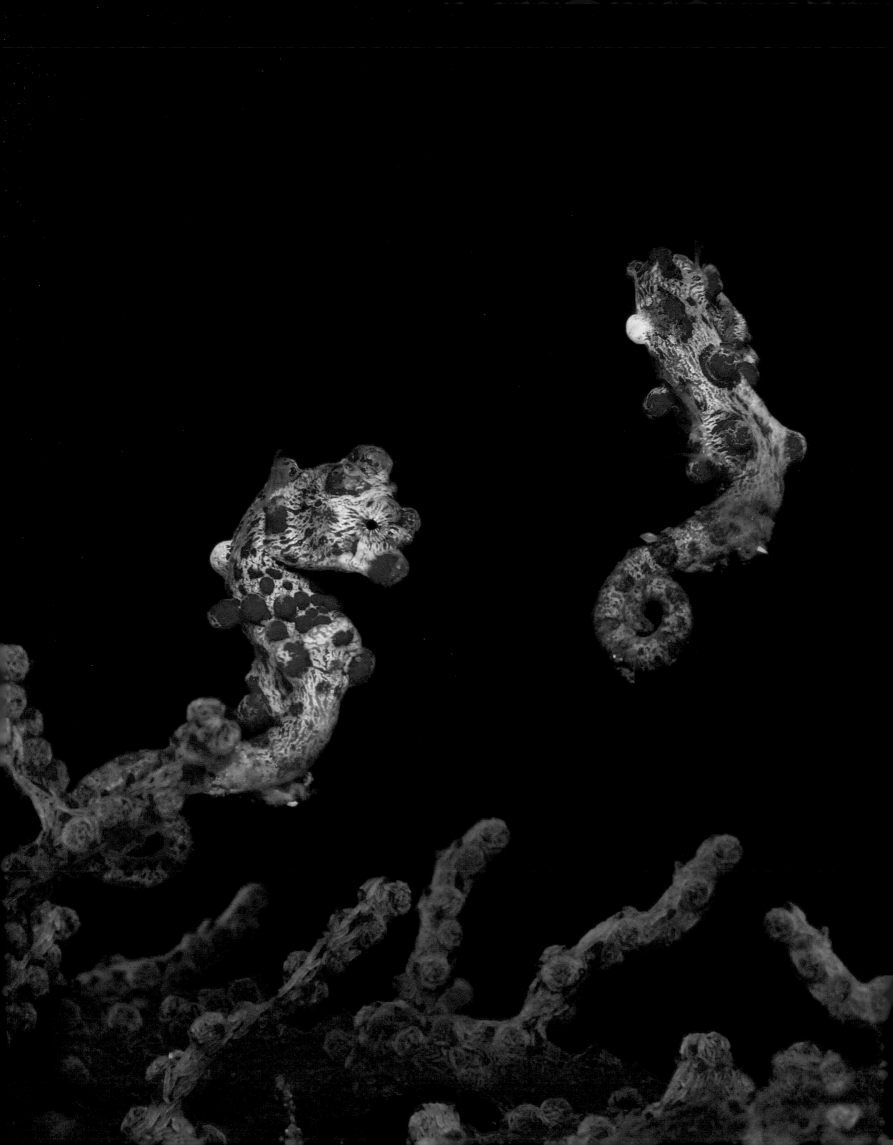

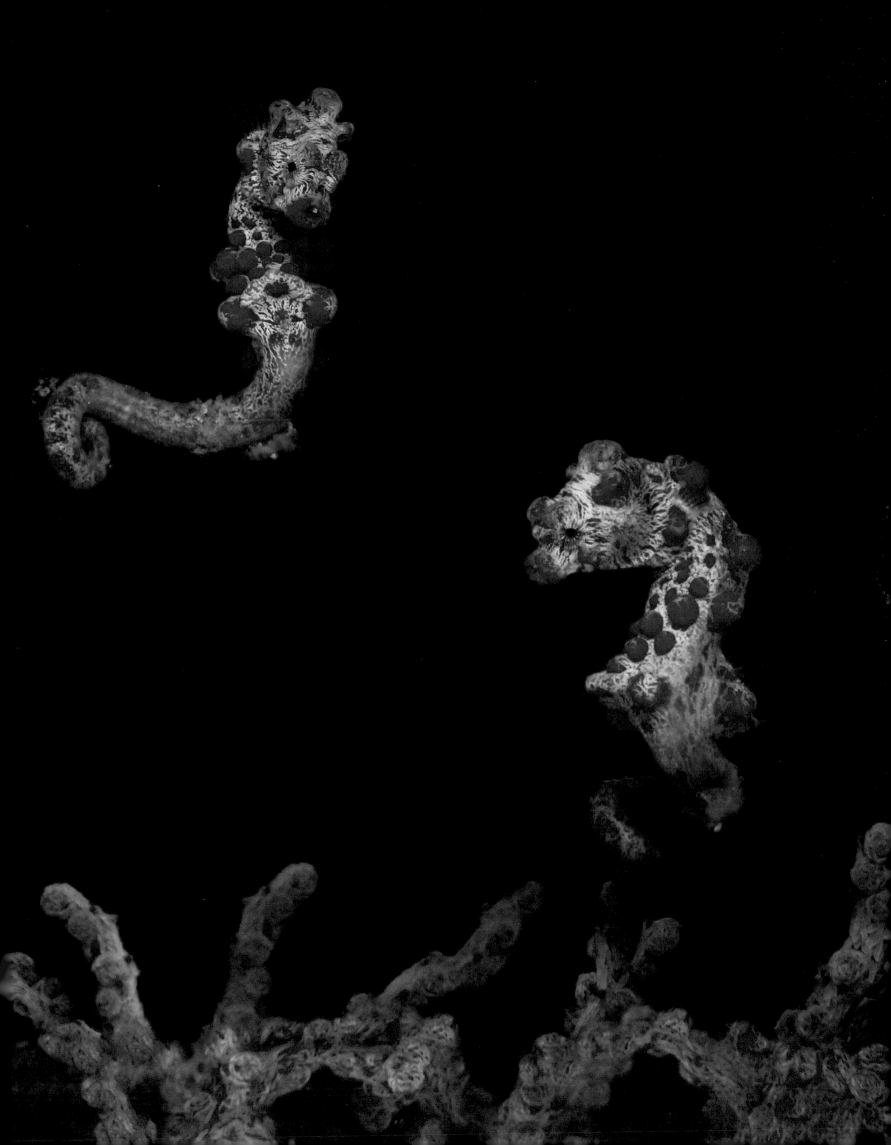

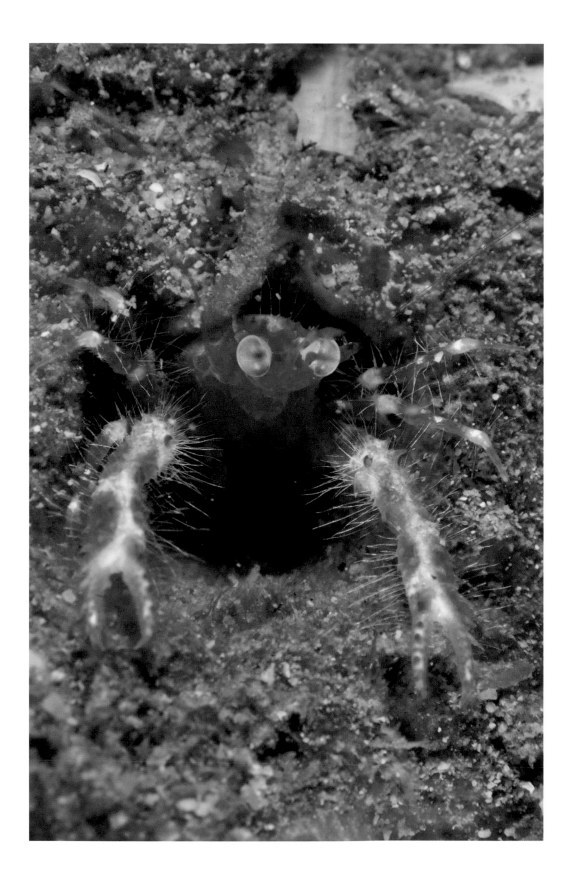

‹‹ Pygmy seahorse swims across a seafan

This composite photo shows four images of the same pygmy seahorse *Hippocampus bargibanti* as it swims from and reattaches to its host gorgonian seafan *Muricella plectana*. This species of pygmy seahorse is adapted to live specifically on this genus of seafan and its body is covered with tubercles that resemble the coral's polyps, creating superb camouflage. Two colour varieties are found: this one, with red lumps and another with yellow lumps, both closely matching the colour of their *Muricella* fans.

Pygmy seahorses are usually found in pairs, often with several pairs on a single fan. Originally thought to be restricted to just a few locations, they are now known to be distributed widely through the tropical west Pacific, from Malaysia in the west to Japan in the north and New Caledonia in the east.

Lembeh Strait, Sulawesi, Indonesia. Molucca Sea.
Nikon D100 + 105 mm, 1/180th @ F38 [m]

› Spanish dancer nudibranch

A Spanish dancer nudibranch *Hexabranchus sanguineus* crosses the reef in the late afternoon. The Spanish dancer is the largest reef sea slug, growing to over 60 cm, and is usually nocturnal. It gets its name from its ability to swim, where its flamboyantly undulating body looks like the skirt of an Andalusian flamenco dancer.

I have once seen a Spanish dancer swimming naturally, but usually they are persuaded to swim by being lifted up by divers. While this rarely harms the nudibranch it is not a practice to be encouraged.

Nuweiba, Gulf of Aqaba, Egypt. Red Sea.
Nikon D2X + 10.5 mm + 1.5x TC. 1/15th @ F10

∧ Squat lobster

An unusual squat lobster *Munida olivarae* peers out from a hole in the reef. The complex structure of the reef provides a wealth of micro-habitats that promote diversity. The burrow of this squat lobster was dug into consolidated sediment, under an overhang on a coastal fringing reef.

FakFak region, South Bird's Head peninsular, West Papua, Indonesia.
Nikon D2X + 105 mm, 1/250th @ F25

^ An oceanic sunfish

An oceanic sunfish *Mola mola* is a visitor to coral reefs in search of a cleaning station. Several large pelagic species, including scalloped hammerhead and manta rays, visit coral reefs to have parasites removed. In the Lombok Strait sunfish visit the reefs and are cleaned by bannerfish *Heniochus acuminatus* and emperor angelfish *Pomacanthus imperator*.

Mola mola are the heaviest bony fish in the world, a 3.1 m long, 4.2 m high individual holding the record at 2.2 tonnes. They also produce the most eggs of any vertebrate; a small 1.4 m female had over 300 million eggs. *Mola mola* are related to the reef's pufferfish and triggerfish and are surprisingly fast swimmers.

Nusa Penida Island, Lombok Strait, Indonesia. Indian Ocean.
Nikon D2X + 16 mm, 1/20th @ F7.1

< Nudibranch glides over coral

A nudibranch *Glossodoris atromarginata* glides over *Porites* coral while searching for its favoured food, sponges, which it devours with its scraping toothy tongue-like radula. This species is widespread over much of the Indo-Pacific region. The two horns at the front of its body are called rhinophores, which are chemosensory.

This species, like many sea slugs, defends itself by chemically converting toxic compounds from the sponges it eats and transferring them to the skin on its back. At least one closely related species *Glossodoris hikuerensis* can secrete a defensive chemical slime when harassed, to ward off predators.

Misool Island, Raja Ampat, Indonesia. Ceram Sea.
Nikon D2X + 150 mm, 1/100th @ F10

CLEANING STATIONS

⌄ Cleaner wrasse and anthias

A young cleaner wrasse *Labroides dimidiatus* attends to a female anthias *Pseudanthias squamipinnis*. Symbiotic cleaning is quintessentially aquatic. On land there are few examples of dedicated cleaning relationships between species, but underwater, and particularly on the reef, cleaning is ubiquitous. The average cleaner wrasse sees 2,000 clients each day.

The basic deal is simple. Client fish are cleaned of parasites, dead skin and loose scales. Cleaner fish benefit from a reliable food supply, delivered direct to their door, and some immunity from predation – at least during the day. Cleaners are much more vulnerable at night and some cleaning wrasse sleep in mucous cocoons for protection.

Cleaner wrasse live in harems, with a single large male and several females, this individual is still a juvenile. Should the male die, the largest female will change sex and take over the harem.

Strait of Gubal, Gulf of Suez, Egypt. Red Sea.
Nikon F100 + 105 mm, 1/250th @ F11

> Cleaning goby on glasseye snapper

A cleaning goby *Gobiosoma genie* tends to a glasseye snapper *Heteropriacanthus cruentatus*. On Atlantic reefs, gobies are important cleaners. Although the benefits of cleaning seem obvious enough, scientists have struggled to show that cleaning actually makes any difference to the health of the reef community, and some even argue that this symbiosis is closer to parasitism than mutualism.

This certainly seems at odds with what we see underwater, where client fish seem so willing for the service. If an Atlantic reef fish is kept in the aquarium it quickly learns to use Indo-Pacific cleaner wrasse despite never encountering one in the wild.

East End, Grand Cayman, Cayman Islands. Caribbean Sea.
Nikon D2X + 105 mm, 1/125th @ F14

Cleaner wrasse in the mouth of a sweetlips

A cleaner wrasse *Labroides dimidiatus* works inside the mouth of a ribbon sweetlips *Plectorhinchus polytaenia*. In all nature creatures are fiercely competitive, always on the lookout to get one up on other species and to exploit every advantage. A classic example in cleaning symbiosis is the false-cleaner blenny, which is almost indistinguishable from a cleaner wrasse and uses its bogus identity to sneak up on fish before nipping out chunks of healthy flesh!

In truth the standard cleaner wrasse is not so angelic, and studies have shown that it too prefers eating healthy fish skin and scales to picking parasites. On the USAT *Liberty* wreck in Tulamben, the cleaner wrasse have gone further still, and have learned to nip at the ears of passing divers to get a free meal – I have been bitten twice!

Tulamben Bay, Bali, Indonesia. Java Sea.
Nikon D2X + 105 mm, 1/25th @ F7.1

Cleaner shrimp walks into the mouth of a grouper

A Pederson's cleaning shrimp *Periclemenes pedersoni* walks into the open mouth of a Nassau grouper *Epinephelus striatus* to pick parasites. The mouths and gills of fish are often targeted by parasites because they are rich in blood. The small size of many cleaners enables them to reach these parts.

Many invertebrates, particularly shrimps, are prolific cleaners. This species advertises its presence to potential clients by rhythmically beating its long white antennae. Cleaner wrasse have a distinctive bobbing dance for the same reason.

George Town, Grand Cayman, Cayman Islands. Caribbean Sea.
Nikon D2X + 105 mm, 1/80th @ F7.1

Stonefish in the rocks

A stonefish *Synanceia verrucosa* sets an ambush in the rocks. Camouflage is crucial for an ambush hunter. Stonefish look like a lump of coral or rock and are far removed from a recognizable fish shape. The disguise of the stonefish is further enhanced by marine growth on its scaleless skin. It strikes with its cavernous mouth, on the left in this photo, engulfing its prey in just 15 milliseconds.

The stonefish is protected by 13 sharp dorsal spines that inject a very powerful venom, the strongest of all fish. Unlike other scorpionfish, whose spines are coated in toxins, the stonefish has hollow spines, each connected to a sac of venom. Stonefish stings are very serious and can even kill people. Recovery can take several months, and although an antivenom was developed in 1959, it is not available in most diving resorts.

Seraya, Tulamben area, Bali, Indonesia. Java Sea.
Nikon D2X + 10.5 mm + 1.5x TC. 1/15th @ F8

Lionfish hunting

A lionfish *Pterois volitans* is a study of concentration as it hunts. Lionfish stalk their prey slowly, usually with their large pectoral fins splayed. Perhaps this very unfishlike shape is camouflage or simply the fins act to corral prey.

Once close enough the lionfish strikes by pulling its fins back, sending it shooting forward to engulf a small fish. This lionfish was photographed on a shallow, silty reef, hence the green-tinged water.

Salawati Island, Raja Ampat, Indonesia. Ceram Sea.
Nikon D2X + 105 mm. 1/20th @ F9

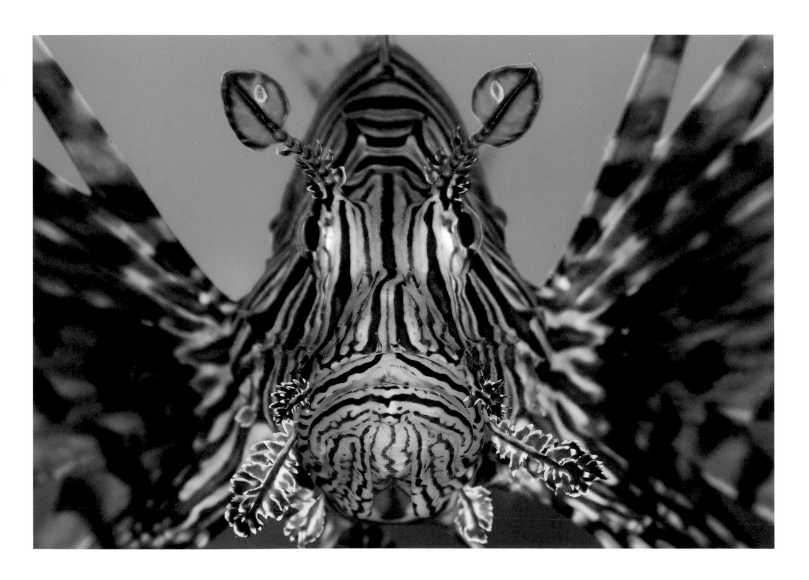

> Yellow frogfish

A yellow frogfish *Antennarius maculatus* is arguably the perfect reef ambush predator. Frogfish have amazing camouflage, aggressively mimicking sponges even to the point of having dark, circular false sponge-siphons on their bodies. Frogfish come in a variety of colours and can change colour in a couple of weeks, if required, to match a particular host sponge.

Their first dorsal fin spine is modified into a fishing lure, which they waggle to attract prey. Frogfish strike even faster than the stonefish – just 6 milliseconds.

Seraya, Tulamben area, Bali, Indonesia. Java Sea.
Nikon D2X + 105 mm. 1/250th @ F29

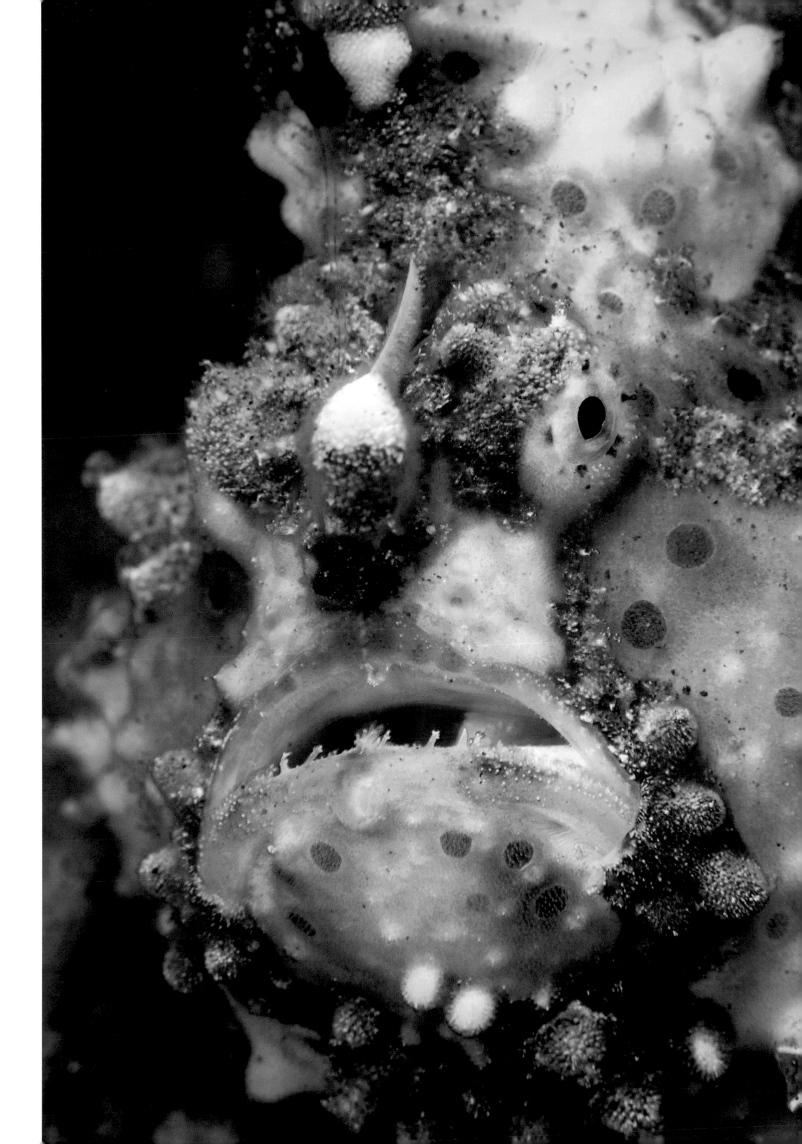

Wobbegong shark with cardinal fish

An elaborately patterned wobbegong shark *Eucrossorhinus dasypogon* with unidentified cardinal fish *Apogon* sp. The unusual appearance of the wobbegong really challenges our mental image of sharks. These carpet sharks forage at night, and in the day ambush small fish that wander too close.

The wobbegong's disruptive markings break up its outline in a similar way to military camouflage patterns. The head of the shark is also covered in branching flaps of skin that further enhance the illusion.

Kaimana region, South Bird's Head peninsular,
West Papua, Indonesia.
Nikon D2X + 17–55 mm. 1/20th @ F8

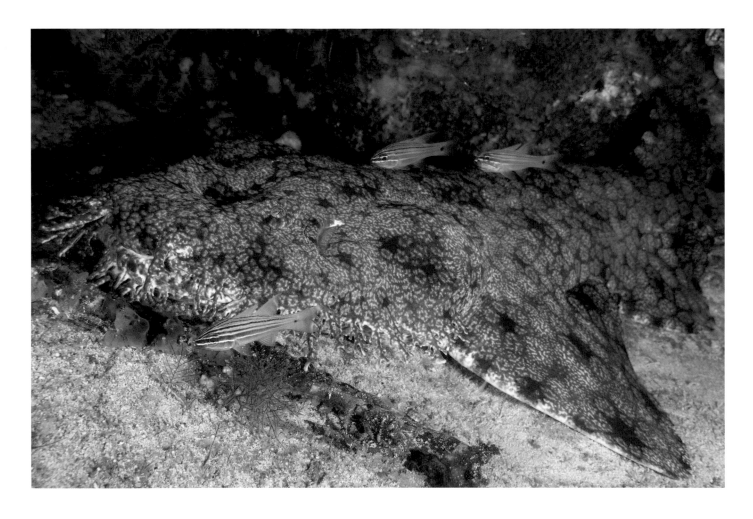

A pair of hawkfish

A pair of Forster's hawkfish *Paracirrhites forsteri* perch on a fire coral *Millepora* sp. Hawkfish are usually solitary, as predators generally have the best feeding opportunities when alone. Like most ambushers they tend to be fairly inactive to conserve energy.

Hawkfish do come together to mate, the male closely following the female as she jumps between several perches as part of their dusk-time courtship. When they spawn they rapidly dart away from the reef, releasing eggs and sperm. The action is so fast that I have yet to take a decent photo; I always end up chopping off the head or tail of one of the speeding fish.

Strait of Tiran, Gulf of Aqaba, Egypt. Red Sea.
Nikon D2X + 150 mm. 1/100th @ F8

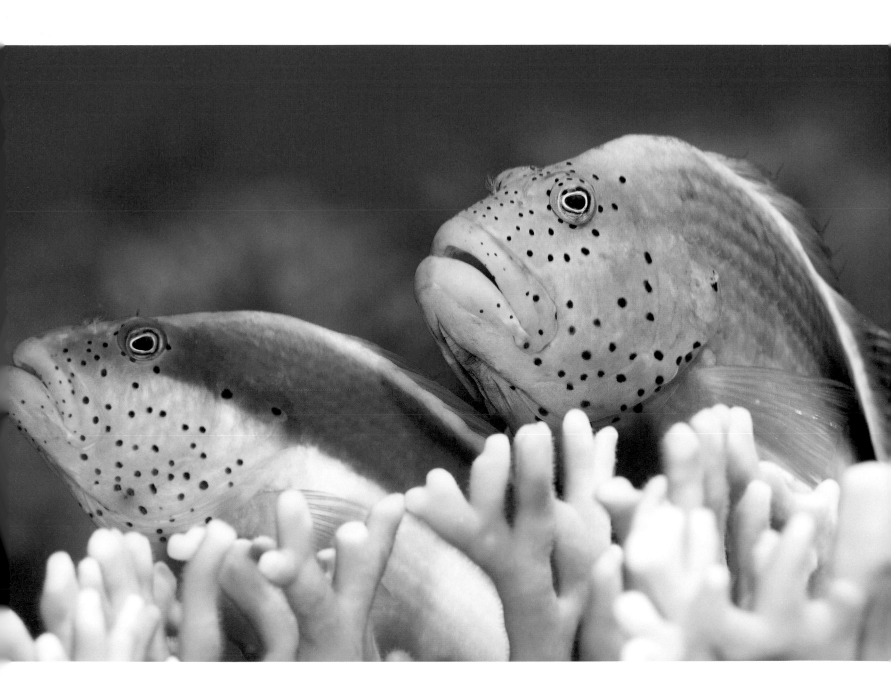

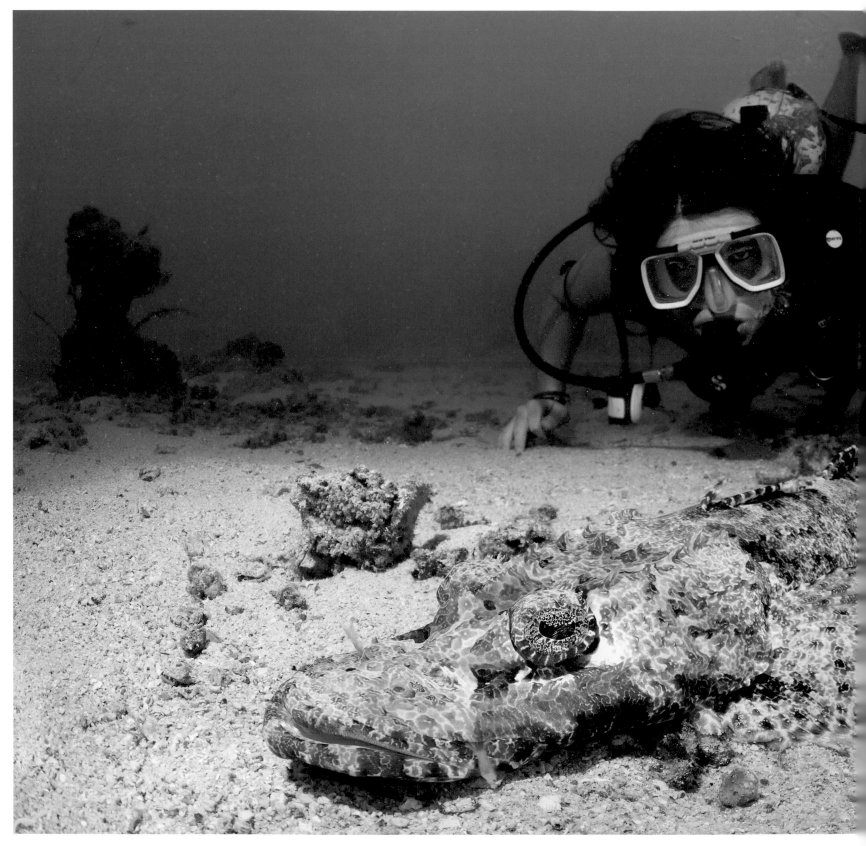

Crocodilefish and diver

A crocodilefish *Cymbacephalus beauforti* is so confident in its camouflage that it lies motionless as a diver studies it. Ambush predation is just one of five fish-eating strategies on the reef. Others are pursuing predators like jacks, which chase down their prey; habituation predators, like groupers that constantly mingle with their prey until they are no longer perceived as a threat; crevice hunters, like moray eels that corner prey in the reef; and stalking predators, like trumpetfish that slowly sneak up on their prey. These strategies are not mutually exclusive and some species employ several.

Up to 60 per cent of the species of reef fish are carnivorous and many of these are also piscivores: between 8 and 53 per cent of reef fish species eat other fish.

Mabul Island, Sabah, Malaysia. Sulawesi Sea.
Nikon D2X + 10.5 mm. 1/20th @ F11

Trumpetfish with diver

Trumpetfish *Aulostomus maculatus* are master stalking hunters and use a range of tactics to catch their food. Commonly, these long, narrow predators pretend to be parts of branching soft corals or tube sponges and will also join schools of herbivores to help them get closer to their unsuspecting prey.

Another well-known strategy is called shadow stalking, where the trumpetfish swims right next to a larger fish, which is not considered a threat by its prey, allowing the trumpetfish to get close enough to strike.

The trumpetfish in this photo was actually using me and my buddy for shadow stalking. The fish stuck to us like glue as we explored the reef, periodically darting out trying to catch small fish.

North Wall, Grand Cayman, Cayman Islands. Caribbean Sea.
Nikon D2X + 12–24 mm. 1/40th @ F9

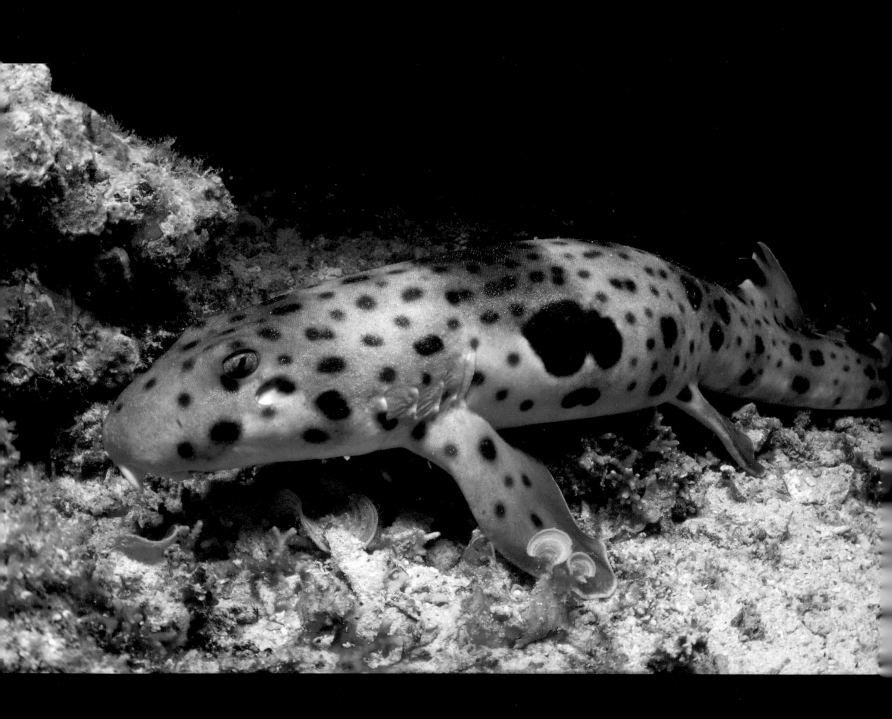

The walking shark

Reefs are full of surprises. This currently undescribed species of epaulette shark *Hemiscyllium* sp. was discovered by scientists in only 2006. Given the nickname the walking shark, it is about a metre long and stands up on its pectoral and pelvic fins to walk around on the seabed with a sinuous motion, rather like a lizard, hunting molluscs and crustaceans.

Geographic isolation of a population is an important mechanism for speciation. Epaulette sharks are a group of small benthic or bottom-dwelling sharks that live in shallow waters around Australia, Papua New Guinea and eastern Indonesia. The sharks attach their eggs to the reef, and these hatch as small (15 cm) versions of the adults. Because neither the attached eggs or the slow walking adults move very much, their populations can become isolated by the complex geography, deep water and strong currents of the Indonesian/Papuan archipelago. Once isolated, these populations slowly change, adapting to their specific conditions and this genetic divergence produces separate species in each location.

Kaimana region, South Bird's Head peninsular, West Papua, Indonesia.
Nikon D70 + 10.5 mm + 1.5x TC. 1/160th @ F16

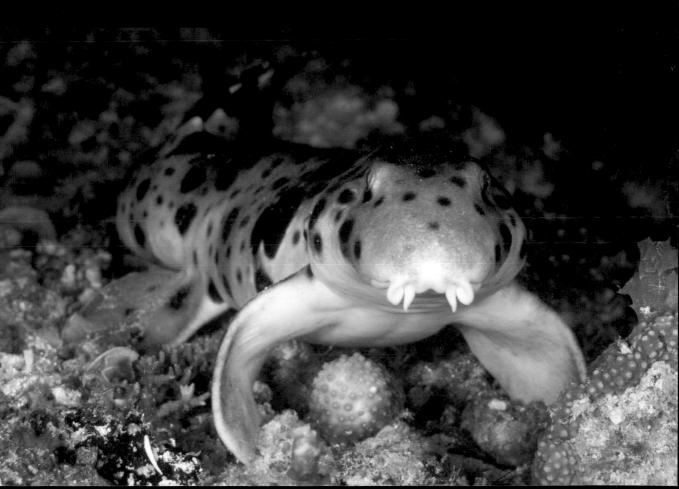

∧ Walking shark perched on pectorals

This photo of the walking shark shows how high it lifts its head off the ground as it perches on its pectoral fins. In all the time I spent photographing the walking sharks I never saw one revert to swimming.

Kaimana region, South Bird's Head peninsula,
West Papua, Indonesia.
Nikon D2X + 60 mm. 1/250th @ F16

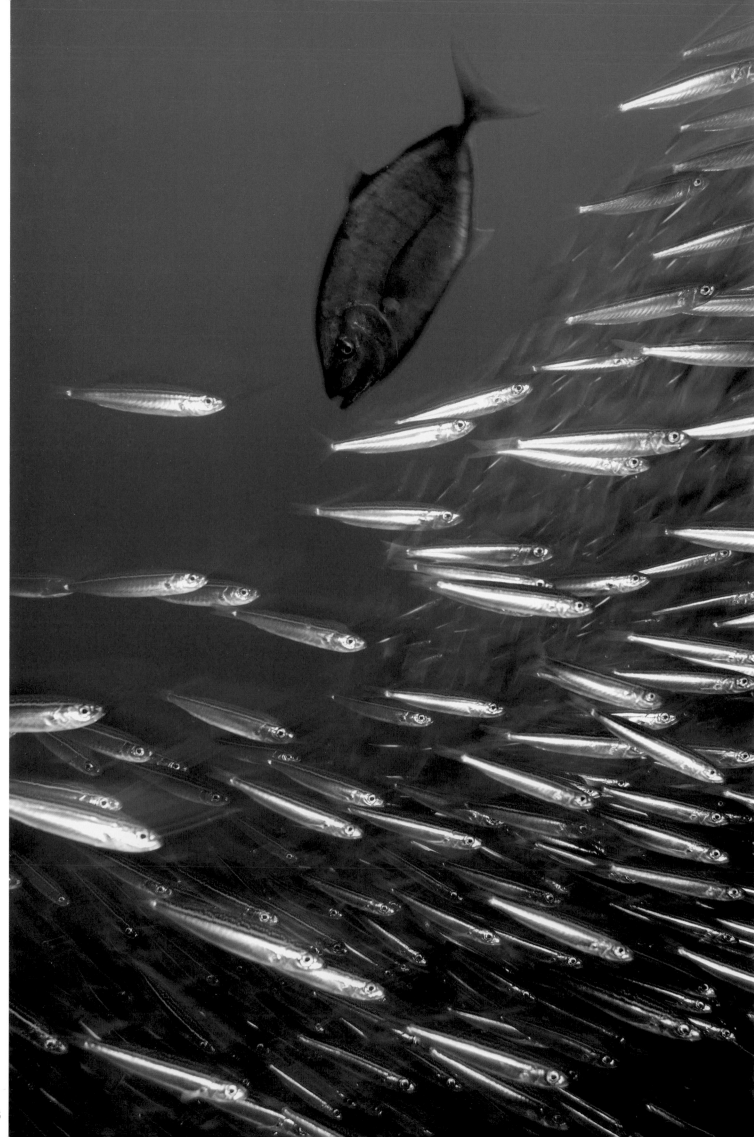

< A trevally hunting schooling fish

An orange-spotted trevally *Carangoides bajad* dives into the ordered ranks of a school of fish, in an attempt to disrupt the ranks and force some to separate. This individual has turned black while hunting, but the species is usually silvery, although it can be entirely golden.

Orange-spotted trevally are adaptable reef predators that often work in small groups. In the Red Sea I have photographed them hiding within schools of migrating masked pufferfish *Arothron diadematus* and darting out to catch prey. Also on popular dive sites I have watched this species using divers as cover, hovering next to their air tanks before racing after a fish.

Misool Island, Raja Ampat, Indonesia. Ceram Sea.
Nikon D2X + 12–24 mm. 1/25th @ F8

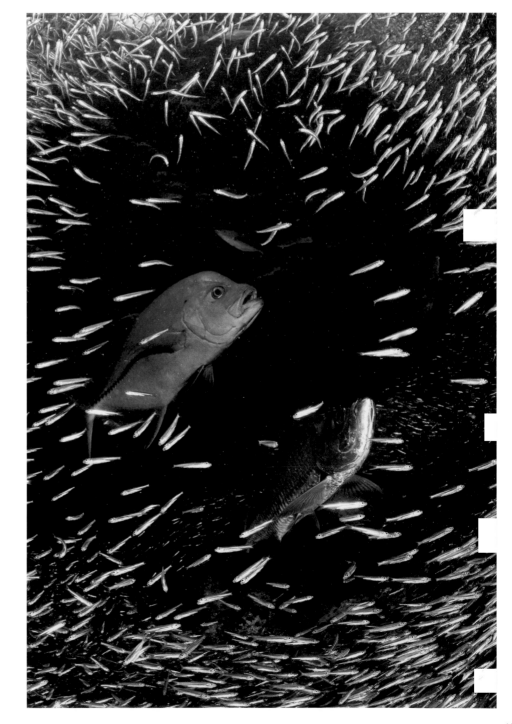

> A jack and tarpon hunt silversides

This black jack *Caranx lugubris* and a tarpon *Megalops atlanticus* join forces to hunt silversides that have gathered in a cavern in the reef. Cooperative hunting is common on reefs, and often the activity of one predator encourages others to join in.

Black jacks are a rare sight on Caribbean reefs, except when silversides schools gather. Then they are common. The black jack is a deeper water species and I wonder whether the noise generated by the schooling fish attracts these predators up into shallow water. Schooling is a defensive mechanism for fish, but maybe in this case it actually increases predation pressure.

East End, Grand Cayman, Cayman Islands. Caribbean Sea.
Nikon D2X + 16 mm. 1/20th @ F8

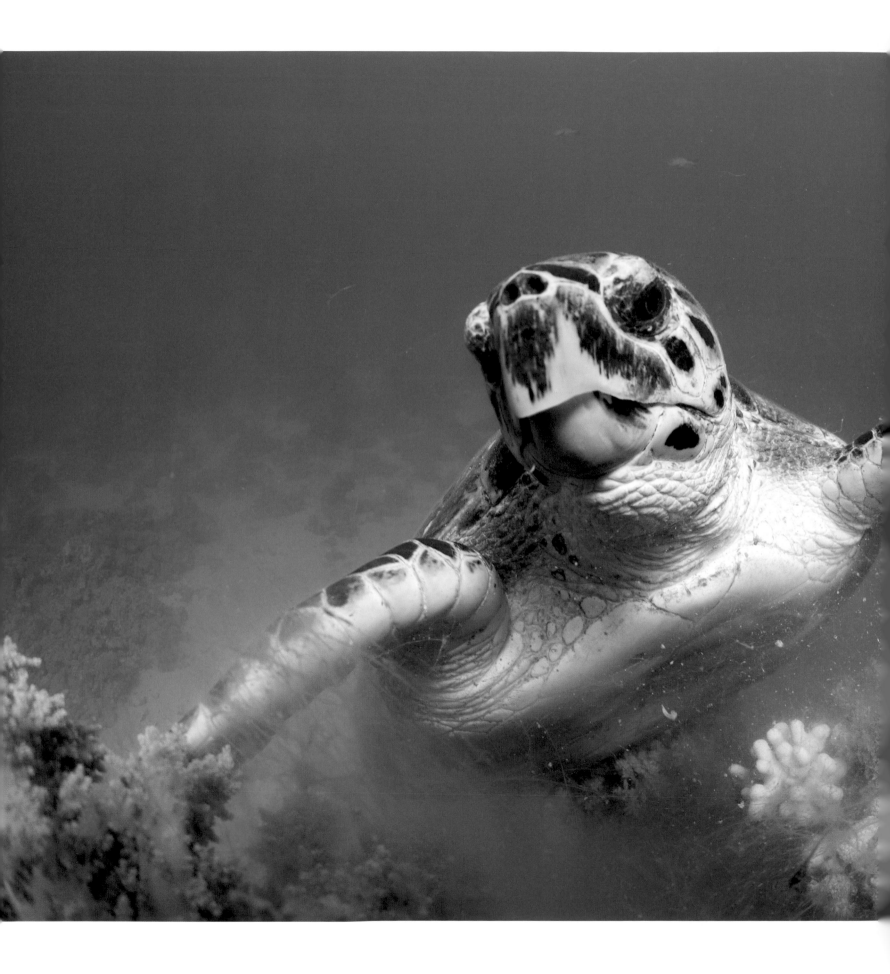

Hawksbill turtle feeding on soft corals

A hawksbill turtle *Eretmochelys imbricata* looks up from feeding on soft corals. The diet of hawksbill turtles varies considerably around the world. In the Red Sea they favour soft corals, while in other areas they mostly eat reef sponges. Hawksbills also make use of seasonally abundant food, like jellyfish blooms. Very young hawksbills feed on plankton and algae in the open ocean.

Hawksbills are one of the smaller marine turtles and grow typically to about 1 m and 80 kg. They live for about 30–50 years and it probably takes them 20 years to reach maturity. Although other turtle species are found on reefs, hawksbills are the real reef specialists.

Ras Mohammed, Sinai, Egypt. Red Sea.
Nikon D2X + 10.5 mm. 1/60th @ F4.5

Hawksbill turtle chewing

Hawksbill turtles *Eretmochelys imbricata* feed on some of the most unappetizing reef invertebrates. Sponges and soft corals are common foods even though both are filled with toxins and indigestible skeletal spines. Sponges have hard needle-shaped silica spicules and soft corals have calcium carbonate sclerites or plates, both designed to deter predators.

Hawksbills eat so many sponges that more than half the weight in their digestive system may be made up of silica – basically glass fragments. How they deal with the highly toxic chemicals in sponges and soft corals is unknown. As one of the few browsers of these invertebrate species, hawksbills release space and influence the succession of species in the sessile community.

Nuweiba, Gulf of Aqaba, Egypt. Red Sea.
Nikon D2X + 28–70 mm. 1/13th @ F8

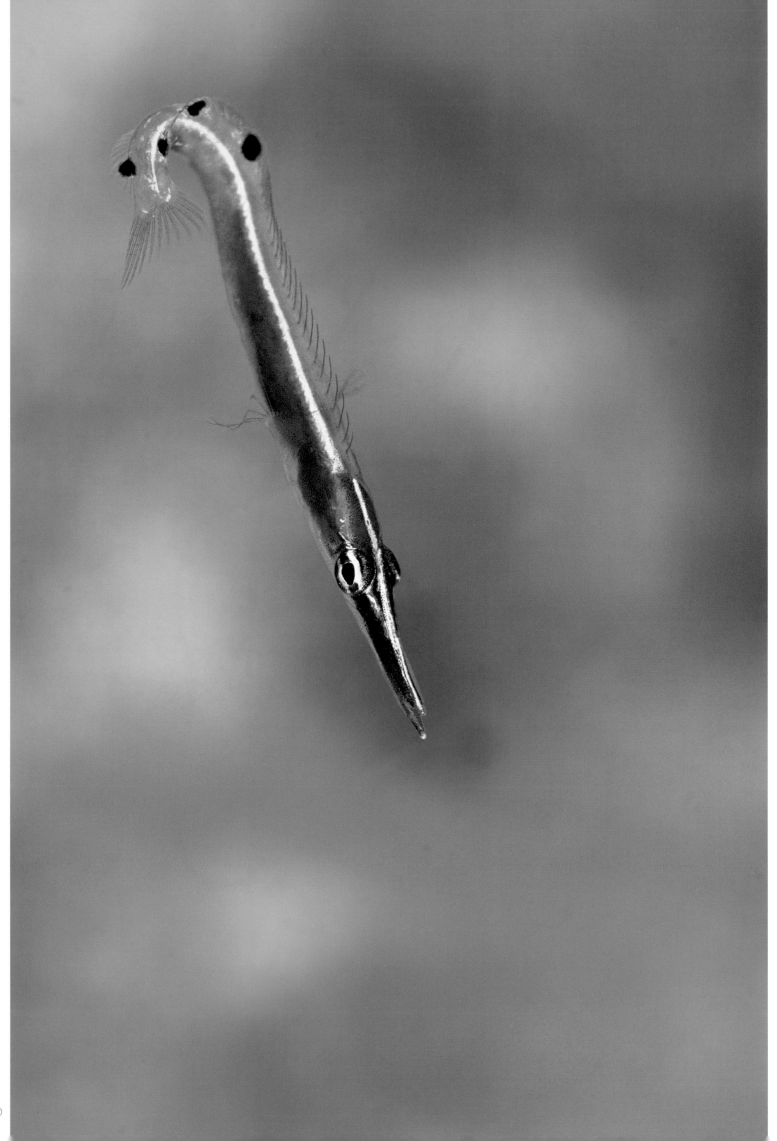

A tiny arrow blenny

An arrow blenny *Lucayablennius zingaro* is one of the smallest fish predators on the reef, growing to only 3 cm long. This tiny, but deadly, piscivore manoeuvres with just its pectoral fins in a stop–start motion, with its tail cocked over, until it is within 10–15 cm of its prey. It then snaps its tail straight, sending its streamlined body shooting forward to catch small gobies nearly as long as itself.

It is often found close to schools of masked hovering gobies *Coryphopterus personatus*, a favoured prey species, near the top of the reef wall. If threatened, it will retreat into empty worm tubes, but generally it is not concerned by close observation by divers.

West Wall, Grand Cayman, Cayman Island. Caribbean Sea.
Nikon F100 + 105 mm. 1/250th @ F11

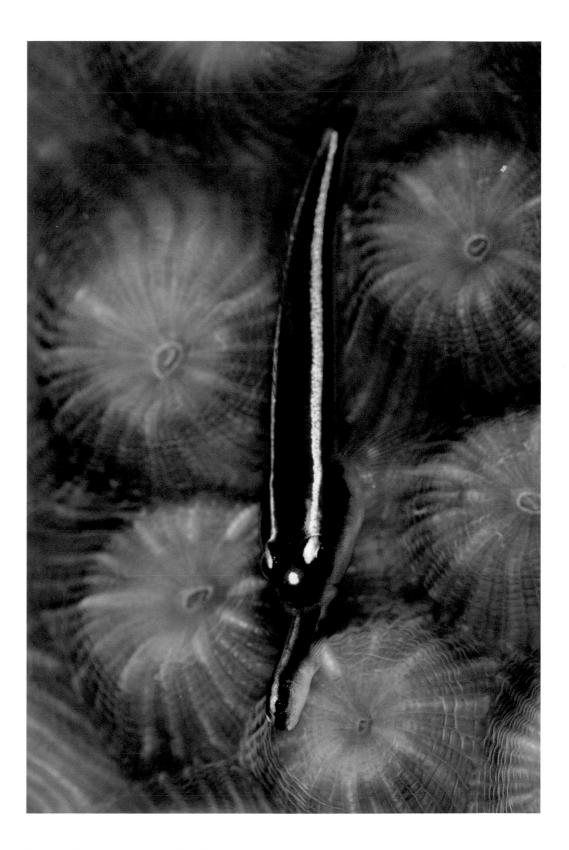

Predation or aggression?

When I took this photo I thought I was photographing cannibalism, as one goby ate another. But later, when I looked at the photos from the sequence, I noticed that the gobies are different species. The larger individual is a spotlight goby *Gobiosoma louisae* and the smaller one is a cleaning goby *Gobiosoma genie*.

Could this attack be motivated by something other than food? The studies of cleaner gobies show that their bellies are almost entirely filled with parasitic isopods. Maybe this attack was more about defending a prime territory.

I don't think I can answer this with any certainty. But then that is one reason why visiting coral reefs is so addictive – there are always new things to see and so many unanswered questions.

North Wall, Grand Cayman, Cayman Island. Caribbean Sea.
Nikon D2X + 105 mm. 1/250th @ F14

A skeleton shrimp feeds on a worm

A skeleton shrimp (*Caprellidae*) snares and bites into a plankton polychaete worm. Skeleton shrimps are colonial amphipods. They are most commonly seen on hydroids and they hold themselves upright with their rear legs. This colony was on a gorgonian.

This individual, less than 2 cm long, has captured a nocturnal planktonic worm with its praying-mantis-like claws. The worm was probably attracted by my dive light.

Misool Island, Raja Ampat, Indonesia. Ceram Sea.
Nikon D2X + 105 mm. 1/250th @ F22

Young jacks accompany a reef shark

Two juvenile bar jacks *Caranx ruber* ride on the bow wave created by a Caribbean reef shark *Carcharhinus perezi*. Their apparently suicidal tendencies actually make sense and they save a great deal of energy being pushed along by the pressure wave created by the shark.

Although the jacks are in front of the shark they can be considered to be following it, as they are able to react to its slightest change in direction, by sensing movement with their lateral lines in the same way they would when schooling with their own kind. So, when the shark changes direction the jacks respond instantaneously, seemingly leading the way.

East End Wall, Grand Cayman, Cayman Island. Caribbean Sea.
Nikon D2X + 28–70 mm. 1/80th @ F4.5

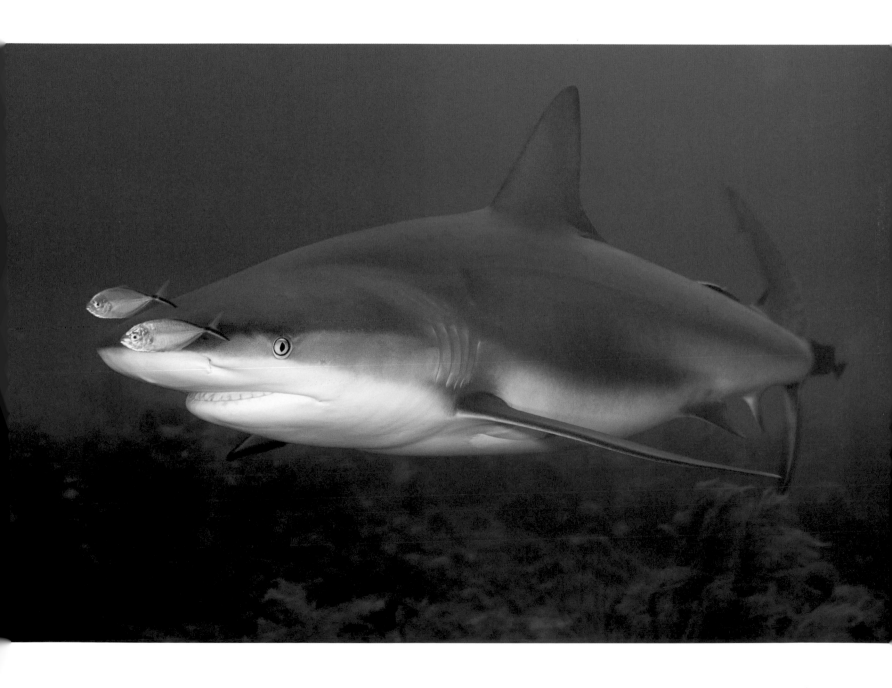

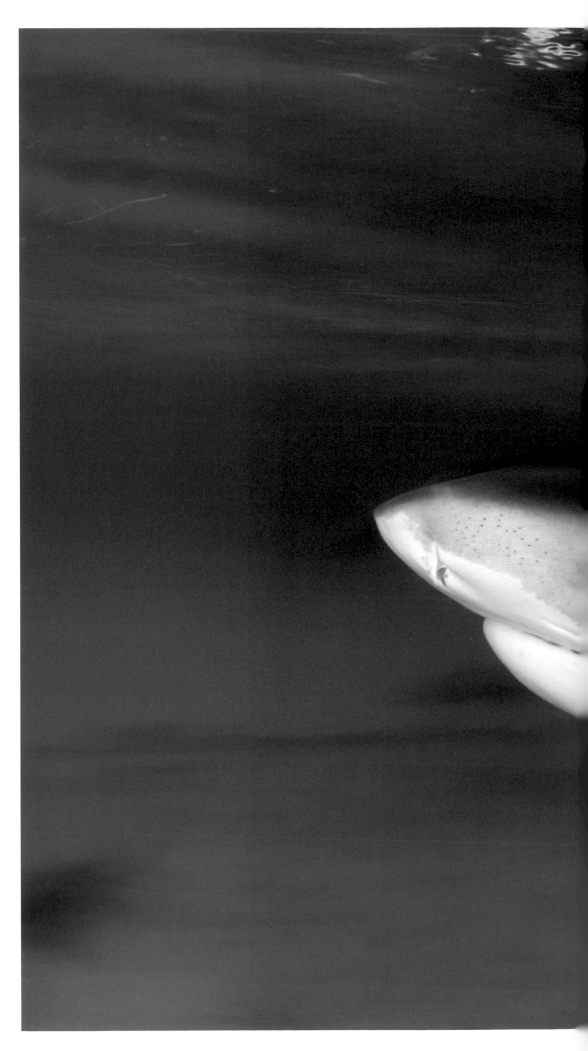

> ## Tiger shark below the surface

The dorsal fin of a large (3.5 m) tiger shark *Galeocerdo cuvier* cuts the surface. Tiger sharks are the largest predators on coral reefs, taking 10 years to reach maturity and having a gestation period of 14–16 months. The unborn young gain extra nutrition from uterine milk, secreted through the lining of their mother's uterus.

Most shark authors rejoice in revealing the details of the adult tiger's diverse diet, particularly the strange objects found in the stomach, including cans, bottles, number plates and even a chicken coop. What this really reveals is how little we know about the lives of tiger sharks, and how most of our knowledge comes from cutting up dead ones.

Little Bahama Bank, Bahamas. West Atlantic Ocean.
Nikon D2X + 10.5 mm. 1/3rd @ F20

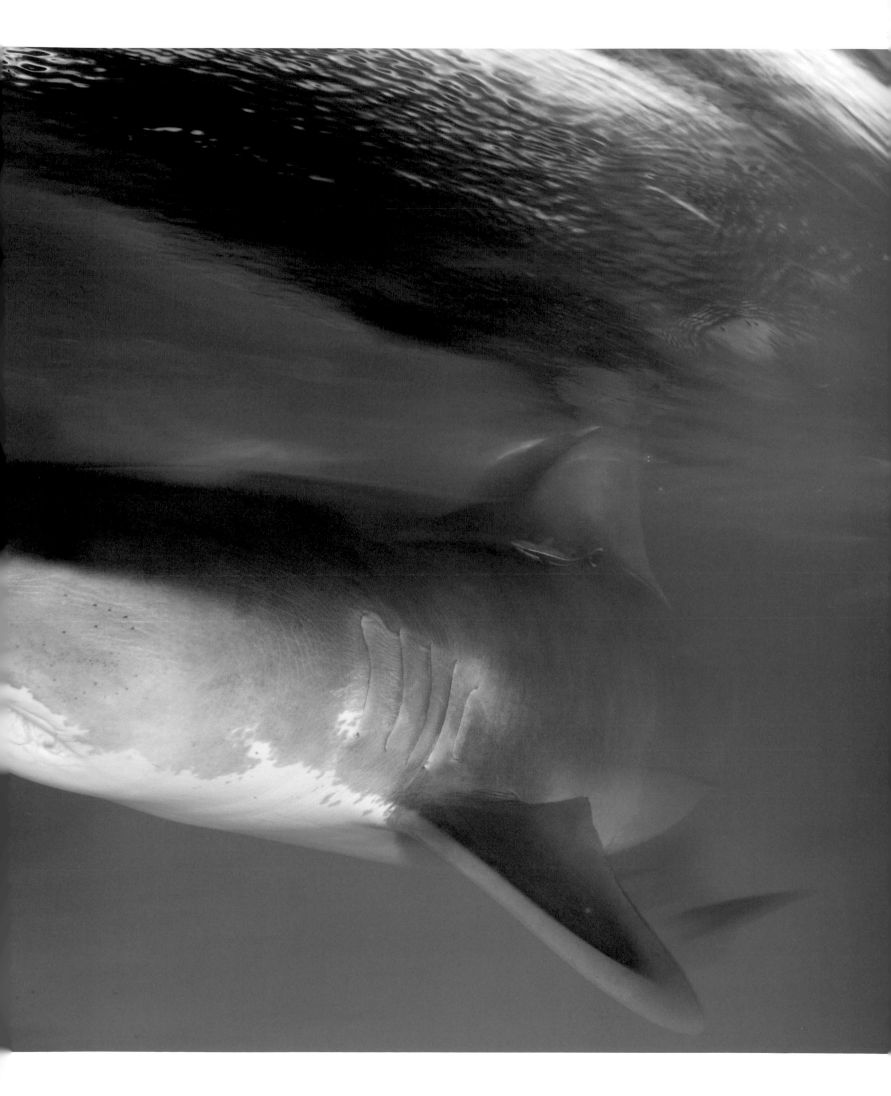

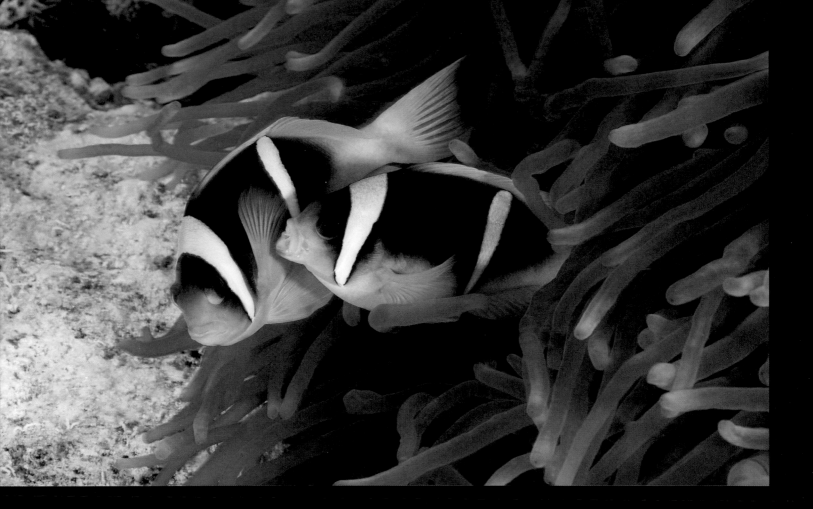

Fighting Nemo

A female Red Sea anemonefish *Amphiprion bicinctus* asserts her dominance over a male. Aggression is used to remind each fish of its place. The female bullies everyone, while the male harasses all the immature fish, and so on. The smallest fish spend so much of their time avoiding bullying that they can struggle to feed enough to grow.

Despite their size the smallest fish in the anemone may not be young at all. The rigid social hierarchy stunts both their growth and sexual maturation. Like many reef fish, anemonefish change sex during their lives and if the female dies the male takes over. Rapidly the male's testes stop functioning and his/her ovaries become active. The largest of the immature fish will take over the role of male and all the fish move one place up the queue.

Strait of Gubal, Gulf of Suez, Egypt. Red Sea.
Nikon D2X + 60 mm. 1/60th @ F9

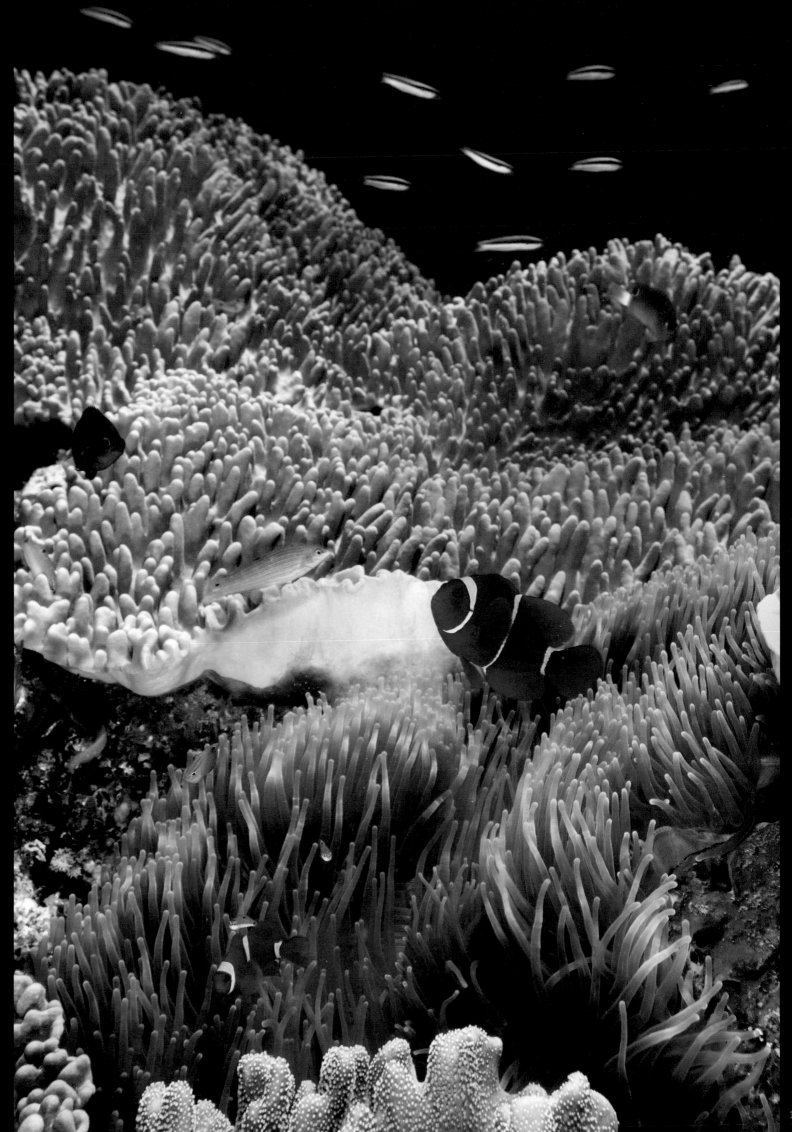

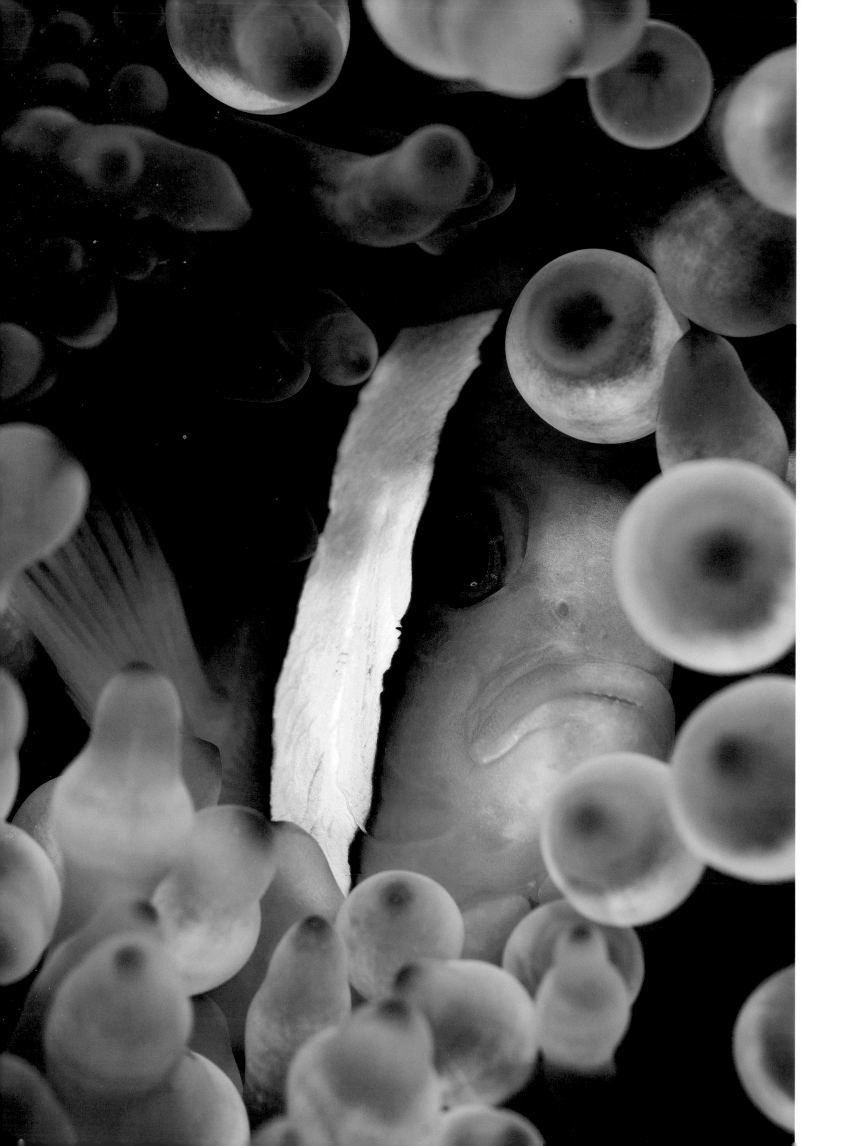

Pair of Red Sea anemonefish

A pair of Red Sea or two band anemonefish *Amphiprion bicinctus* (15 cm) rise up aggressively from their anemone to meet my approach. Anemonefish will often actively defend their anemone, although their antagonistic attitude always seems most highly charged when they are tending eggs.

It is common to find anemonefish guarding eggs, which are laid on bare rock, usually under a fold in their host anemone. Unlike most other members of the damselfish family, the male is joined by the female in cleaning, defending and aerating their eggs. Each clutch usually takes between 5 days and a week to hatch and the whole process can often be followed during a normal diving vacation.

Sharm El Sheikh, Gulf of Aqaba. Egypt. Red Sea.
Nikon D2X + 105 mm. 1/125th @ F9 [m]

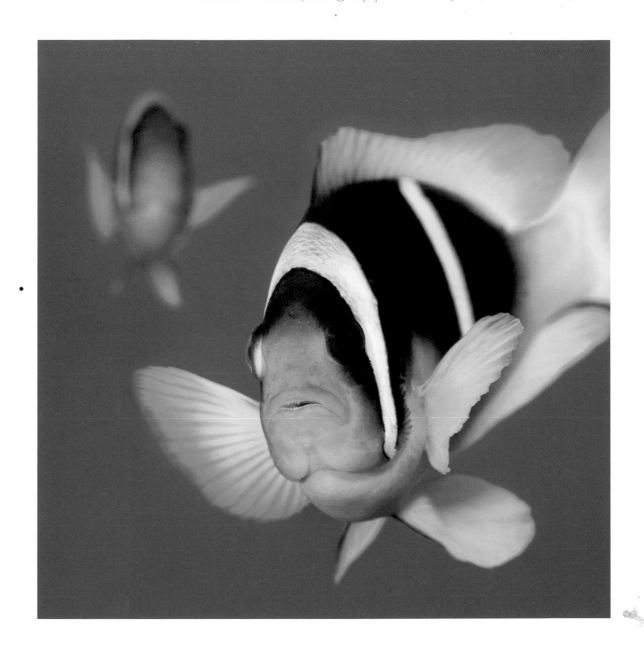

Clark's anemonefish in tentacles

A Clark's anemonefish *Amphiprion clarkii* buries itself in the protective stinging tentacles of its host anemone. There are 28 species of anemonefish in the Indo-Pacific region, which live in just 10 species of anemone. Some species of anemonefish are always associated with just one species of anemone, like the spinecheek anemonefish *Premnas biaculeatus*, which is always associated with the bulb-tentacle anemone *Entacmaea quadricolor*. Clark's anemonefish is the most geographically widespread species and is also found in all 10 species of anemone.

Misool Island, Raja Ampat, Indonesia. Ceram Sea.
Nikon D2X + 150 mm. 1/80th @ F7.1

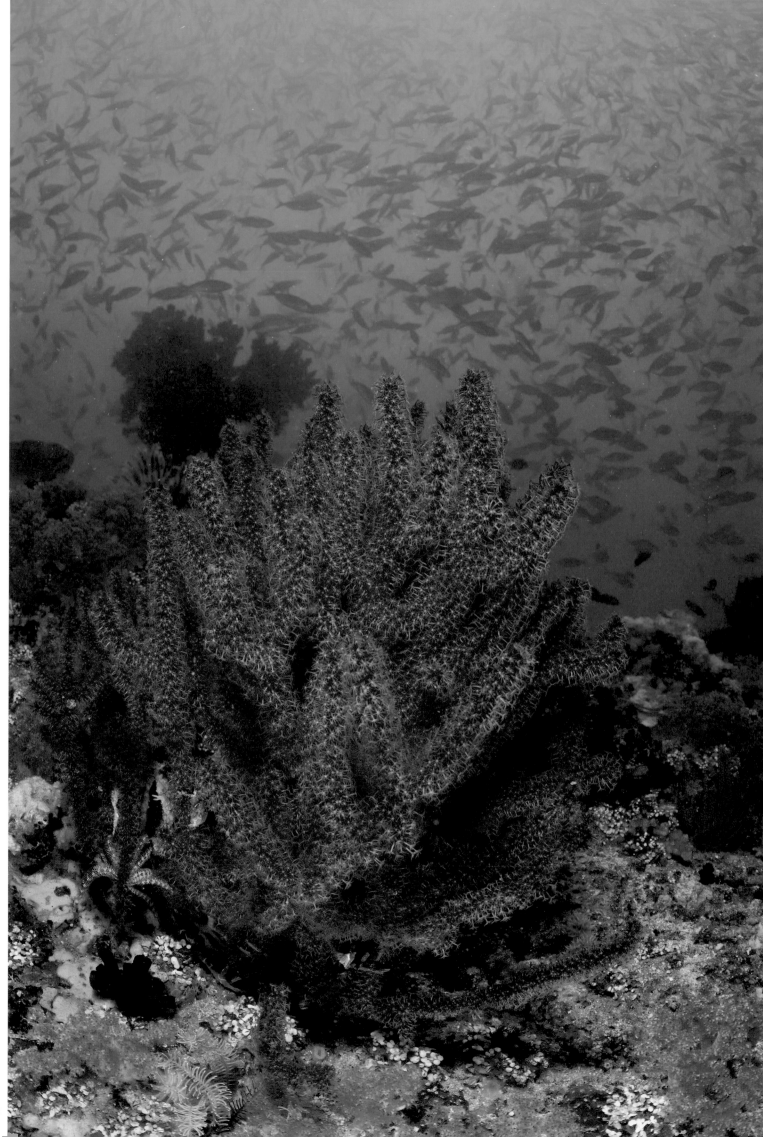

< A gorgonian and schooling fish

A gorgonian *Ellisella* sp. and schooling fusiliers *Caesio* sp. thrive in the plankton-rich waters of this coastal reef. Gorgonians have strong and flexible skeletons made out of a hard protein called gorgonin. The skeleton is covered in polyps, which are used to catch small plankton.

Fusiliers are larger than many of the plankton-feeding fish on the reef and this makes them less at risk from predation. They are able to feed further from the reef, and get the best pickings of plankton.

Kaimana region, South Bird's Head peninsula,
West Papua, Indonesia.
Nikon D2X + 16 mm. 1/30th @ F8

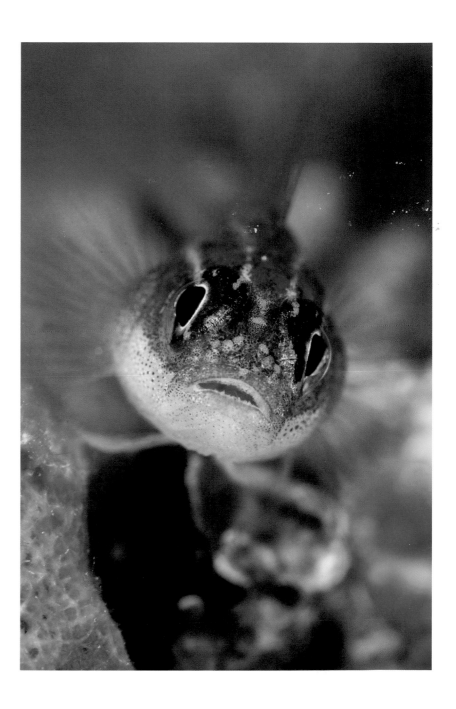

∧ Neon triplefin portrait

The small neon triplefins *Helcogramma striata* (3 cm) are territorial fish, usually found perched on sponges or sea-squirt-covered areas of the reef. Most reef triplefins have drab colours and are semi-transparent for concealment, but the neon triplefin is brightly coloured, possibly an effective camouflage in its colourful micro-habitat. This species lives in small groups and feed on zooplankton.

Seraya Bay, Tulamben Area, Bali, Indonesia. Java Sea.
Nikon D2X + 105 mm. 1/250th @ F25

Schools of silversides *Atherinidae* are made up of several species of 5-cm herring-like fish that mix together in large shoals for their protection; their reflective scales and massed ranks dazzle and confuse predators. For us they are an enchanting spectacle, dancing in the rays of light, with the fish moving in unison as if they are a single creature.

Shoaling is a common behaviour in fish; about half of all species gather in shoals at some point during their lives for defence, feeding or mating. But when does a shoal become a school? All groups of fish that remain together are a shoal, and a shoal becomes a polarized school when all the fish are synchronized in a common direction. Both can comprise fish of different species, but schooling requires similar-sized fish swimming at the same speed.

East End, Grand Cayman, Cayman Islands. Caribbean Sea.
Nikon D2X + 16 mm. 1/160th @ F8

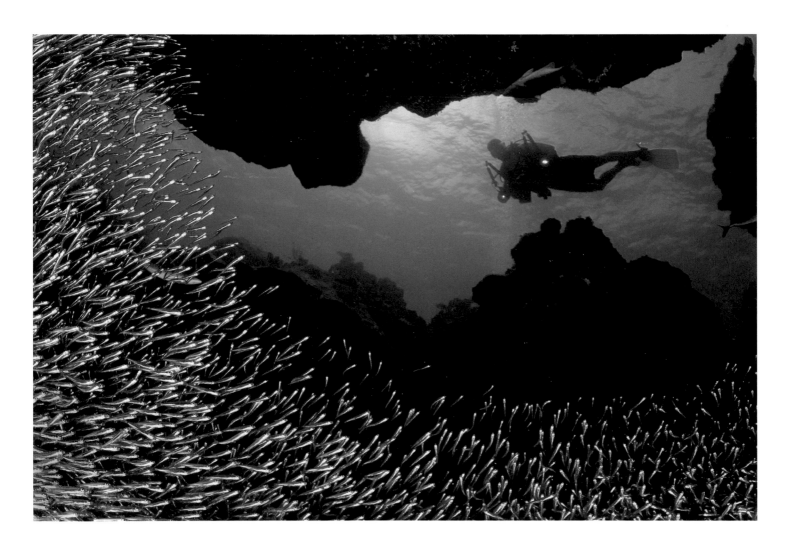

> School of bohar snappers

Large bohar snappers *Lutjanus bohar* (70 cm) gathered in an impressive school for spawning. Spawning aggregations can be divided into daily or annual events. Daily spawns involve species migrating small distances, usually to the edge of the reef to spawn at dusk. Annual spawns often require individuals to migrate tens to hundreds of kilometres, over days or weeks to reach their breeding areas. Most spawning aggregations occur at traditional sites; these snappers gather once a year, in the early summer, at Ras Mohammed at the tip of the Sinai peninsular.

Unfortunately, their regular habits make spawning aggregations easy for fishermen to predict too, and a couple of days' intensive fishing can wipe out predators from a wide area. Thankfully, the Ras Mohammed marine park protects these particular fish.

Ras Mohammed, Sinai, Egypt. Red Sea.
Nikon D2X + 16 mm. 1/50th @ F5

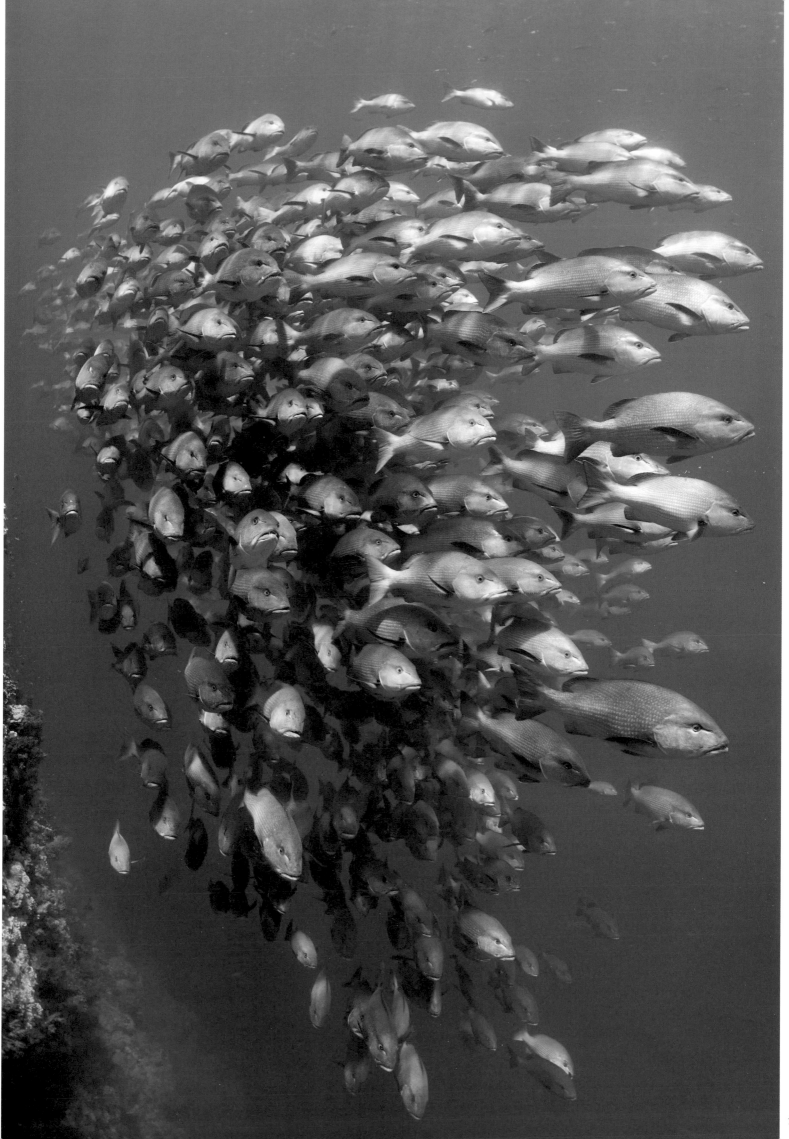

> Schooling barracuda

A school of blackfin barracuda *Sphyraena qenie*. Even large species like barracuda can benefit from schooling to protect them from their predators. The main protective advantages of safety in numbers are: each member of the school has less chance of being eaten; predators struggle to pick out an individual; aggregated prey are less likely to randomly encounter a predator, and most individuals are able to take evasive action before the predator gets close, based on the movements of other fish.

Ras Mohammed, Sinai, Egypt. Red Sea.
Nikon D2X + 12–24 mm. 1/30th @ F7.1

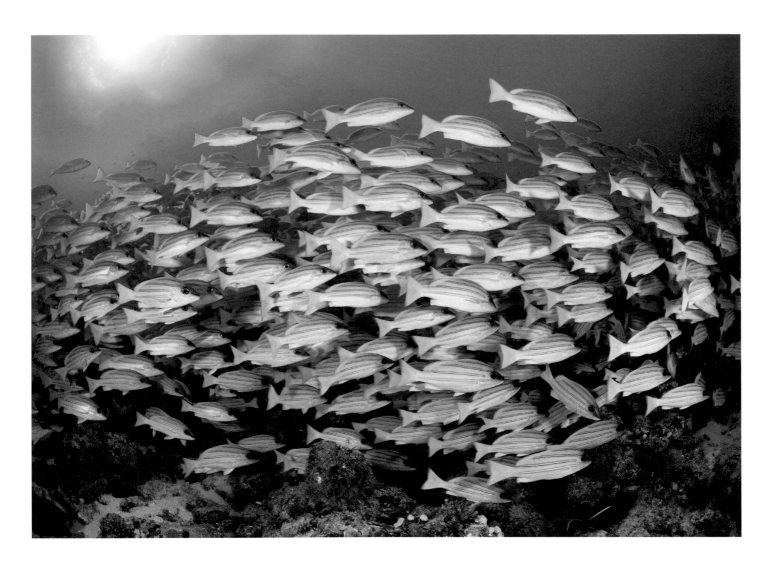

∧ A school of bluelined snappers

Many species of snappers, grunts and sweetlips are nocturnal hunters, spending the day in schools on the reef and dispersing at night to feed. These daytime schools can be thought of as dormitories, with the fish resting in a protective formation before the next night's excursion. This school is made up of 20-cm long bluelined snappers *Lutjanus kasmira*.

The exact spacing of individuals and the precise and unified movement of schools are controlled mainly by eye contact, although the lateral line which can sense movement is also important.

Ari Atoll, Maldives, North Indian Ocean.
Nikon D2X + 10.5 mm. 1/60th @ F9

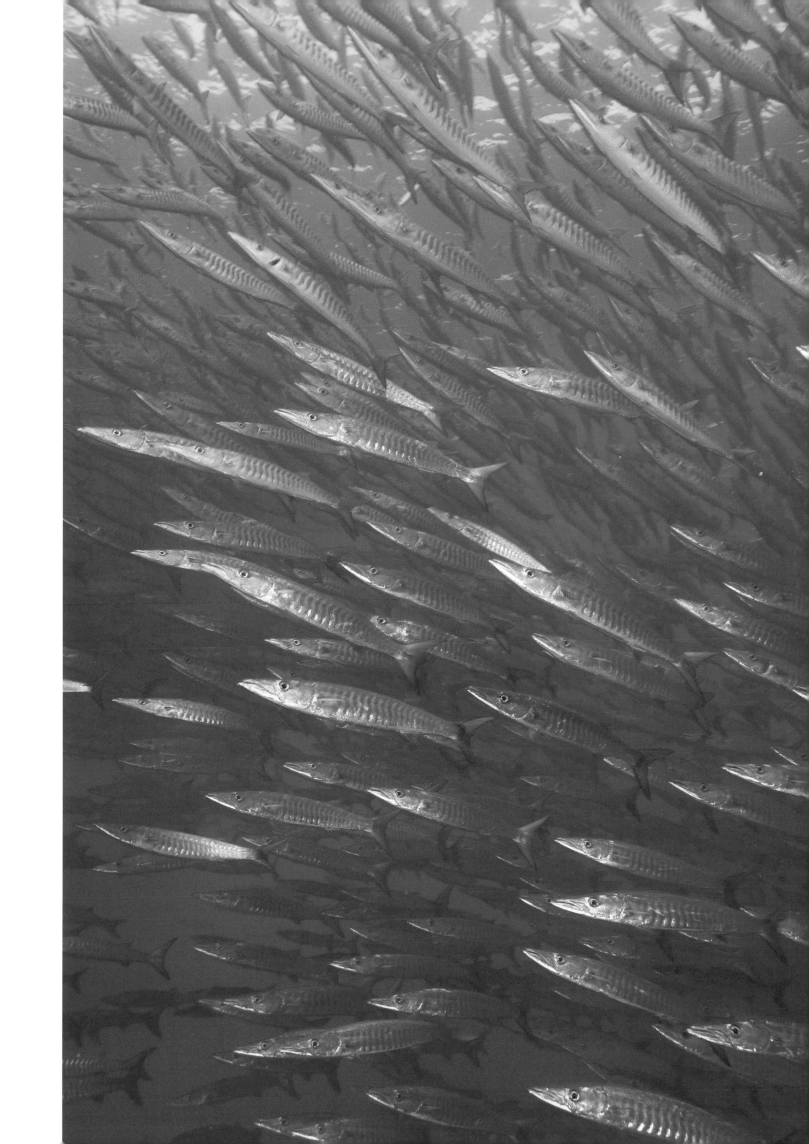

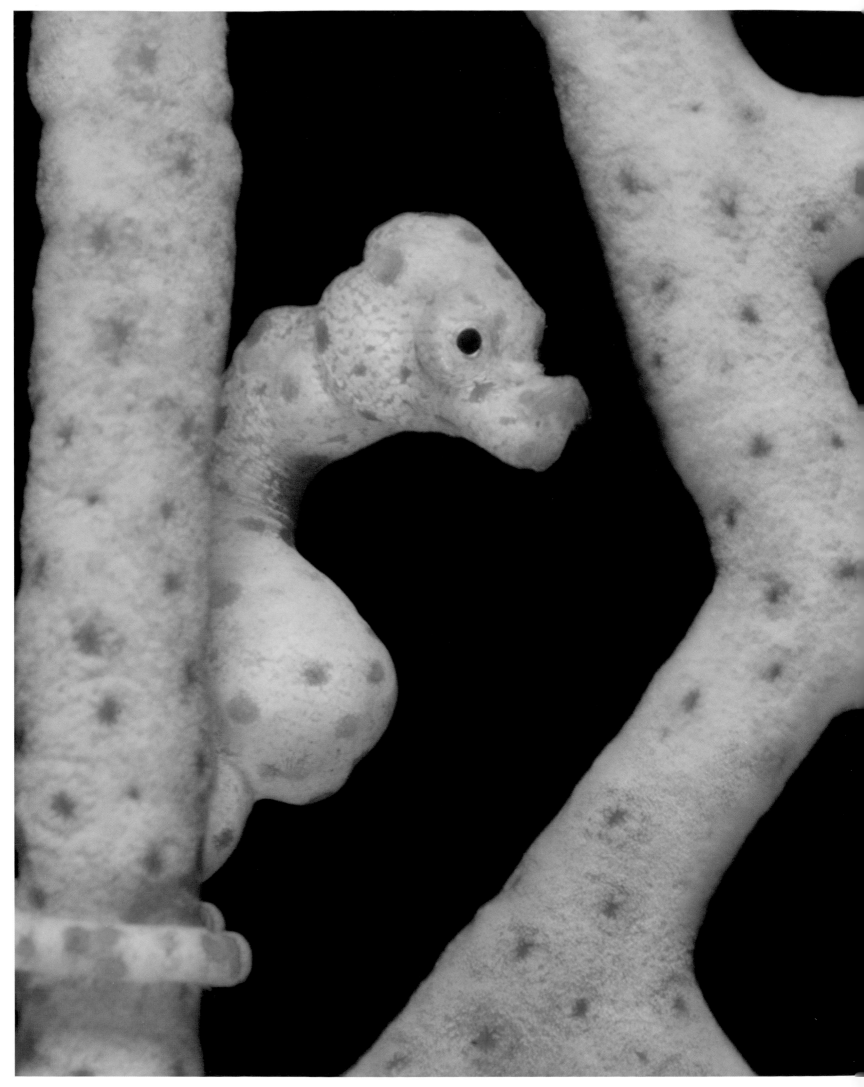

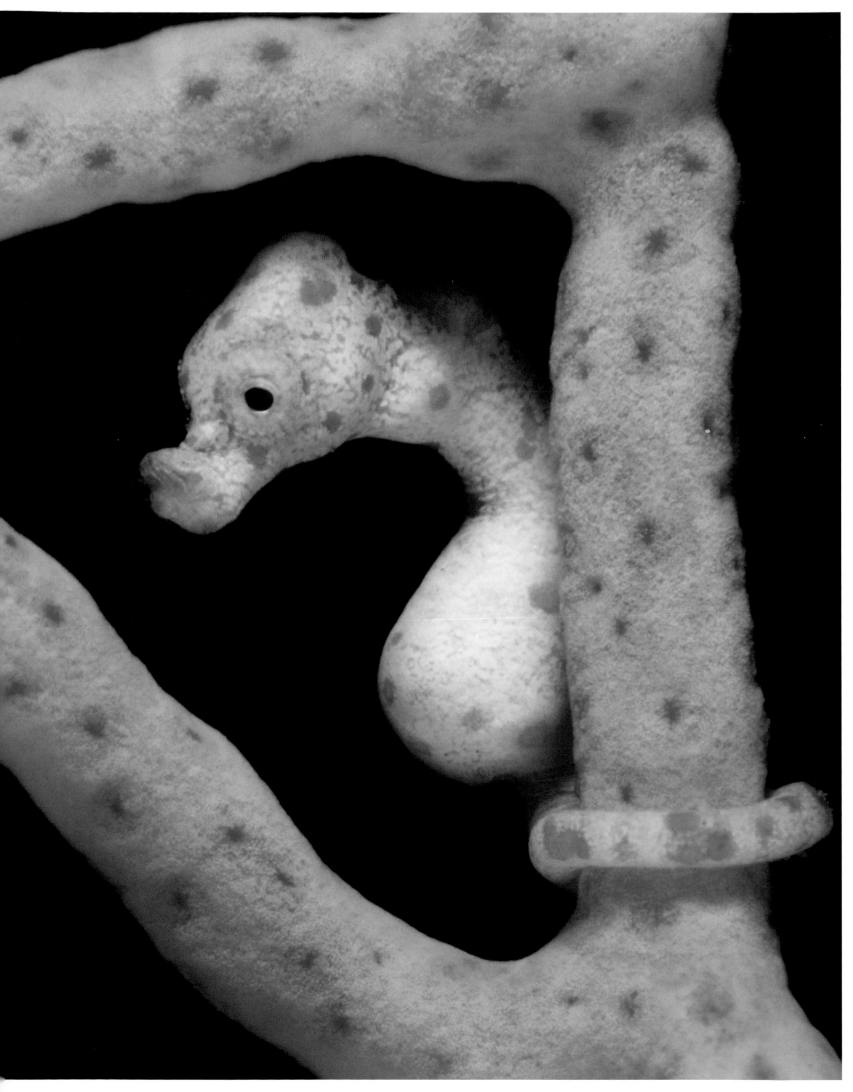

<< Pygmy seahorses on a seafan

A composite image of Denise's pygmy seahorses *Hippocampus denise* on seafan *Subergorgia mollis* shows their remarkable camouflage in their environment. Note that the bodies of these tiny seahorses are smaller than 1 cm. The fatal threat of predation drives many morphological and behavioural adaptations in reef creatures, but these must always be balanced against the needs to feed and mate.

Camouflage enables creatures to avoid the notice of predators, but is not without biological costs. These seahorses hardly move within the branches of this seafan, which limits their own opportunities for feeding and reproduction.

Misool Island, Raja Ampat, Indonesia. Ceram Sea.
Nikon D2X + 12–24 mm. 1/30th @ F7.1 [m]

∨ A devil scorpionfish

The devil scorpionfish *Inimicus didactylus* looks like a lump of dead coral and often has algae growing on its scaleless skin. This species regularly buries itself in the sand, with just its eyes and mouth protruding, or moves slowly across the sand, walking on the rays of its pectoral fins. Disguises are an excellent form of primary defence, but are not much help once an individual is located by its predator. Devil scorpionfish have sharp, poisonous spines running down their backs as an added defence.

When threatened, the devil scorpionfish breaks out from its usually camouflaged clothes and flashes the bright warning colours hidden on the underside of its pectoral fins and on its tail. These colours advertise its toxic spines.

Lembeh Strait, Sulawesi, Indonesia. Molucca Sea.
Nikon D100 + 60 mm. 1/30th @ F22

Secretary blenny, sponge and zoanthids

A secretary blenny *Acanthemblemaria maria* (4 cm) in a sponge *Cliona* sp. covered in zoanthids *Parazoanthus parasiticus*. Tube blennies live in worm holes in the reef, gaining protection the traditional way with four strong walls.

The association between sponges and zoanthids is also thought to keep both parties safe. The zoanthids benefit because few species can stomach the sponge's poisonous flesh and the sponge, in turn, is protected from some of its predators by the stinging zoanthids. The sponge also creates feeding currents that help provide food to the regularly spaced zoanthids.

West side, Grand Cayman, Cayman Islands. Caribbean Sea.
Nikon D2X + 60 mm. 1/250th @ F18

Pink leaf scorpionfish

The laterally compressed body of the pink leaf scorpionfish *Taenianotus triacanthus* allows this species to masquerade as a leaf. The fish further enhances its disguise by rocking back and forth in the surge and some of its scales are modified into skin flaps.

Leaf scorpionfish are more commonly black, brown, cream or golden. The pink colour variety is usually found in colourful reef areas, where it may help the fish to blend in with vivid corals. This species is usually found in groups of two or three individuals, each of a different colour.

Tulamben Bay, Bali, Indonesia. Java Sea.
Nikon D2X + 105 mm. 1/250th @ F22

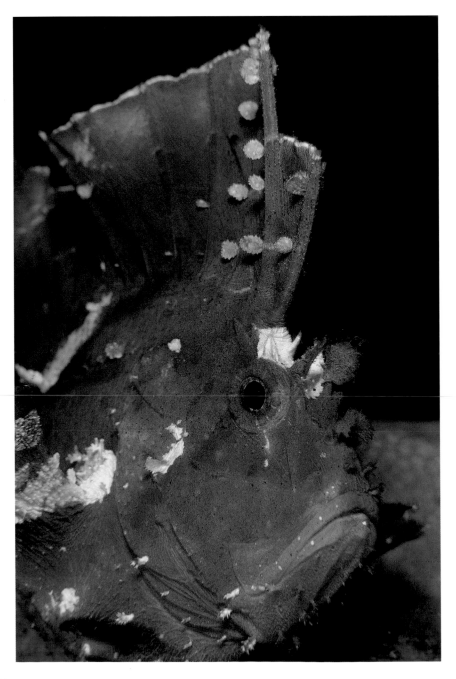

A cube trunkfish

A slow-swimming male cube trunkfish *Ostracion cubicus* (45 cm) paddles in the open water near the reef, confident in its defences. The trunkfish's box-like body is built of strong hexagonal semi-fused plates, which form a protective carapace. The only holes in this armour-plating are for the eyes, mouth, fins and gills, each sealed with tough skin. This species is also able to secrete a toxic mucus, ostracitoxin, through its skin.

Trunkfish are able to blow jets of water from their mouth, which helps them uncover food in sandy areas. This male was formerly a yellow-coloured female.

Ras Mohammed, Sinai, Egypt. Red Sea.
Nikon D2X + 105 mm. 1/50th @ F8

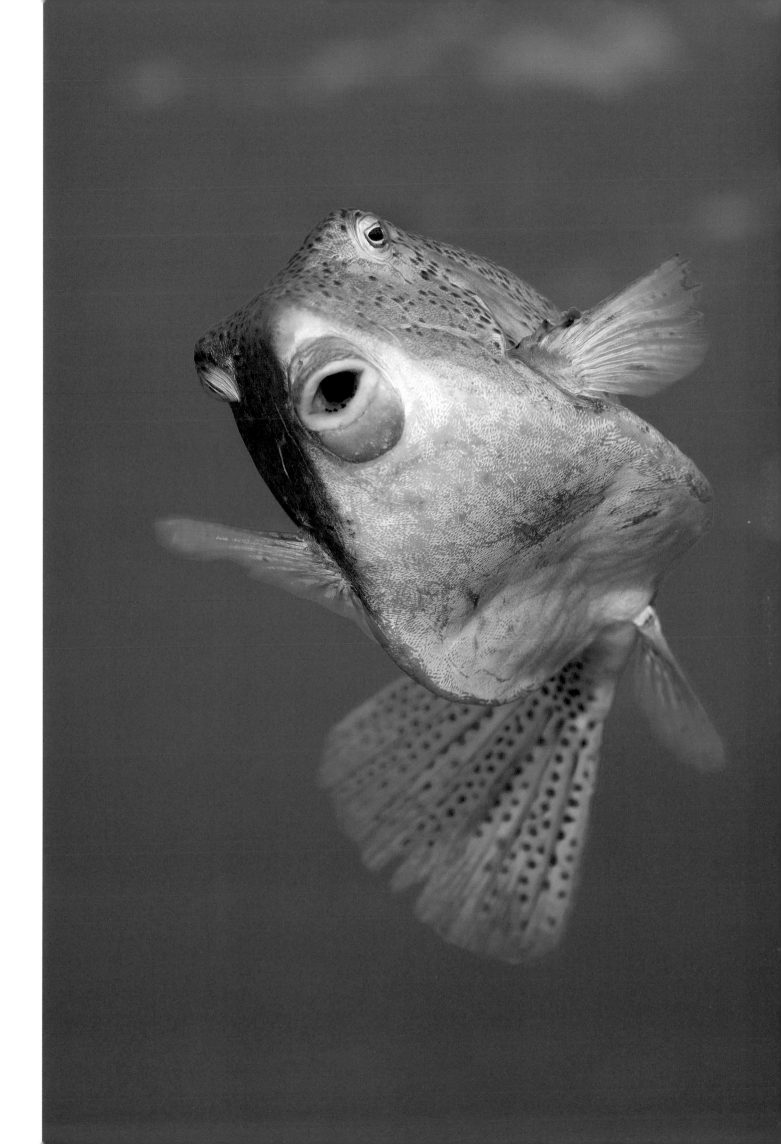

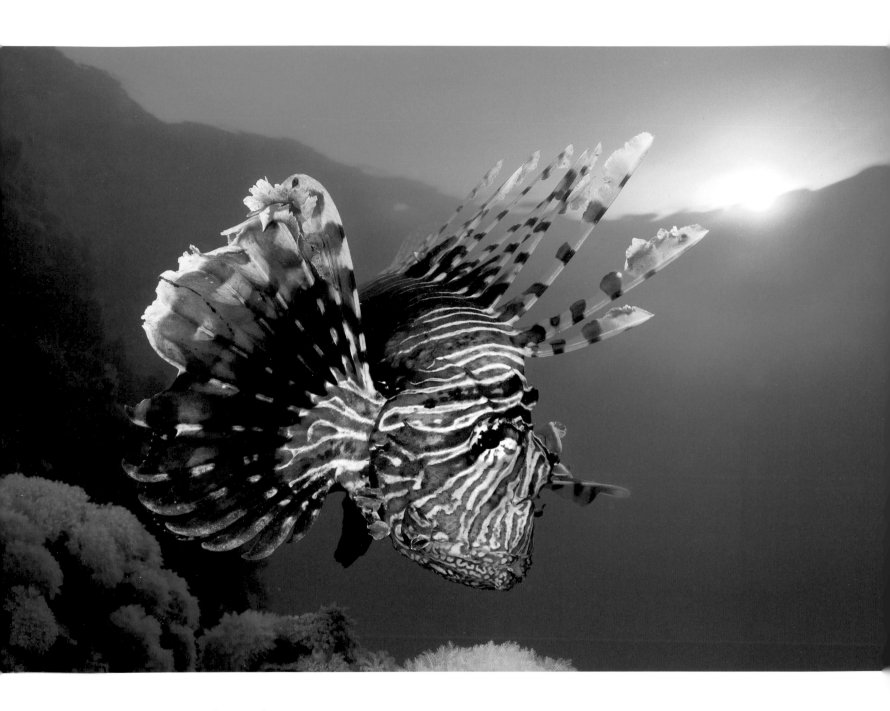

∧ Lionfish hovers above the reef

A lionfish *Pterois volitans* hovers above the reef, secure in the protection offered by its venomous spines. The spines of the dorsal fin and also the anal and pelvic fins are sharply pointed and coated in venom. Their sting is extremely painful to humans, although non-fatal. It has been shown to be fatal to smaller species, where the dose is proportionally higher relative to body size. Curiously, in 2006 researchers in India have shown that the active compound in lionfish venom kills cancer cells.

More than 200 species of marine fish have venomous spines; several are pictured in this book.

Strait of Tiran, Gulf of Aqaba, Egypt. Red Sea.
Nikon D2X + 16 mm. 1/80th @ F8

Pufferfish face

The dramatic pattern of a map puffer *Arothron mappa* (40 cm) may be disruptive camouflage or warning coloration – this species is poisonous. Pufferfish poison, tetraodoxin, is derived from symbiotic bacteria and is present in their skin as well as concentrated in their liver and ovaries.

Pufferfish are well defended in other ways, with a tough and elastic skin and an inflatable belly that can increase their size to about three times their original volume. I spotted this individual swimming with its belly partly distended, despite no obvious signs of threat.

Misool Island, Raja Ampat, Indonesia. Ceram Sea.
Nikon D2X + 12-24 mm. 1/30th @ F7.1

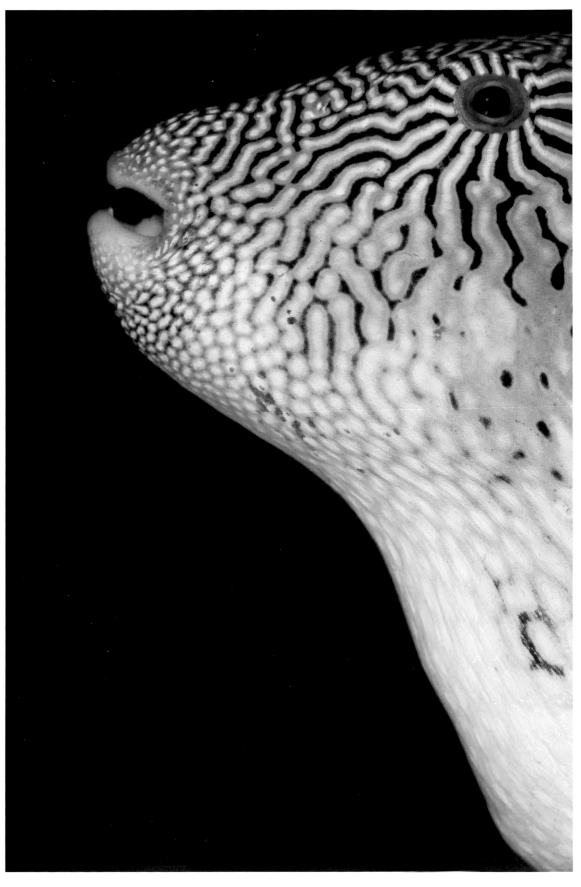

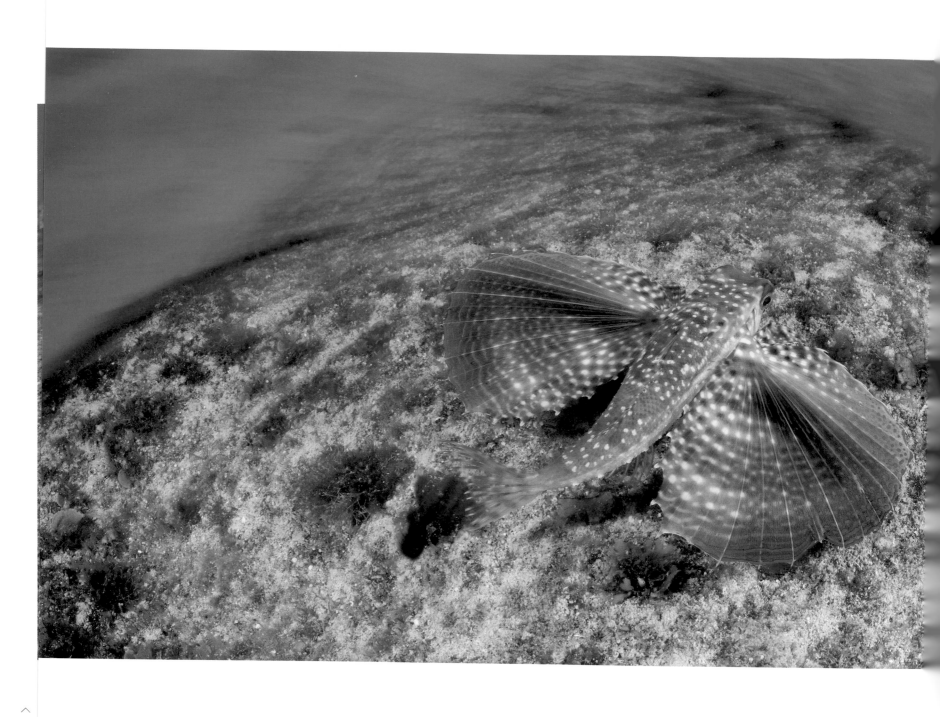

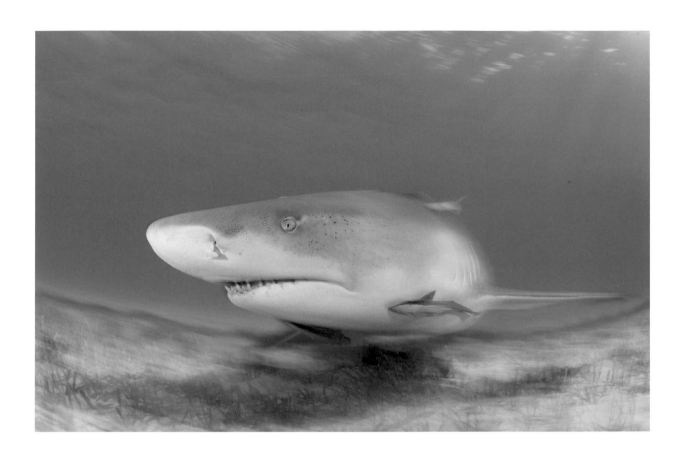

∧ Lemon shark with remoras

A lemon shark *Negaprion brevirostris* (2.5 m) with remoras *Echeneis naucrates*. Lemon sharks inhabit a variety of reef-associated habitats: the young favour the protection of the mangroves, while subadults tend to congregate in lagoons formed by fringing and barrier reefs. The adults range more widely, returning annually to their breeding grounds.

This species has long, thin teeth specialized for gripping fish, although it also feeds on larger reef invertebrates, like lobsters. It is known to feed on both trunkfish and pufferfish, although how it overcomes their poisons is not known.

Little Bahama Bank. Bahamas. West Atlantic Ocean.
Nikon D2X + 10.5 mm. 1/15th @ F20

A flying gurnard

This flying gurnard *Dactylopterus volitans* spreads its dramatically coloured 'wings' as it flees. Flying gurnards are cigar-shaped fish that feed on the seabed, walking on finger-like spines on their pectoral and pelvic fins.

When frightened, flying gurnards suddenly unfold large pectoral fins, dramatically changing their appearance, as they take off, swimming with an exaggerated waggle. Their wings are marked with bright iridescent blue lines and spots, which are thought to startle predators. Some species of grasshoppers and moths have similar startling patterns on their wings.

George Town, Grand Cayman, Cayman Islands. Caribbean Sea.
Nikon D2X + 16 mm. 1/8th @ F13

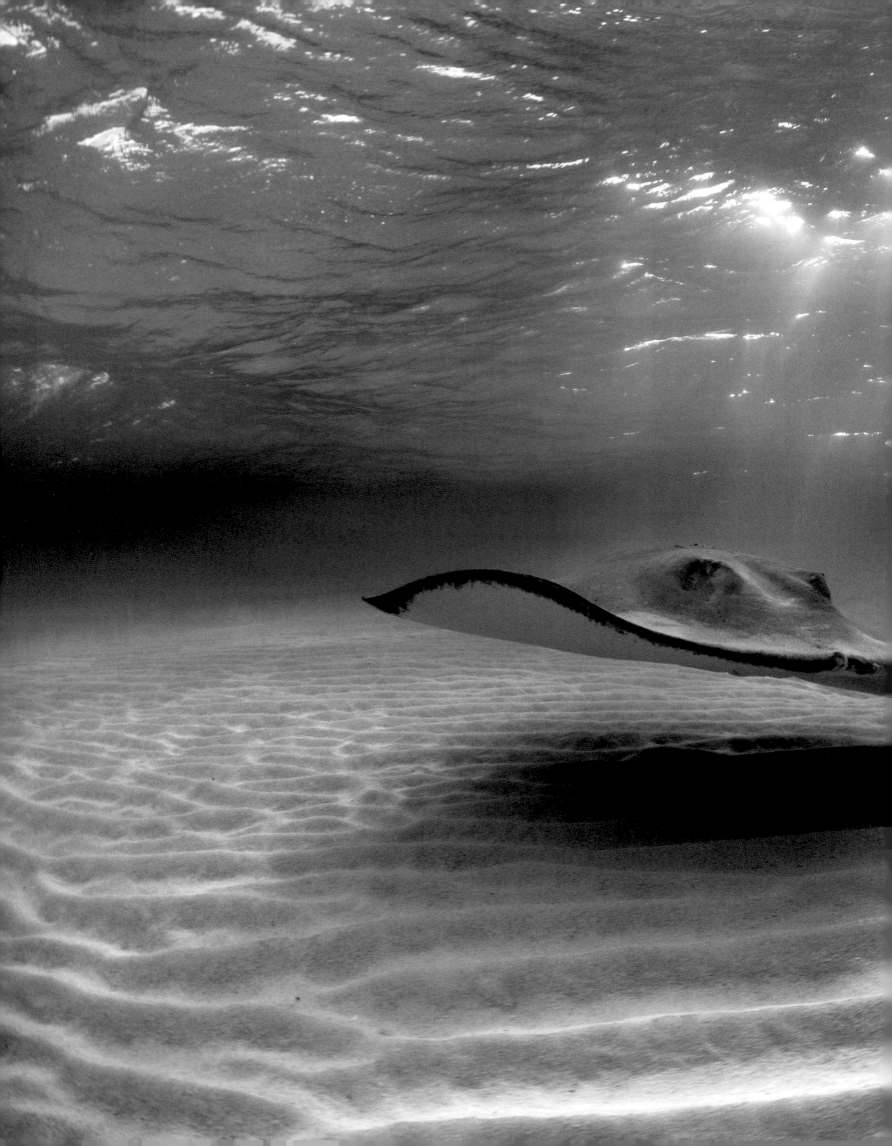

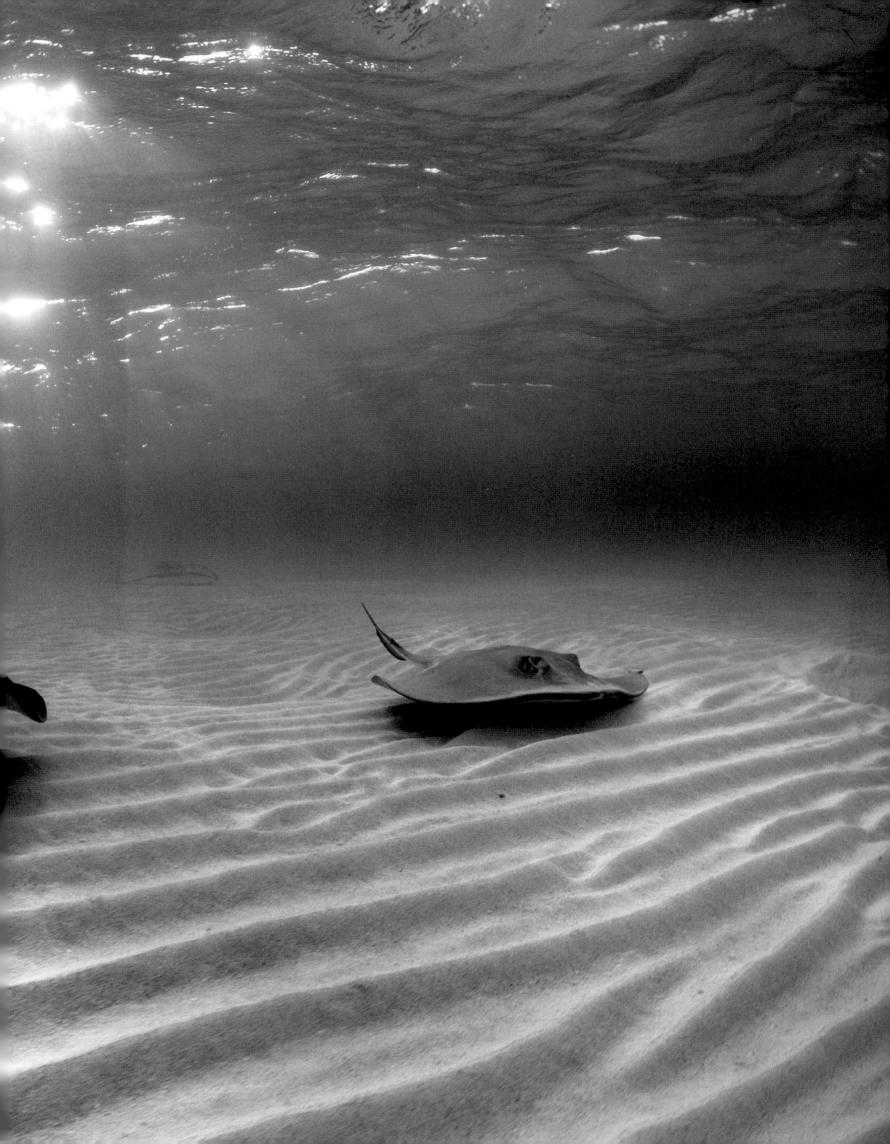

Southern stingrays *Dasyatis americana* glide over a sandbar at sunset, searching for molluscs and crustaceans. Their wide, flat bodies are an adaptation for life on the seabed. Stingrays hide by burying themselves until only their eyes protrude from the sand. Spiracles, openings behind each eye, allow rays to breathe when their mouths and gills are obstructed. In areas where they are common I regularly see their imprints in the sand, reminding me of snow angels.

North Sound, Grand Cayman, Cayman Islands. Caribbean Sea.
Nikon D2X + 10.5 mm. 1/125th @ F5.6

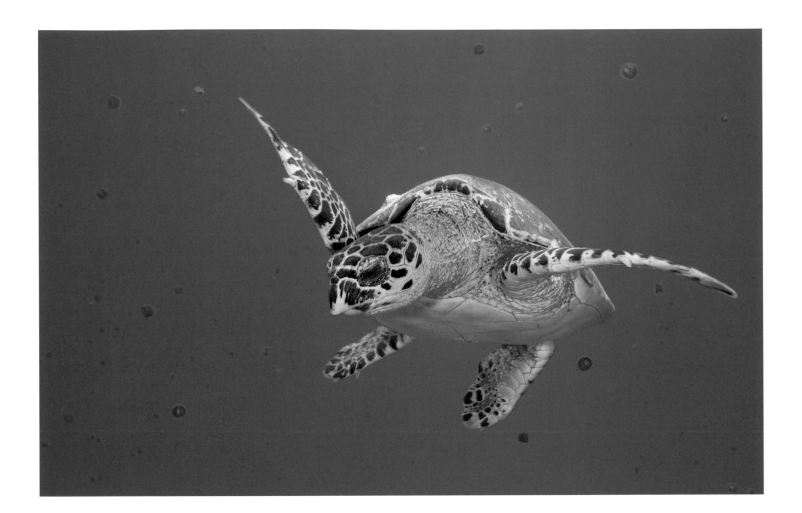

∧ Hawksbill turtle feeding on jellies

At about Easter time in the Caribbean it is common to get dense swarms of the small thimble jellyfish *Linuche unguiculata*, which provides a seasonal windfall for hawksbill turtles *Eretmochelys imbricata*. Although Caribbean hawhsbills more usually feed on sponges, they readily switch diet, swimming up into the open water above the reef to feed on the jellies.

Thimble jellyfish are probably best known because their microscopic larvae are a major cause of sea itch, but their unusual life history is equally interesting. Their swarms contain both male and female jellyfish and their main breeding season is in April and May. The resulting larval jellyfish do not stay in the water column for long and after a few days they stop swimming and attach themselves to the sea floor. Here they undergo an extraordinary transformation. The larvae change into polyps, similar to coral polyps, reproducing asexually and growing into a small colony. Over the winter young jellyfish grow attached to the colony in long chains, rather like a production line, and bud off one by one, developing into adults by the following spring.

North Wall, Grand Cayman, Cayman Islands. Caribbean Sea.
Nikon D2X + 28–70 mm. 1/125th @ F6.3

› Soft coral and green turtle

The common colourful soft coral *Dendronephthya* sp. lacks zooxanthellae (photosynthetizing algae) and often thrives in deeper water on reef slopes and walls. *Dendronephthya* have much weaker stings than hard corals and catch their prey by rapidly seizing particles and plankton that bump into one of their tentacles, which are covered in pinnules or lobes. The tentacle then pushes the food into the central mouth.

These inflatable soft corals are prickly to touch because of sharp calcium carbonate sclerites (plates) that support each polyp.

Sipadan Island, Sabah, Malaysia. Sulawesi Sea.
Nikon D2X + 10.5 mm. 1/200th @ F8

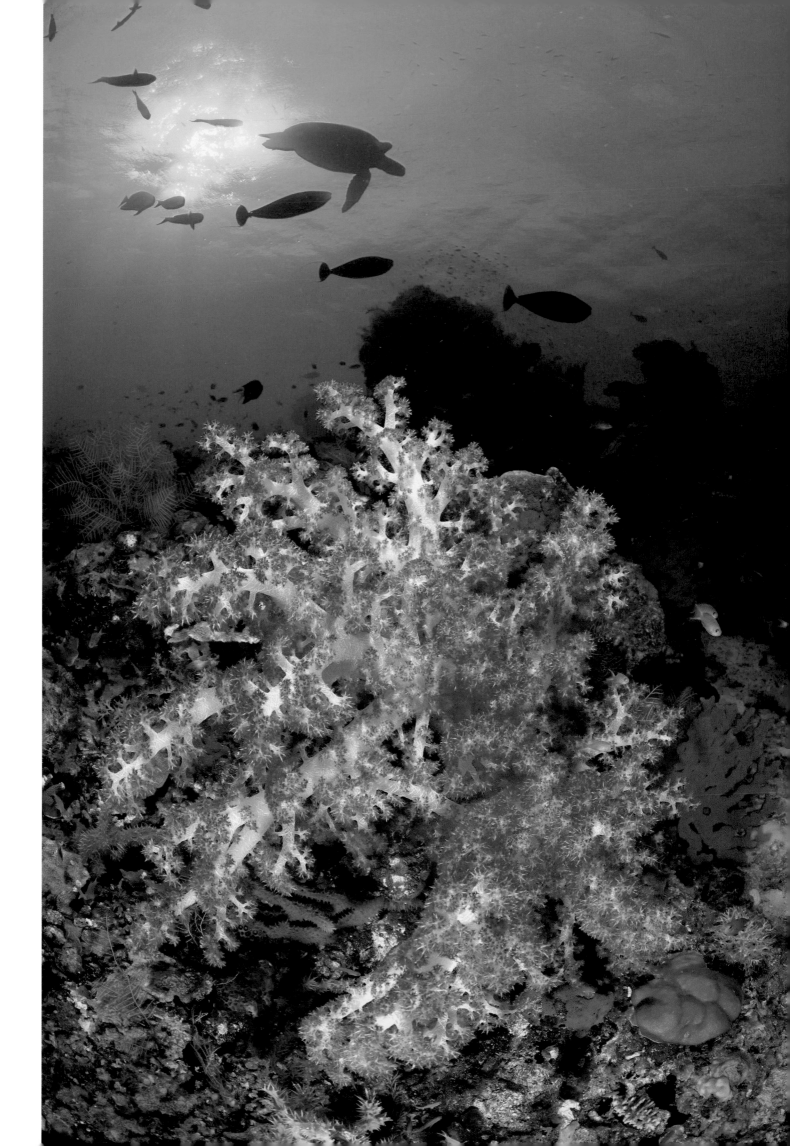

> Seafan with crinoid

A gorgonian seafan *Melthaea* sp. grows outwards and upwards from the reef to reach richer feeding conditions. Close to the reef, friction restricts the current, and filter feeders do not receive as abundant a supply of food in this lower boundary layer. Here an opportunistic black crinoid or feather star, also a filter feeder, has climbed high on a seafan for the same reason.

Many seafan species vary in shape and strength, in response to their local conditions. In stronger currents, seafans develop a smaller mesh to give them more rigidity.

Misool Island, Raja Ampat, Indonesia. Ceram Sea.
Nikon D2X + 10.5 mm. 1/50th @ F7.1

^ A pair of bigeyes

A pair of bigeyes *Priacanthus blochii*; their large eyes and red coloration are characteristic of nocturnal reef fish. Most reef fish either feed during the day or are active at night. Often both shifts on the reef use the same structures for shelter. Nocturnal species generally come from more ancient lineages of fish, and show less specialized feeding adaptations.

A few fish do not show any obvious diurnal behaviour patterns, particularly larger fish-eating predators such as barracuda and groupers, although these species often hunt most successfully during the transition periods at dusk and dawn.

Nuweiba, Gulf of Aqaba, Egypt. Red Sea.
Nikon D2X + 105 mm. 1/50th @ F9

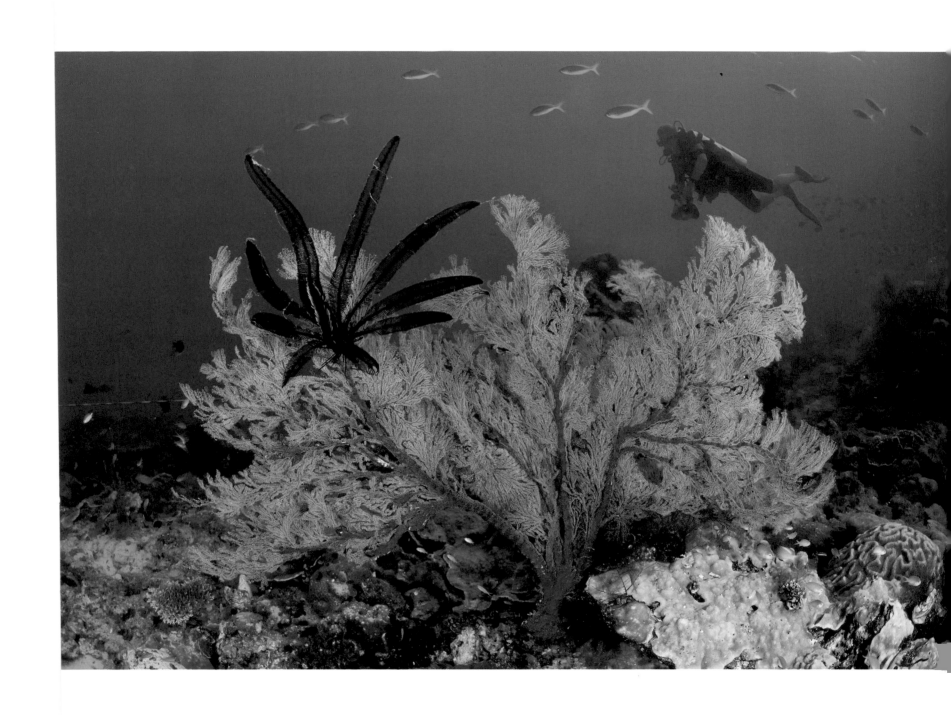

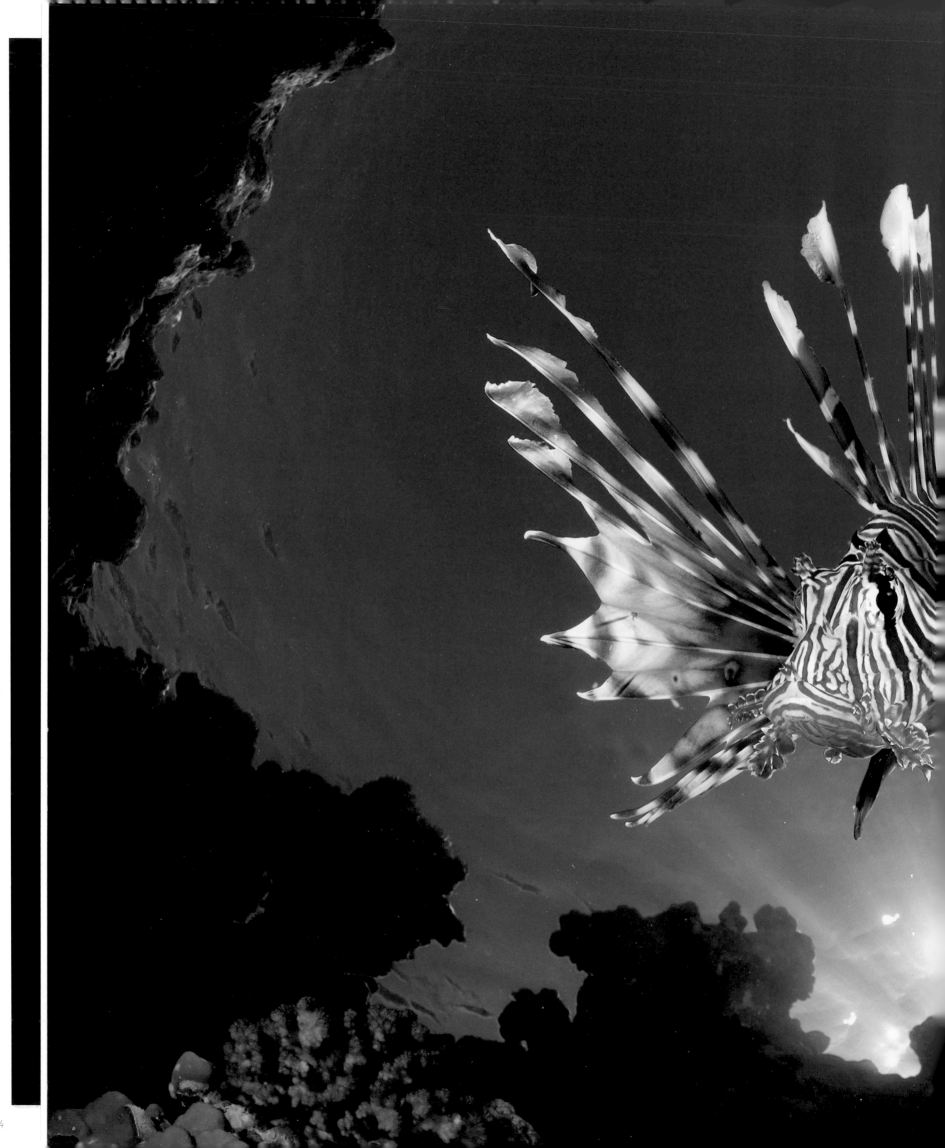

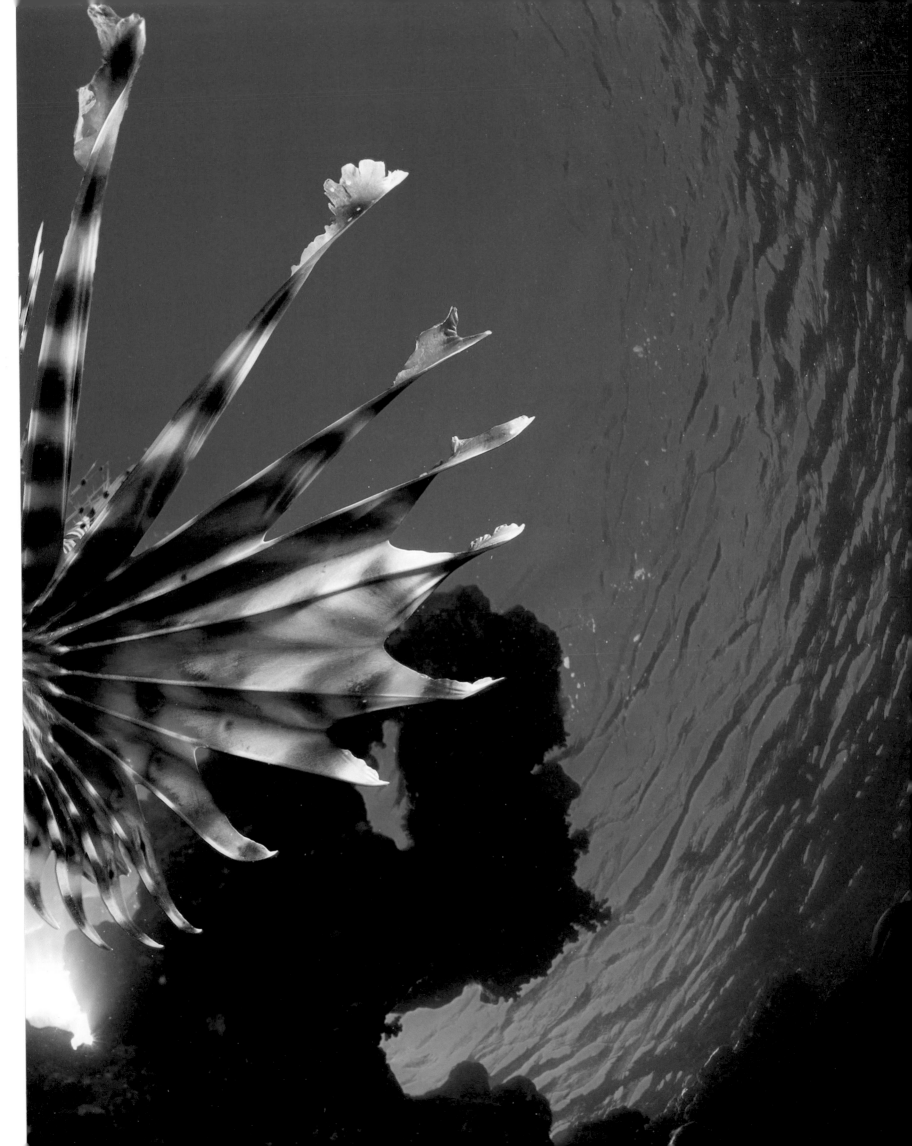

> Courting rock beauties

A larger male rock beauty angelfish *Holacanthus tricolor* courts a female. Rock beauties live in harems of three to five females to each male and mating takes place at dusk on most days. The males court the females in a circling spawning rise, then the male will nuzzle the female's abdomen as the pair swim further up from the reef and spawn.

Most pelagic spawning reef fish attempt to release their eggs high above the reef, which is thought to reduce predation from other reef species and to aid their dispersal into the plankton. The upward swimming also helps fertilization, as both eggs and sperm are thoroughly mixed together in the parents' wake.

Georgetown, Grand Cayman, Cayman Islands. Caribbean Sea.
Nikon D2X + 105 mm. 1/250th @ F6.3

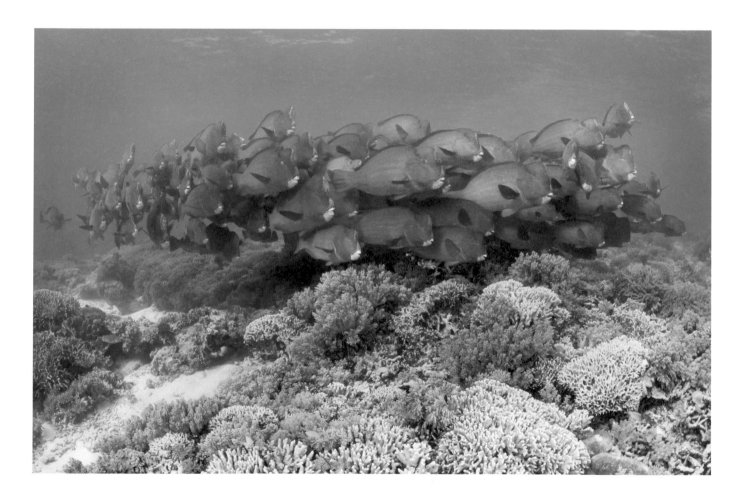

∧ Bumphead parrotfish school

A school of large (up to 1.3 m) bumphead parrotfish *Bolbometopon muricatum* herd on the reef in the early morning, migrating to their feeding grounds. Bumpheads are the largest species of parrotfish and feed by biting off chunks of algae-covered rock and corals with their beaks. These are then ground up with their pharyngeal mill, specialized teeth located in their throat.

The resulting sand passes through their guts and is defecated as as white coral sand. Parrotfish may produce as much as one ton of coral sand per acre of reef each year, being one of the main agents of reef erosion on sheltered reefs.

Sipadan Island, Sabah, Malaysia. Sulawesi Sea.
Nikon D2X + 10-17 mm. 1/40th @ F9

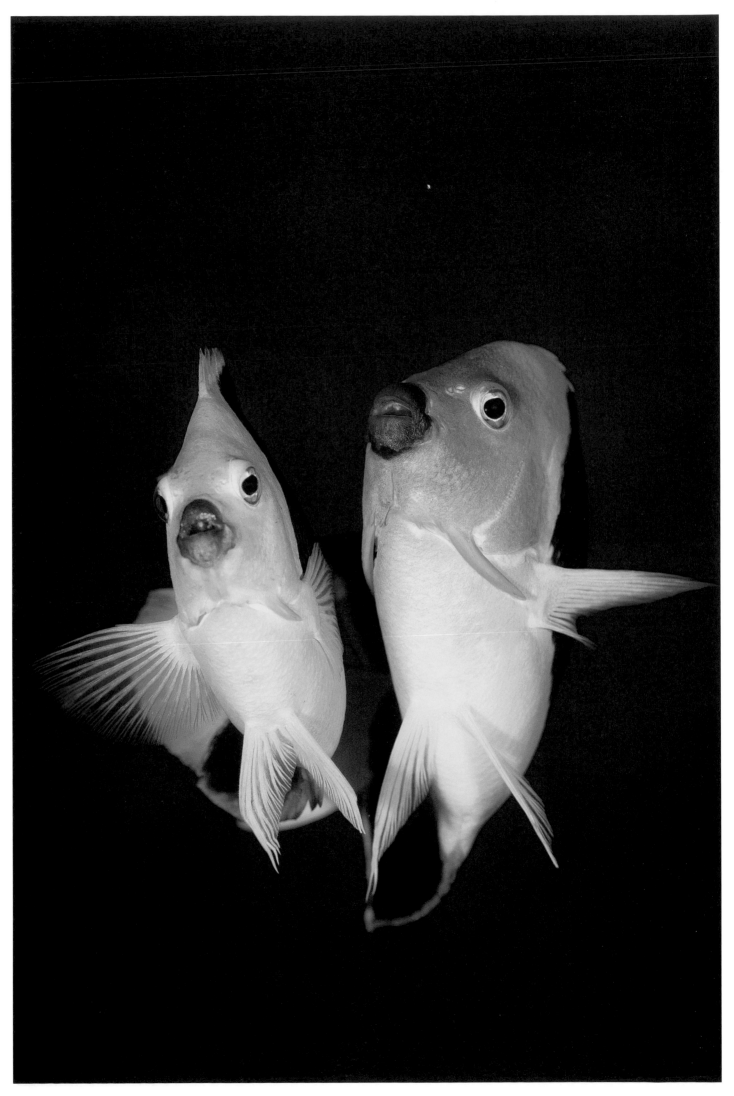

MATING HAMLETS

> Mating hamlets

At school we are taught that the evolution of a new species takes hundreds of millions of years, so we can never see it happen. While that is true, in reality it isn't quite that simple. Evolution is an inexorable process, and hamlets are one group of closely related reef fish that provide us with a rare glimpse of how species are formed.

Hamlets *(Hypoplectrus* spp.*)* are small Caribbean groupers that confound taxonomists who try to classify them. There are at least ten distinct colour morphs that are widespread in the Caribbean, and apart from their strikingly different colours they are anatomically indistinguishable. Some ichthyologists are convinced that they are all one species, while most recognize them as ten separate ones.

These days a scientist no longer needs to see an animal to classify it – the riddle of its evolution can be solved by the chemistry of its proteins. But even if we look at hamlet DNA, we find that different species from opposite sides of the Caribbean can be more closely related than individuals of the same species from the same reef. The explanation is that hamlets are so recently evolved that the species have not yet had time to genetically differentiate, and the variation seen in their genes is the remnants of that in their ancestors. All hamlets shared a common ancestor within the last 500,000 years – a blink of an eye in geological timescales. Hamlets are right in the grip of diversification.

The mechanism for speciation comes because hamlets are particularly choosy about their mates and almost always select identical colour morphs. Mixed pairs account for less than 5 per cent of matings and the resulting hybrids are even less common, usually making up about 1–2 per cent of the adult population. Each time a pair of the same colour morph of hamlet spawns they take a step closer to being distinct species. Each time a mixed pair hybridizes they take a step back.

Hamlets remind us that evolution is a relentless process, and we should not expect our definitions of species to be suitable for all animals. Charles Darwin was well aware that not all life fits neatly into boxes, and wrote: *'I have just been comparing definitions of species ... It is really laughable to see what ideas are prominent ... It all comes, I believe, from trying to define the undefinable.'* I think Darwin would have liked hamlets.

A) shy hamlets *Hypoplectrus guttavarius*
B) indigo hamlets *Hypoplectrus indigo*
C) butter hamlets *Hypoplectrus unicolor*
D) black hamlets *Hypoplectrus nigricans*
E) masked hamlets *Hypoplectrus providencianus*
F+G) hybrid spawning between shy *H. guttavarius* and yellowbelly *H. aberrans* hamlets

George Town, Grand Cayman, Cayman Islands. Caribbean Sea.

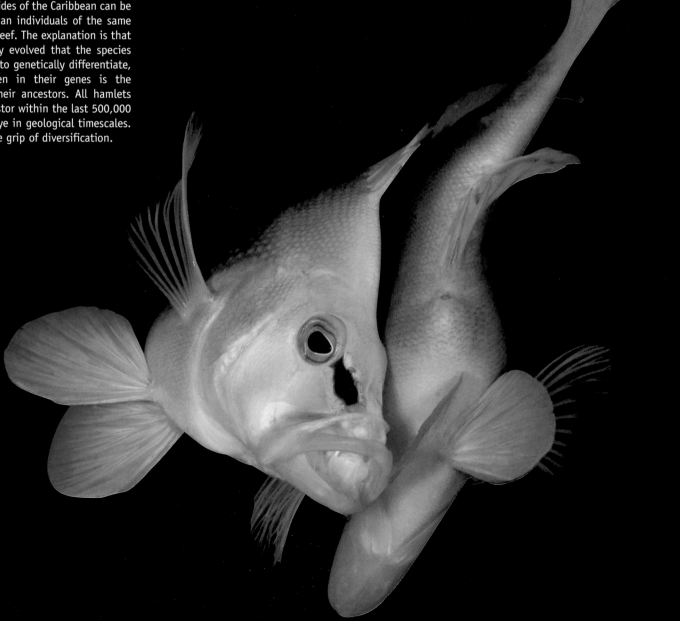

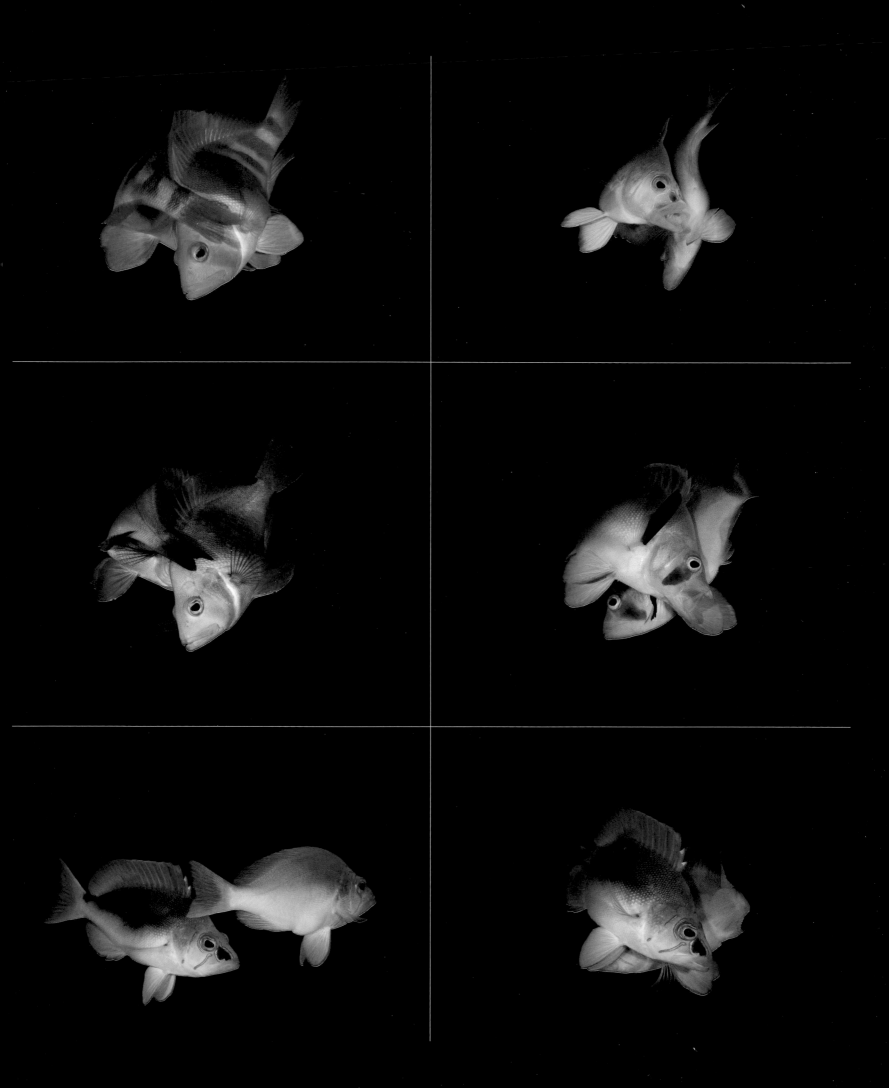

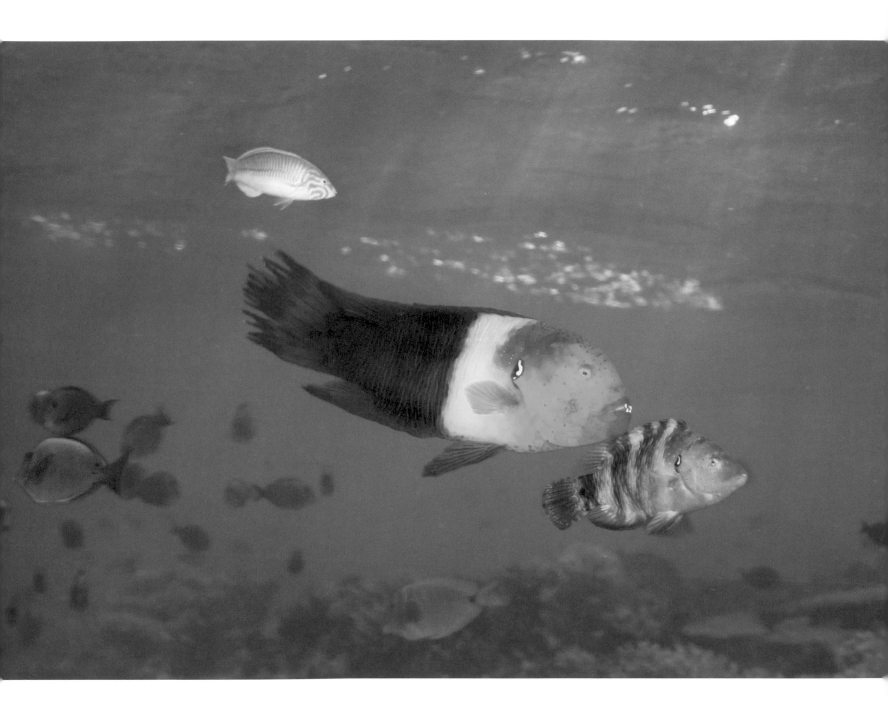

> Dancing male anthias

Male anthias *Pseudanthias squamipinnis* displaying. At dusk, during the summer in the Red Sea, the larger red-purple male anthias swim up above their harems and perform a mating dance with exaggerated waggling of their pectoral fins and tail. These displays are interspersed with U-shaped dives down through the females to further impress them.

Female reef fish produce and carry eggs all the time during the mating season, and the elaborate displays of males provide them with a stimulus and time to hydrate their eggs in preparation for spawning. The bellies of the female can swell prodigiously at this time.

Ras Mohammed, Sinai, Egypt. Red Sea.
Nikon D2X + 105 mm. 1/60th @ F7.1

> Spawning anthias

A male anthias *Pseudanthias squamipinnis* yawns as he spawns with a female. Note the fusiliers *Caesio* sp. in the background loitering downstream feasting on the eggs.

Once the female anthias are ready to spawn they rise up and join the males before engaging in a high-speed spawning dash into open water releasing eggs and sperm. This action becomes incredibly frenetic when hundreds of fish from a large colony start spawning all along the reef. Groups of bachelors, unable to assemble a harem of their own, lie in wait below and rush in en masse to try to spawn with as many females as they can before the resident males chase them off.

Ras Mohammed, Sinai, Egypt. Red Sea.
Nikon D2X + 105 mm. 1/13th @ F7.1

⌐ Mating broomtail wrasse

A mating pair of broomtail wrasse *Cheilinus lunulatus* at dusk. The male is much larger (40 cm) and more elaborately coloured than the smaller, drab female. Also note that a small Klunzinger's wrasse *Thalassoma rueppellii* is following the pair, hoping to feed on their nutritious eggs.

Sexual dimorphism is particularly prevalent in reef fish that change sex as they grow. Many species switch from females to dominant males, and as a result the males are usually larger, requiring brighter colours to attract their mates. During their sex change, females grow rapidly, their efforts free from producing energy-filled eggs.

Strait of Gubal, Gulf of Suez, Egypt. Red Sea.
Nikon D2X + 60 mm. 1/100th @ F6.3

Rhino triplefins spawning

A male rhino triplefin *Helcogramma cf. rhinoceros* (3 cm) shows off his stunning mating colours and long snout to a drab female as she lays eggs in his nest.

Many smaller reef species, such as blennies, gobies, seahorses, damselfish and anemonefish, give the young a better chance of survival by laying eggs and guarding them until they hatch. This strategy requires less energy dedicated to producing eggs, but more in looking after them. Males are often charged with the responsibility of guarding the eggs, while females continue feeding and producing the next clutch.

Seraya, Tulamben area, Bali, Indonesia. Java Sea.
Nikon D2X + 150 mm. 1/250th @ F13

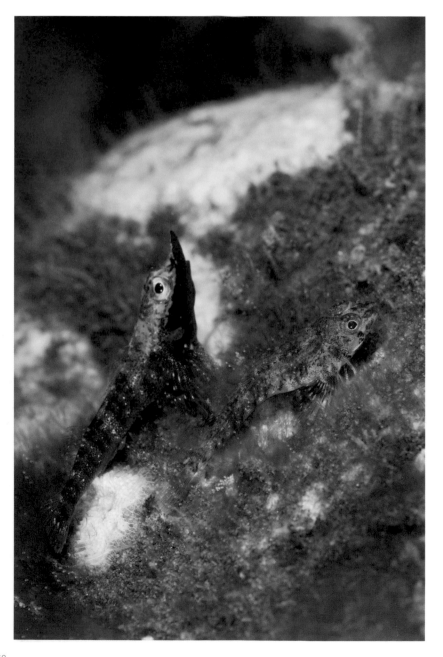

Bohar snapper and spawning aggregation

An adult bohar snapper *Lutjanus bohar* in front of its spawning aggregation. This species reaches a maximum size of 90 cm and matures at about 45 cm. A fearsome reef predator, it usually lives alone, but gathers annually for spawning. When caught and cooked, this species is one of several known as red snapper.

By comparison with smaller reef fish, the larger species produce fewer eggs in proportion to their body weight and tend to spawn less frequently. Their great spawning aggregations are known to attract the largest egg thieves, and both whale sharks and manta rays are known to turn up at dusk to feast off the dense clouds of eggs produced by these spectacular gatherings.

Ras Mohammed, Sinai, Egypt. Red Sea.
Nikon D100 + 105 mm. 1/45th @ F13

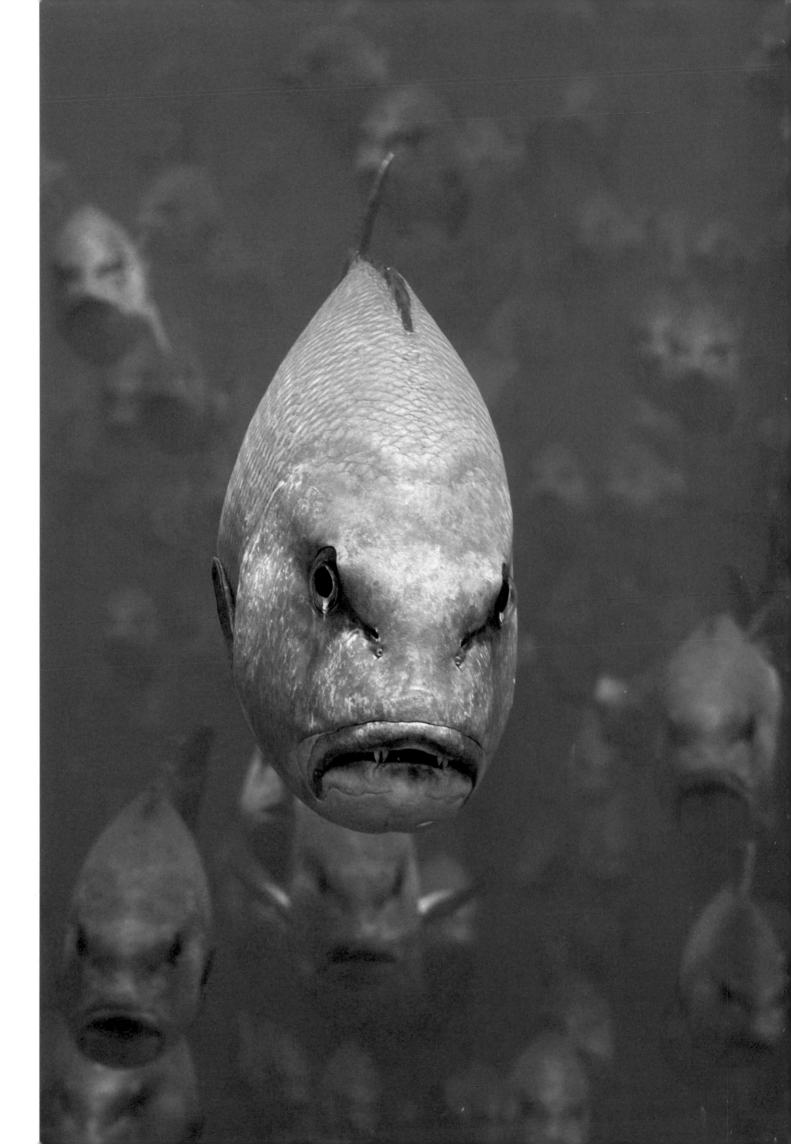

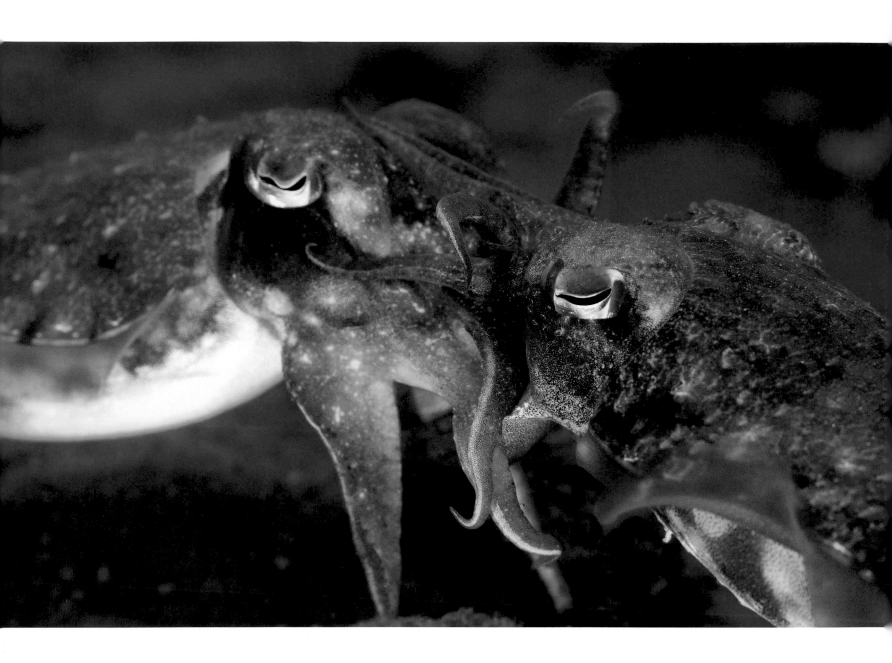

⌃ Mating cuttlefish

A male cuttlefish *Sepia pharaonis* wraps his arms around the face of a female as he deposits a sac of his sperm into her spermatheca, a pouch beneath her mouth. The eggs are not fertilized at this point. Fertilization occurs when the eggs rub against the sperm sac just before the female lays them.

A male cuttlefish usually stays close to the female until she has laid all her eggs, guarding her from other males, which would try to flush out the first sperm sac and replace it with their own. Cuttlefish do not have a pelagic larval stage and the young hatch look like miniature versions of the adults.

Seraya, Tulamben area, Bali, Indonesia. Java Sea.
Nikon D2X + 105 mm. 1/100th @ F6.3

Nudibranch laying eggs

A nudibranch *Hypselodoris bullockii* laying its bright ribbon of eggs that warns of their toxicity. Sea slugs are simultaneous hermaphrodites, performing both sexual roles with a self-explanatory reproductive gland called the ovotestis.

They are not capable of self-fertilization, instead mating is reciprocal with both individuals providing sperm to fertilize the other's eggs. Fertilization of the eggs occurs independently of mating, when the eggs are laid.

The nudibranch's larvae join the plankton and have a shell, which is lost when they transform to adults and begin life on the reef.

Kaimana region, South Bird's Head peninsula, West Papua, Indonesia.
Nikon D2X + 105 mm. 1/250th @ F20

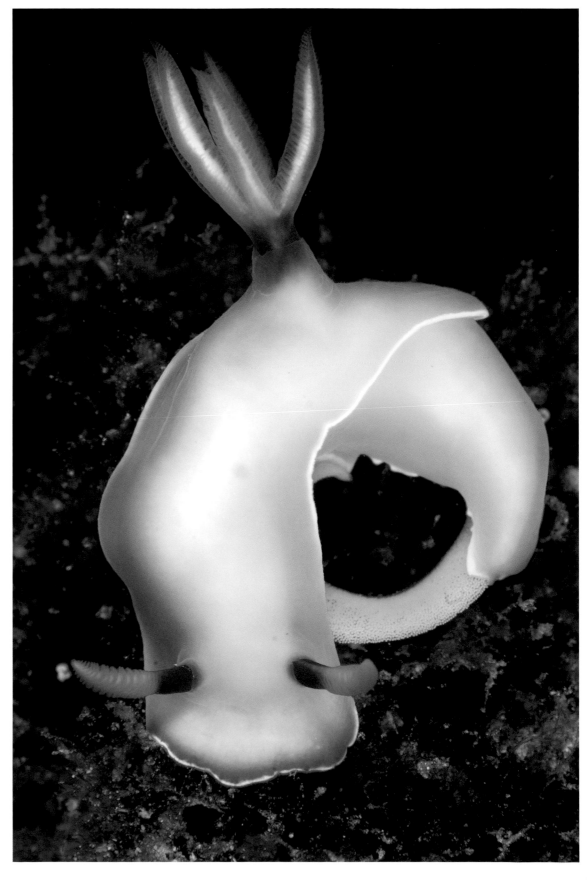

> ## Sponges and crinoids on a sloping reef

Axinellida sponges and crinoids grow on a reef slope. There are more than 5,000 species in the diverse group that were the first multi-cellular animals, originating more than 650 million years ago.

Sponges were the earliest animal reef builders. Ancient vase-shaped *Archaeocyathids* constructed reefs in the shallow seas more than 500 million years ago, creating a habitat occupied by many marine species. Sponges remain important members of the reef community, although a number of species are more active as reef destroyers, boring their way into coral rocks to create a space to live.

Seraya, Tulamben area, Bali, Indonesia. Java Sea.
Nikon D2X + 10.5 mm + 15x TC. 1/30th @ F6.3

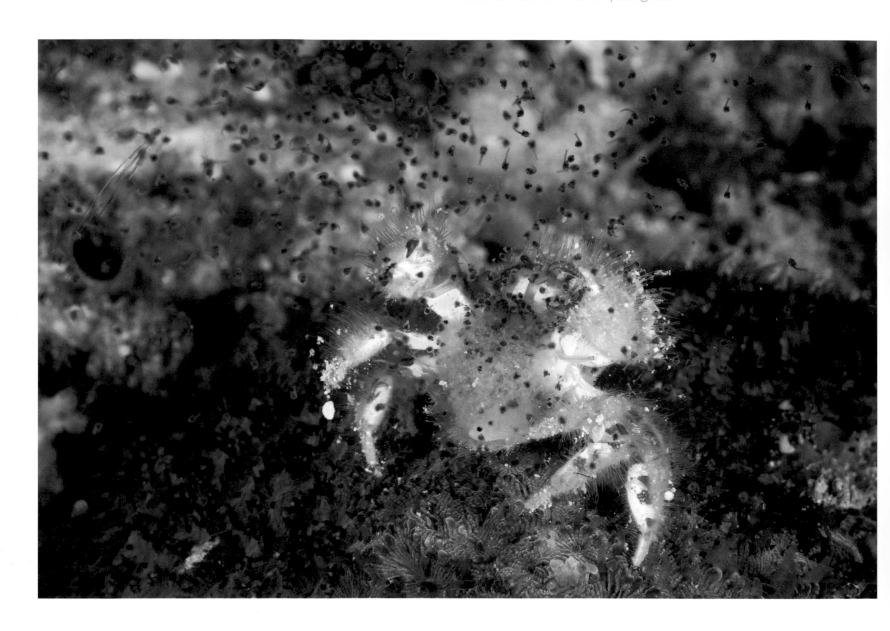

A crab releases larvae

A female xanthid crab climbs up on to a coral before she releases her zoea larvae. Many crustaceans carry their eggs around until they are ready to hatch and join the plankton, giving them a head start in this 'eat or be eaten' community.

Crab zoea are the microscopic medieval knights of the ocean, with long spines on their armoured-helmet-like carapace. Despite many years on the microscope studying plankton samples, I still rate crab zoea as my favourite larvae!

Kaimana region, South Bird's Head peninsula,
West Papua, Indonesia.
Nikon D2X + 60 mm. 1/200th @ F29

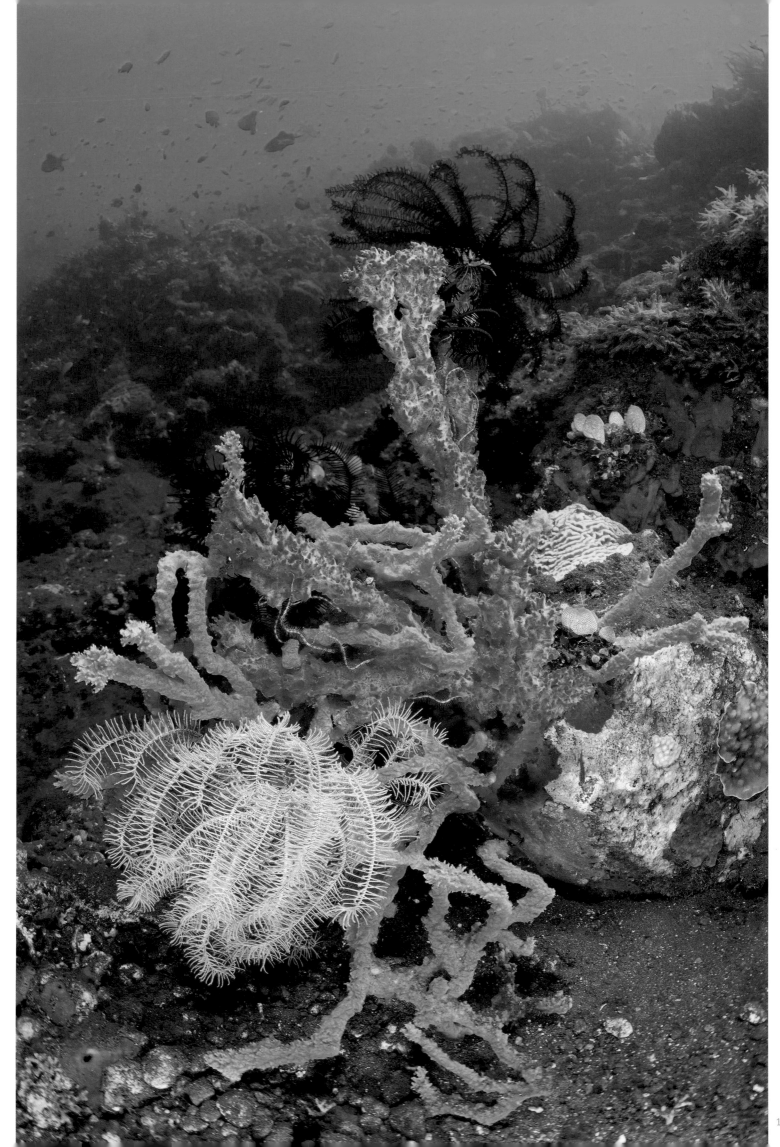

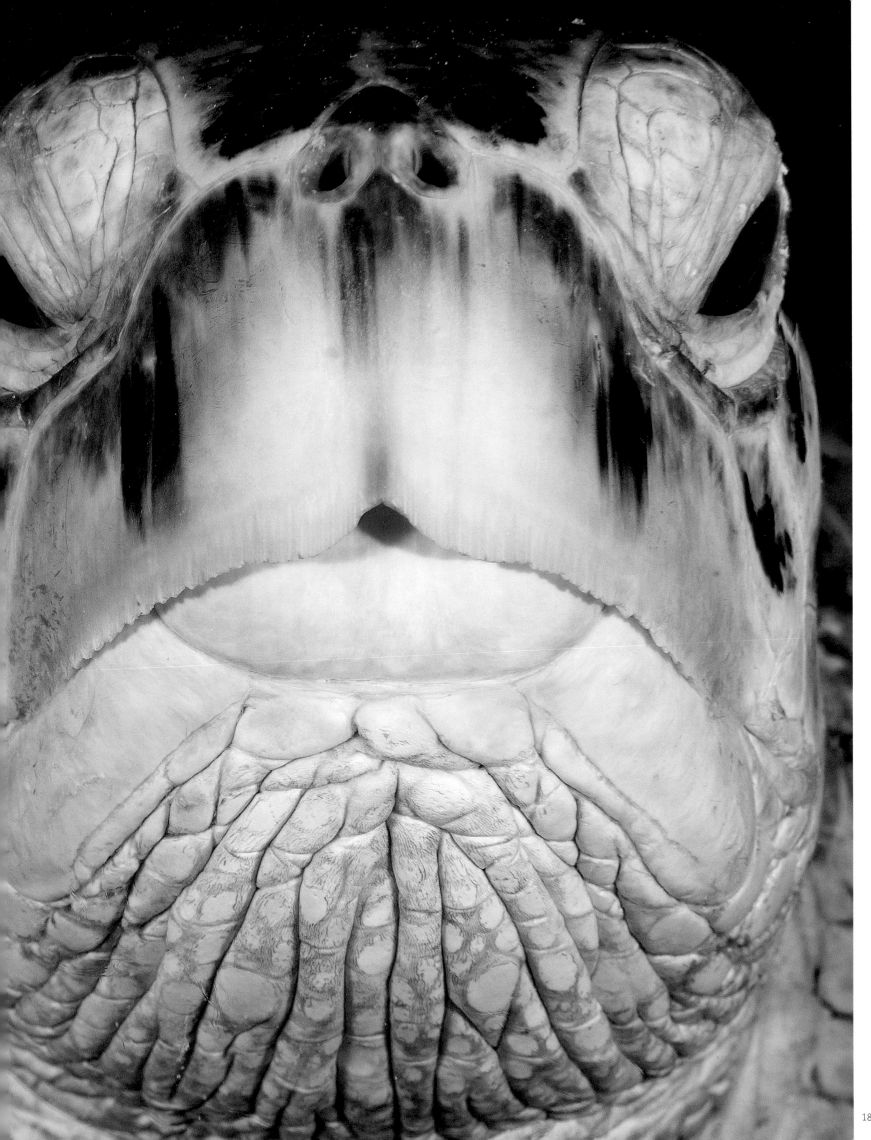

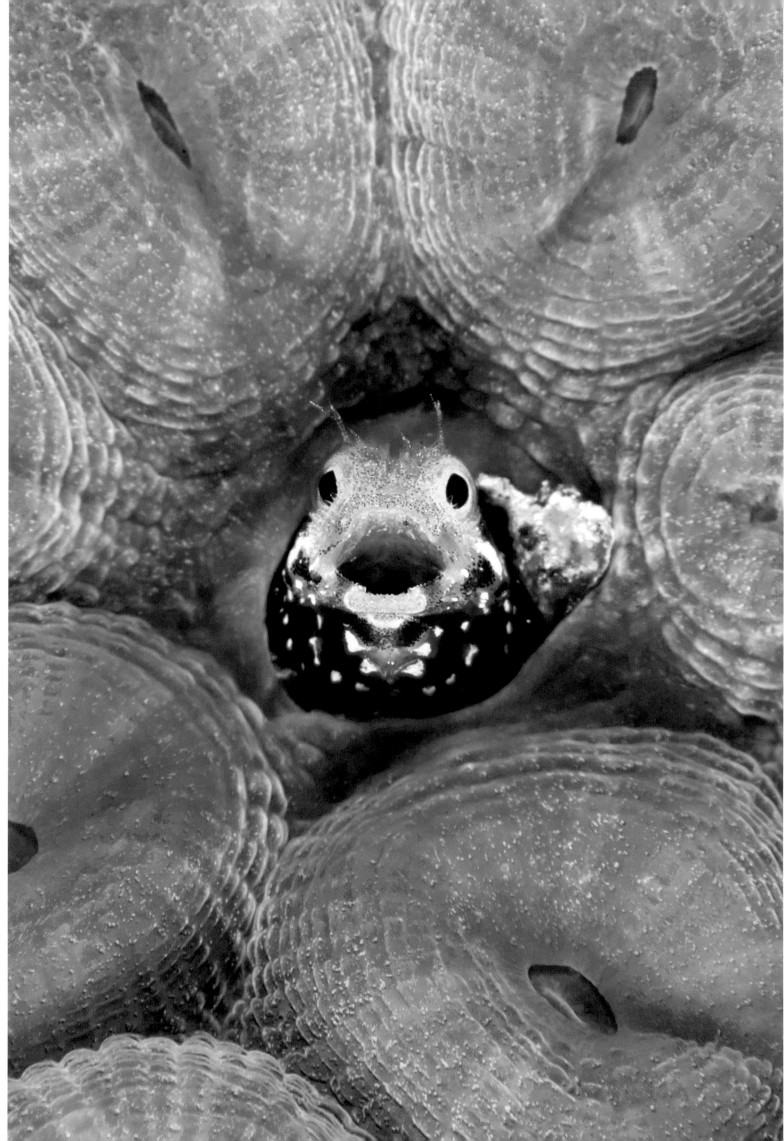

A green turtle

A mature green turtle *Chelonia mydas* observes the photographer as she has her picture taken. Coral reefs flow with life and it is the sheer accessibility of this underwater world of biodiversity that is probably their greatest charm for the visitor.

For me, this is the finest environment on the planet for observing wildlife – not only are the animals painted in the most staggering array of brilliant colours, but they are also packed in like sardines. Coral reef animals are also amazingly accepting of our presence. Being able to observe animals going about their everyday lives and witnessing their natural behaviour is as good a measure as any that our presence in their home is not an intrusion.

Sipadan Island, Sabah, Malaysia. Sulawesi Sea.
Nikon D2X + 28–70 mm. 1/60th @ F10

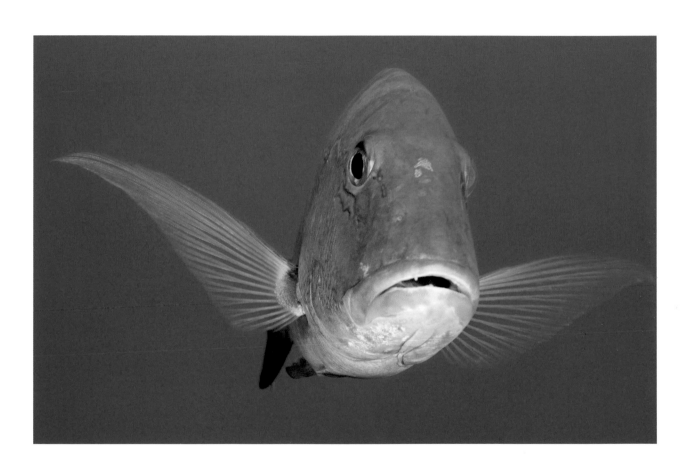

Secretary blenny living in a tube in the coral

A secretary blenny *Acanthemblemaria maria* looks out of its tube in a great star coral *Montastrea cavernosa*. Gregarious tube blennies tend to occupy old wormholes and form small colonies with a strict social hierarchy. The larger dominant males occupy the most spacious worm tubes and prefer holes highest up in the colony, where they have the easiest access to their planktonic food.

I regularly see tube blennies without tubes. These are usually young individuals, and out in the open they are very vulnerable to predation. If they do not find a tube quickly they will be eaten. When one of the dominant blennies in a colony dies the next blenny in the pecking order will take over its hole, and all the blennies in the colony end up taking one step up the property ladder!

West Bay, Grand Cayman, Cayman Islands. Caribbean Sea.
Nikon D100 + 105 mm. 1/180th @ F32

∧ A mutton snapper

A mutton snapper *Lutjanus analis* hovers above the reef at a cleaning station. Like many larger reef species it is heavily exploited by fishing and is listed as threatened in the IUCN Red List of endangered species.

Reefs are highly productive and can make good fisheries if they are properly managed but this is rarely so. The prevalence of destructive fishing practices, such as trawling and dynamite fishing, which damage the reef structure, is particularly worrying.

Fishing has wider impacts beyond depleting fish stocks. Reef fish also play important roles in the whole ecosystem; for example, herbivores keep levels of algae down and thus maintain the balance between seaweeds and corals.

Georgetown, Grand Cayman, Cayman Islands. Caribbean Sea.
Nikon D2X + 28–70 mm. 1/60th @ F8

NOTE ON THE PHOTOGRAPHY

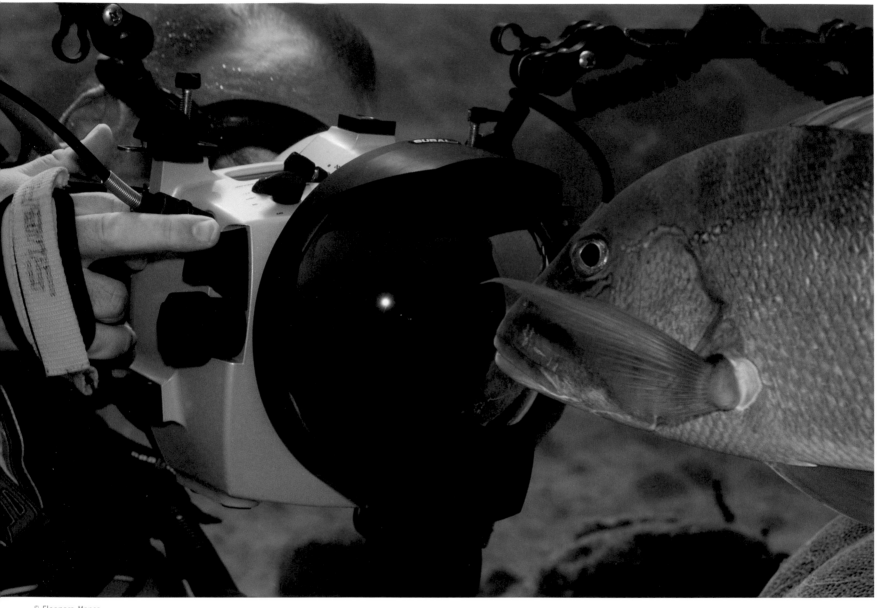

© Eleonora Manca

My aim with *Reefs Revealed* is to celebrate the wonders of life on coral reefs. Coral reefs are severely threatened by human activities, but I have chosen not to include photographs of damaged or dead reefs in this collection (although sadly I have been able to take many). Instead I hope that this book helps you to understand reefs and their inhabitants more intimately, and that it demonstrates what stands to be lost and shows why reefs must be conserved.

I took my first underwater photographs on a coral reef when I was nine years old and I guess I have been working on this collection, with a few distractions along the way (school, PhD, jobs, etc.), ever since. I am a marine biologist by training, and until three years ago this was my full-time profession. Undeniably my education and experience influence my photographic style, giving me the advantage that when I approach a subject I know the biological stories I want to tell with my images. You can take the marine biologist out of the lab, but you can't take the marine biologist out of the photographer …

Academic description alone, whether by word or biologically themed image, cannot adequately capture the essence of a coral reef. Although this book contains many photographs that show the behaviours and adaptations of reef species to their lives, I have deliberately also included wholly non-scientific images that I feel reveal the personality or the character of the creature I was photographing. These are the individuals that are averaged out by the statistics of a scientific study, but are usually our most indelible memory from any visit to a reef.

Coral reefs vary a great deal around the world and I wanted to reveal both the similarities and differences and to provide a balanced regional coverage. Many recent coral reef books have focused entirely on the most diverse reefs found in south-east Asian seas of the tropical West Pacific. Here I have tried to include approximately equal numbers of photographs from the coral communities of the tropical Pacific, Atlantic and Indian Oceans. Caribbean reefs seem particularly unfashionable with photographers. Yet some of the reef's most intriguing natural history stories come from their endemic fauna. The photographers who shun this region miss out.

EQUIPMENT

Unusually for a professional photographer, I only have one camera, but I am pleased to say that my Nikon D2X has been 100 per cent reliable throughout this project. This camera goes underwater in a Subal housing with lighting provided by Subtronic strobes, positioned with arms from Ultralight. When photographing for a book there is a need for more lenses than for a magazine shoot, to give the larger image collection more visual variety. The lenses I used for this book were: (Nikon unless stated) 10.5 mm FE, 12–24 mm, 16 mm FE, 17–35 mm, 17–55 mm, Sigma 28–70 mm, 60 mm macro, 105 mm macro, 105 mm VR macro, Sigma 150 mm macro. I always used close-up dioptres to improve corner sharpness with wide angle rectilinear lenses (12–24, 17–35 and 17–55 mm) behind dome ports. I also used close-up dioptres (such as Nikon 5T and Canon 500D) for extra magnification in many macro photographs. For wide-angle photography without flash I used the Magic Filter extensively. I also used a Kenko 1.5x teleconverter in conjunction with 10.5 mm fisheye for macro wide-angle photographs. Photographic settings are included in each caption, although for brevity I have not listed filters or strobes used.

MANIPULATION

Photoshop is a powerful and controversial tool in digital photography. In wildlife photography I feel it is important that photographs offer an accurate representation of the natural world, as it appeared through the viewfinder. With the exception of a handful of images all marked [m] in their caption, no photographs have had their content manipulated in Photoshop: nothing has been added and nothing has been taken away. One of the exceptions is where four frames of the same seahorse were composited together to tell a story that would be impossible in a single frame. I feel that the few manipulated images I have used in the book are justified because of the stories they communicate and add artistically to the collection.

TECHNIQUES

Digital cameras have introduced many new techniques and possibilities for the underwater photographer. I also believe that they have instigated a change in our mandate. In the good ol' days we considered ourselves as the privileged few who got to see the wonders of the underwater world. Our job was simply to record what we saw to share it with those who never would. These days we have to credit our audience with more sophistication. The average person in the street knows what an anemonefish looks like. As a result our mandate is no longer to merely record what we see, but to add our photographic interpretation to our subjects. A portrait photographer does not just take passport photos, and I believe the same should be true underwater. My technical goal

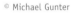
© Michael Gunter

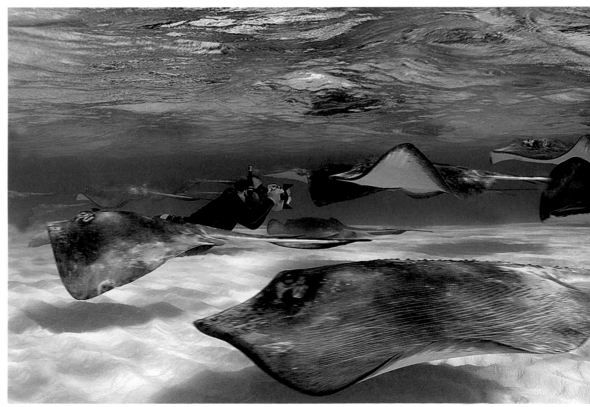

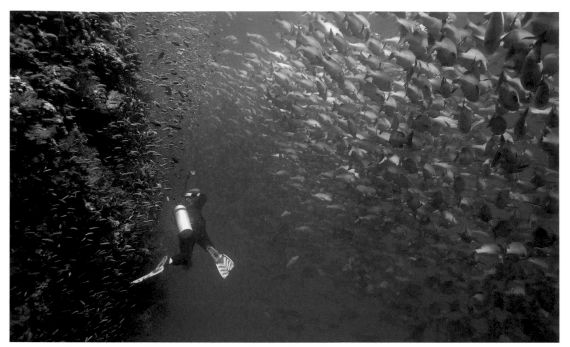

photographs with a macro foreground portrait of a subject set in an expansive wide-angle background.

Finally, fish are reputedly uncooperative photographic subjects and I am often asked how I am able to find willing individuals that allow me to take such revealing portraits or natural behaviours. My usual explanation is that I do not eat fish and I think that the subjects can tell I am not a threat. But the truth is simply spending lots of time with my subjects, waiting until they are relaxed, trying to get as close as possible and only taking pictures when they are ready. Digital cameras have made many new techniques possible in underwater photography, but the basic rules remain the same. Although you could always try not eating fish.

with this project was to harness the new possibilities of digital cameras to create a stunning and original collection of coral reef images.

Reefs are extraordinary ecosystems, characterized by colourful, bustling life. I was keen to reveal the vibrancy of reef life in colourful and dynamic photographs, often showing movement blur. Whenever possible I tried to shoot balanced light images, where the illumination from my flashguns was balanced with the ambient light to help place a creature or behaviour in its natural setting. I often used reasonably long exposures to achieve this. I found that the vibration reduction of Nikon's new 105 mm VR lens was a great benefit for long exposure macro photographs.

Much of the photography in this book used many of the traditional techniques of underwater photography. But here I would like to mention three of the new techniques because I have played a large part in pioneering them. First was the use of filters, specifically the Magic Filter that I developed, which has revolutionized what is possible in wide-angle available light photography. This technique was useful for capturing the broad vistas of coral gardens, schooling fish, large marine life and shipwrecks seen in this book. Second was underwater telephoto that used the 105 mm and 150 mm lenses in non-macro photography and which was a key element of producing striking portraits of larger marine life. And third there was the macro wide-angle technique, which combines the 10.5 mm Fisheye lens with a 1.5x Teleconverter to produce

ENVIRONMENT

Underwater photographers often have a bad reputation for damaging coral or harassing marine life in their pursuit of photographs. Such behaviour is totally unacceptable and also unnecessary as long as the photographer has proper buoyancy skills. I take great care when I am underwater not to harm the reef and will turn down a photo opportunity if I think that I might cause damage to get the shot. Furthermore, to capture revealing portraits or intimate behaviour I really must win the trust of my subjects, and this is not achieved by hounding them or crashing into corals.

As divers we must also remember that our responsibilities to the marine environment do not end when we surface. There is no point spending a dive being careful not to touch the coral and then ordering a grouper for dinner. When we are travelling we should also think about our demands for water, food, power and waste disposal and we should consider our carbon footprint. I have offset all the carbon emissions produced by the air travel required for this book with Climate Care (www.climatecare.org). Finally, it is important that we do not think of reefs as distant from our daily lives, the decisions we make each day about the products we demand and the emissions we produce do make a difference on a global scale. Surely we should do our utmost to conserve this remarkable ecosystem.

SELECTED BIBLIOGRAPHY

Brahic, C. (2007) 'The Impacts of Rising Global Temperature'. *New Scientist*, February 2007.

Davidson, O. (1998) *The Enchanted Braid. Coming To Terms With Nature On The Coral Reef*. John Wiley & Sons, Inc. New York, USA.

DeLoach, N. & Human, P. (1999) *Reef Fish Behavior, Florida, Caribbean, Bahamas*. New World Publications Inc. Florida, USA.

Ferrari, A. & Ferrari, A. (2004) *Oceani Segreti*. Mondadori Electa SpA. Milan, Italy.

Ferrari, A. & Ferrari, A. (2006) *A Diver's Guide To Reef Life*. Nautilus Publishing, Malaysia.

Gosliner, T., Behrens, D. & Williams, G. (1996) *Coral Reef Animals of The Indo-Pacific*. Sea Challengers Natural History Books, California, USA.

Grimsditch, G. & Salm, R. (2006) *Coral Reef Resilience and Resistance to Bleaching*. IUCN, Gland, Switzerland.

Halstead, B. (2000) *Coral Sea Reef Guide*. Sea Challengers Natural History Books, California, USA.

Hanna, N. & Mustard, A. (2006) *The Art of Diving*. Ultimate Sports Publications. London, UK.

Human, P. & DeLoach, N. (2002) *Reef Fish Identification, Florida, Caribbean, Bahamas*. Third Edition. New World Publications Inc. Florida, USA.

Intergovernmental Panel On Climate Change (2007) *IPCC 4th Assessment Report – Climate Change 2007*. IPCC, Paris, February 2007.

Kleypas, J., Feely, R., Fabry, V., Langdon, C., Sabine, C. & Robbins, L. (2006) *Impacts of Ocean Acidification on Coral Reefs and Other Marine Calcifiers*. A Guide for Future Research, report of a workshop, St Petersburg, Florida, sponsored by NSF, NOAA, and the U.S. Geological Survey.

Kuiter, R. & Debelius, H. (2006) *World Atlas Of Marine Fishes*. IKAN Publishing. Germany.

Marshall, P. & Schuttenberg, H. (2006) *A Reef Manager's Guide to Coral Bleaching*. Great Barrier Reef Marine Park Authority, Townsville, Australia.

Perrine, D. (1997) *Mysteries of the Sea*. Publication International Ltd. Illinois, USA.

Petrinos, C. (2001) *Realm of the Pygmy Seahorse*. Starfish Press, Athens, Greece.

Pitkin, L. (2001) *Coral Fish*. The Natural History Museum, London, UK.

Porter, J. & Tougas, J. (2001) *Reef Ecosystems: Threats to Their Biodiversity*. Encyclopedia of Biodiversity, Vol. 5. Academic Press, California, USA.

Reader's Digest (1984) *Great Barrier Reef*. Reader's Digest, Sydney, Australia.

Sale, P. (Ed.) (1991) *The Ecology of Fishes on Coral Reefs*. Academic Press, California, USA.

Sale, P. (ed.) (2002) *Coral Reef Fishes: Dynamics and Diversity in a Complex Ecosystem*. Academic Press, California, USA.

Sorokin, Y. (1995) *Coral Reef Ecology*. Ecological Studies, Vol. 102. Springer-Verlag. Berlin, Germany.

Stafford-Deitsch, J. (1991) *Reef, a Safari Through the Coral World*. Headline Book Publishing PLC. London, UK.

Steene, R. (1999) *Coral Seas*. New Holland Publishers, London, UK.

Stern, N. (2007) *Stern Review on the Economics of Climate Change*. Cambridge University Press, UK.

Waddell, J. (Ed.) (2005) *The State of Coral Reef Ecosystems of the United States and Pacific Freely Associated States*. NOAA Technical Memorandum NOS NCCOS 11. USA.

Wilkinson, C. (ed.) (2004) *Status of Coral Reefs of the World: 2004*. AIMS: Townsville, Australia.

Wood, R. (1999) *Reef Evolution*. Oxford University Press. Oxford, UK.

ACKNOWLEDGEMENTS

Undertaking a project as large as *Reefs Revealed* just would not be possible without the help of many people. Indeed one of the privileges of working on a project like this is that it has allowed me to make many new friends all filled with contagious enthusiasm for coral reefs.

I am particularly grateful to the many dive resorts, liveaboard and dive centres that have hosted me during the photography for this book. I only have space to list company names here, but it is the people behind these names that have made my trips so productive and enjoyable. Thank you. In Bali: Scuba Seraya Resort, Diving 4 Images, Bali Hai Diving Adventures, Geko Dive, Zen Resort Hotel, Water Garden Hotel, Mimpi Resort Menjangan and Mimpi Divers. In Grand Cayman: Ocean Frontiers, Dive Tech, Sunset House, Deep Blue Divers, Compass Point and Villas of the Galleon. In the Maldives: Maldives Scuba Tours and MY *Sea Queen*. In West Papua: Diving 4 Images and MY *Seahorse*. In Florida and the Bahamas: Jim Abernethy Scuba Adventures, Wetpixel and MV *Shearwater*. In Malaysia: Seaventures Dive Resort, Kapalai Dive Resort, Borneo Divers Mabul Resort and Scubazoo. In the Red Sea: Tony Backhurst Scuba Travel, Tornedo Marine Fleet, MV *Cyclone* and MV *Typhoon*, Emperor Divers, Divers La Siréne and the Coral Hilton Nuweiba. In Sulawesi: Kungkungan Bay Resort, Santika Manado Hotel, Eco Divers, and Thalassa Dive Centre. In addition I would like to thank Divequest, Andrea and Antonella Ferrari, Robert Delfs, Paul Lees and Steve Broadbelt for their help with my travels.

I would also like to thank Steve Warren and the gang at Ocean Optics in London for supplying and looking after my underwater camera equipment, and Tony Clark FRPS and his team at London Camera Exchange, Southampton for supplying my camera and lenses. I would also like to thank Subal housings, Cameras Underwater, Cathy Church's Underwater Photo Center, Ikelite, Nikon Professional Service UK, Sigma UK and Magic Filters for their products and support. Throughout this project my strobes have been less than reliable and I am very grateful to my friends JP Trenque and Jane Morgan for lending me their strobes at short notice. I am grateful to Scubapro for providing me and my underwater models with first-class diving equipment, particularly to Andy Shears, James Lutener and Laura Edwards of Scubapro UWTEK UK.

I must also express my gratitude for the erudite advice of two of the governors of British underwater photography: Peter Rowlands and Martin Edge. Peter travelled with me on several of the shoots for this book and provided invaluable suggestions and encouragement. He also appears in several images – a large object is useful to give some scale. I have never dived with Martin, but he took time out from his busy teaching schedule to visit me and made a very significant contribution in helping create the shortlist of photographs. His wise eye did much to sort out the wheat from the chaff. I would also like to acknowledge and thank Mike Conquer at the National Oceanography Centre, Southampton for his advice during my development as a photographer. And I would like to thank my friends and peers at Wetpixel.com and the British Society of Underwater Photographers for their encouragement and guidance.

I would also like to thank Dr Luiz Rocha; Leslie H. Harris, Natural History Museum of Los Angeles County (California, USA); William Heaton; Dr John E. (Jack) Randall, Bishop Museum (Hawaii, USA) and Graham Abbott, Diving 4 Images for helping me to identify the various creatures in these photographs. This book is not intended as an identification guide and any incorrect identifications are my responsibility.

I would like to thank Peter Martin, Ben Steward, Andrea Ferrari and Thornton Mustard for their useful comments and suggestions on the text of this book. And I am grateful to Dr Annelise Hagan, University of Cambridge (UK), for her comments on the scientific content. I am particularly grateful to Sylvia Sullivan for editing the book and improving and sharpening my text immeasurably, and to Mandy McDougall for designing such a fantastic book. I am also very grateful to Pete Duncan and all at Constable & Robinson for making this project possible.

Finally, I would like to thank my family and friends for their support. In particular to l'amore mio Eleonora for your love and understanding – I can't wait to continue exploring coral reefs with you.

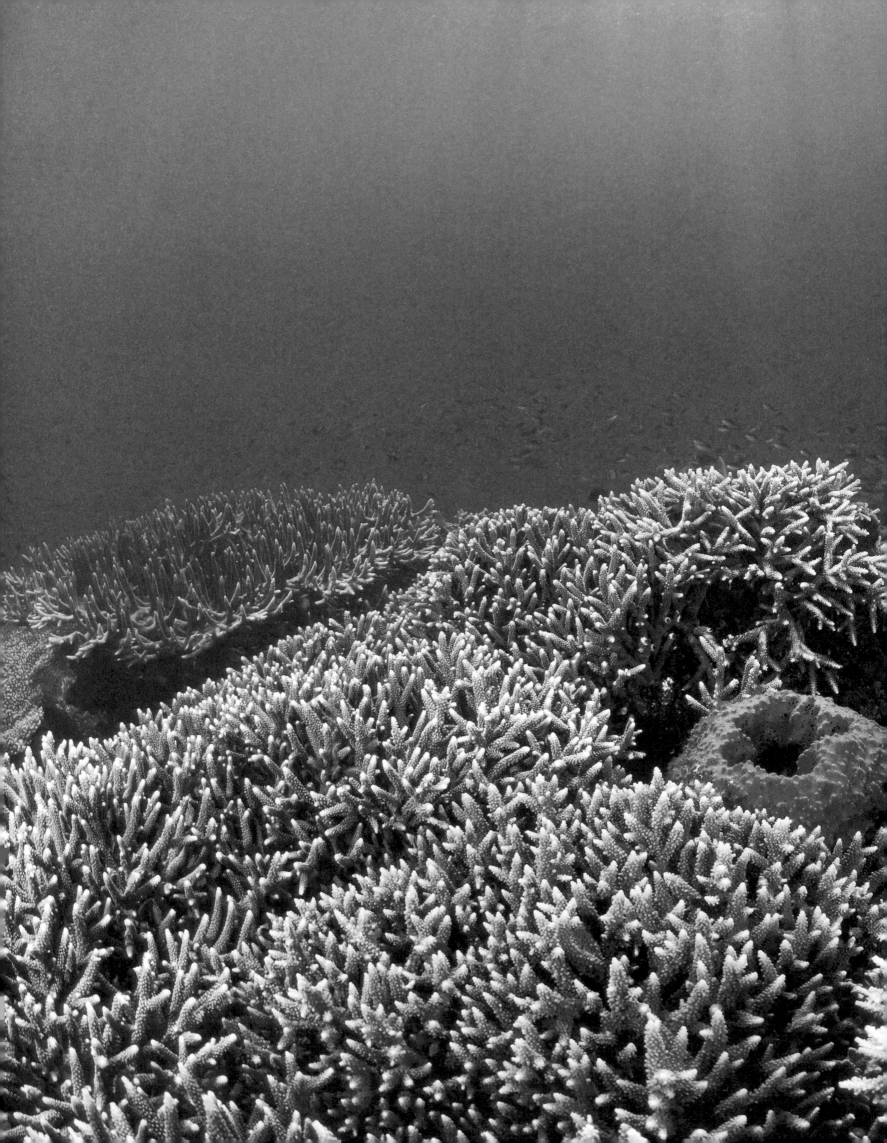